Pelican Books

Style and Civilization | Edited by John Fleming and Hugh Honour

Mannerism by John Shearman

John Shearman, born in 1931, was educated at Felsted and the Courtauld Institute of Art, London University, where he gained his B.A. in 1955 and his Ph.D. in 1957. In 1964, he went to the Institute for Advanced Study at Princeton on a research fellowship which gave him the time and opportunity to write this book. Among his other works are *Landscape Drawings of Nicolas Poussin* (1963), *Andrea del Sarto* (1965) and *Raphael's Cartoons* (1972). Besides these, he has written articles on Renaissance, Mannerist and seventeenth-century art for English, American, and European journals. He has also given lectures and broadcasts on his subject. Professor Shearman is Deputy Director of the Courtauld Institute. He is married with four children and enjoys yacht and dinghy racing, music, and travel. He is now working on a *Catalogue of Italian Paintings, 1300–1600, in the Royal Collection*, as well as *Painting in Italy: 1400–1900*, for the Pelican History of Art.

John Shearman

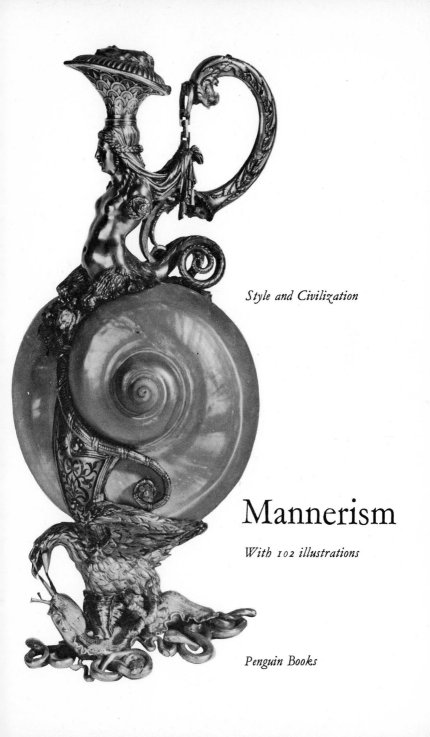

Style and Civilization

Mannerism

With 102 illustrations

Penguin Books

Penguin Books Ltd, Harmondsworth,
Middlesex, England
Penguin Books, 625 Madison Avenue,
New York, New York 10022, U.S.A.
Penguin Books Australia Ltd, Ringwood,
Victoria, Australia
Penguin Books Canada Ltd,
2801 John Street,
Markham, Ontario, Canada L3R 1B4
Penguin Books (N.Z.) Ltd, 182–190 Wairau Road,
Auckland 10, New Zealand

First published 1967
Reprinted 1969, 1973, 1977, 1979

Designed by Gerald Cinamon
Made and printed in Great Britain by
Butler & Tanner Ltd, Frome and London
Set in Monotype Garamond

To Jane

Contents

Editorial Foreword

The series to which this book belongs is devoted to both the history and the problems of style in European art. It is expository rather than critical. The aim is to discuss each important style in relation to contemporary shifts in emphasis and direction both in the other, non-visual arts and in thought and civilization as a whole. By examining artistic styles in this wider context it is hoped that closer definitions and a deeper understanding of their fundamental character and motivation will be reached.

The series is intended for the general reader but it is written at a level which should interest the specialist as well. Beyond this there has been no attempt at uniformity. Each author has had complete liberty in his mode of treatment and has been free to be as selective as he wished – for selection and compression are inevitable in a series, such as this, whose scope extends beyond the history of art. Not all great artists or great works of art can be mentioned, far less discussed. Nor, more specifically, is it intended to provide anything in the nature of a historical survey, period by period, but rather a discussion of the artistic concepts dominant in each successive period. And, for this purpose, the detailed analysis of a few carefully chosen issues is more revealing than the bird's eye view.

Preface

One of the notable events in the art-world in the last few years is that Mannerism has again become fashionable. This is obvious whether we look at sale-prices or museum acquisitions, libraries or coffee-tables. A sane man must approve, at least in principle, of the curiosity that all this signifies. The questions that then arise fall under three headings: what happened in Mannerism, how – as a historical sequence – did it happen, and why? It is the first of these questions that I feel has bothered us less than it should, and it is this question with which I am chiefly concerned.

The editors of this series quite rightly intended that such a question should be framed as widely as possible. This led me to seek guidance in unfamiliar fields from many friends, among whom I remember with particular gratitude Michael Hirst, Lewis Lockwood, Samuel Pogue and Michael Rinehart. Sir Anthony Blunt, Roberto Weiss and Sydney Freedberg were so kind as to read the typescript and offer several pertinent criticisms. In assembling the photographs I received more than usual assistance from Dottore Renato Cevese, Dottoressa Anna Forlani-Tempesti, Dr Erwin Auer, Dr Peter Kidson and the staff of the Conway Library, and the Banca popolare di Vicenza. I would also like to thank all those who have kindly consented to the illustration of works of art in their possession or charge.

This book could not have been written, or at least not with any time for reflection, but for a providential invitation to the Institute for Advanced Study at Princeton, which I owe to Professors Robert Oppenheimer and Millard Meiss. Angela Benham earned my gratitude and admiration for her painstaking work in preparing successive typescripts. The first draft, without the many improvements in sense and style suggested by John Fleming and Hugh Honour, is something I would prefer to forget.

The Courtauld Institute, London
28 July 1965

Mannerism

I

The Historical Reality

This book will have at least one feature in common with all those already published on Mannerism; it will appear to describe something quite different from what all the rest describe. It is as well to be frank about this from the start. Such is the confusion in our present usage of the term that one perfectly natural reaction, to be found even among art-historians, is that Mannerism does not exist.

Obviously, my editors and I believe that Mannerism does exist, with the same kind of reality (and no more) as the other style periods that are commonly acknowledged. In my view the contradictions in contemporary meanings for the word 'Mannerism' are to a great extent due to the fact that most of them are too contemporary and not sufficiently historical. In the attempt to rescue sixteenth-century art from the ill repute that much of it enjoyed in the nineteenth century, it has been endowed with virtues peculiar to our time – especially the virtues of aggression, anxiety and instability. They are so inappropriate to the works in question that some pretty odd results are bound to follow (the sixteenth-century viewpoint of works of art was admirably relaxed). My conviction is that Mannerist art is capable of standing on its own feet. It can be and ought to be appreciated or rejected on its *own* terms, and according to its own virtues, not ours. This raises no particular difficulty unless we succumb to a certain aesthetic squeamishness, for some of the relevant virtues are, unquestionably, hard to accept today.

At all events, it is a fact that many interpretations now exist for Mannerism. The conclusion is unavoidable: each author must define his term and justify the way he uses it – not as an academic ritual but so that the reader may make up his own mind about where it goes right and where it goes wrong.

DEFINING THE TERM

In the term 'Mannerism' there is a trap, concealed in the word itself. 'Mannerism' appears among purely descriptive terms,

'Gothic', 'Renaissance' and 'Baroque', and it alone is an 'ism'. This is an invitation to conceive it as a movement, like those of the nineteenth and twentieth centuries: as if it had a conscious direction, a manifesto, and a self-awareness that is focused in the notion of conflict with the art of the immediate past. But these ideas are anachronistic if they are projected back into the sixteenth century; they distort one pattern of development into another, and while they have the apparent virtue of making tidy something that is in reality untidy they end in an embarrassing disagreement between what is said now and what was said and thought at the time.

The problem of defining the term Mannerism is first of all a problem of method. Part of our present trouble is due to a certain arbitrariness in its application. A great deal of six-teenth-century art had been consigned to limbo by critics from the seventeenth to the nineteenth centuries; they thought it perverse and decadent. Around 1920 it was realized that so sweeping a condemnation was unjust. A number of interesting things happened in this neglected period; many of them were strange and fascinating, some of them were beautiful. To these phenomena, isolated and examined, was then applied the term Mannerism which was, as we shall see, conveniently at hand; it was as if the label could be attached freely to anything with-out one. Since the sixteenth century embraced some remark-ably diverse styles, Mannerism as a concept became, not unnaturally, strained.

But another process may be used. The label did, in fact, come down to us firmly attached to something; we have in-herited, not invented, it. If we give up the right to make it mean anything we like, we have in return a meaning that is specific, arguable and historically legitimate. For the expression Man-nerism is unusual among our style-labels since, like Im-pressionism, it may be traced back to ideas in circulation in the cultural context of the works themselves. Having found out what, historically, it should apply to, we may at that stage begin to define tendencies in style that are in harmony with it. This may provide us, finally, with a more restricted field of operation than does the more arbitrary approach, but this is of no significance. We are not bound to account for all the multitude of tendencies in the sixteenth century; and the value of any such term as ours varies in inverse propor-tion to the number of diverse phenomena it is made to embrace.

The origin of the expression Mannerism lies in an Italian word: *maniera*. This word was used during the Renaissance period in a number of grammatically different ways and carried with it a like number of meanings, but Mannerism is derived from one particular usage only: the absolute one. *Maniera* may in all cases be translated into the English word *style*. We use our word in various ways, most often with some qualification, as when we talk of Giotto's style, Byzantine style, abstract style, and so on. More rarely we use it absolutely; we say that a person, a performance or a man-made object (artefact or motor-car) *has style*, or equally has not. In the same way *maniera* was a possible, and in general desirable, attribute of works of art. For example Raphael and Castiglione wrote a most significant letter in 1519 to Pope Leo x on the architecture of Rome, in which they said that the buildings of the Goths were 'privi di ogni gratia, senza maniera alcuna' (devoid of all grace and entirely without style); in its context this remark implied that the qualities of grace and *maniera* were to be appreciated in the architecture of antiquity. Already in 1442 a sonnet listed *maniera* among the heaven-sent gifts of Pisanello; and in 1550 Vasari included it among the five qualities which, by being more highly developed in the art of the sixteenth century than that of the fifteenth, made his period superior.

The precise meaning of the word, when used absolutely as in these and several other cases, may be narrowed down by considering its still earlier history. Renaissance criticism of the visual arts was a less mature, articulate and well-armed discipline than many other literary forms of its kind, and the device of borrowing terms of reference and analytical techniques that occurs throughout the history of these disciplines was at that moment a very necessary one for writers in this field. The concept *maniera* was borrowed from the literature of manners, and had been originally a quality – a desirable quality – of human deportment. Lorenzo de'Medici, for example, required *maniera* in the deportment of ladies. In turn the word had entered Italian literature from French courtly literature of the thirteenth to the fifteenth centuries. There *manière*, like its Italian derivative, meant approximately savoir-faire, effortless accomplishment and sophistication; it was inimical to revealed passion, evident effort and rude naïveté. It was, above all, a courtly grace. This meaning survives, not only through its transference in Italy to the visual arts but also in its modern

English equivalent, 'style'. *Maniera*, then, is a term of long standing in the literature of a way of life so stylized and cultured that it was, in effect, a work of art itself; hence the easy transference to the visual arts.

However, there were two sides to this coin, then as now. If we say that a person has style we may wish to imply that he is unnatural, affected, self-conscious or ostentatious. In the sixteenth century *maniera* was generally a desirable attribute of a work of art, but this positive aspect was accompanied by the realization of the negative one that corresponded to what we now call, derogatively, stylization. Vasari found this defect, perhaps rightly, in the self-generating abstraction of Perugino, and another writer, the Venetian Lodovico Dolce (1557), implied that there was a general recognition of a deplorable tendency towards the reduction of artistic creation to a stereotype, to *maniera*. It was understood that *maniera*, whether in people or works of art, entailed a refinement of and abstraction from nature and this might or might not be a good thing. The tendency, setting in towards the end of the sixteenth century, was increasingly to question its validity, and thus it was that the negative aspect of the quality *maniera* came, in time, to be its whole meaning. To the seventeenth-century theorist Bellori *maniera* – the vice that destroyed good painting between, approximately, Raphael and Rubens – was an ideal born in the artist's fantasy and based not upon reality but upon *pratica*: stylistic convention and technical expertise.

Changing prejudice often inverts the value of words while preserving most of their sense; virtues are turned into vices, artistic qualities become defects. A case that concerns us is the word 'artificial' which is now normally pejorative, implying something meretricious. But it was not originally so, and in the sixteenth century the word *artifizioso* was wholly complimentary, and to a great extent concomitant with *maniera*; books ought to be written, and pictures painted, with artifice. Benedetto Varchi (1548) defined the intention of artistic creation as 'an artificial imitation of nature', which is the more interesting for being a widely held view rather than an original one. We have also, equally irrationally, made a term of abuse out of the word 'rhetorical'. These things happen when the convictions of one age are no longer reconcilable with those that succeed it. It is our nature to assume that our convictions alone are right, which they are unlikely to be.

As applied to people the notion of 'style' had always had, in France, derivative adjectives; in the first half of the sixteenth century there was current in Italy the flattering term *manieroso*: stylish, in the sense of polished. It was not long before works of art were similarly described. An alternative in the seventeenth century is *manierato*: more negatively intended, like our 'stylized'. The objective sense of the word is exemplified in a note made by Jonathan Richardson (1722), the heir to the whole Renaissance and academic tradition of criticism, on an antique bust of a girl in the Uffizi: 'very young, and a natural pretty air: this is not common in the Antique, which is generally *Manierato*'. Simultaneously there appeared in France the abusive name for a type of artist, more concerned with technical facility than anything else: *maniériste*. When in turn this title was transferred once more into Italian by the great historian Luigi Lanzi (1792) he adhered more precisely to the ideas implied by the root of the word since he specifically meant that group of artists previously stigmatized by Bellori with the vice of *maniera*; and this is important for it was Lanzi who invented, in the same context, the substantive we now use: *manierismo*.

The title thus given to a period is derived from a quality which is singled out, soon after the period in question, as most characteristic of it, and from a quality that is appreciated before and during that period. So, when we turn to look for tendencies in the art of the sixteenth century that may justifiably be called Mannerist, it is logical to demand that these should be, so to speak, drenched in *maniera* and, conversely, should not be marked by qualities inimical to it, such as strain, brutality, violence and overt passion. We require, in fact, poise, refinement and sophistication, and works of art that are polished, rarefied and idealized away from the natural: hot-house plants, cultured most carefully [1]. Mannerism should, by tradition, speak a silver-tongued language of articulate, if unnatural, beauty, not one of incoherence, menace and despair; it is, in a phrase, the stylish style.

There may have been an element of chance in the early selection of one quality in this kind of art to typify the whole, and we should greatly impoverish our understanding of Mannerism if we did not take account of other ideas intimately associated, in the same cultural context, with *maniera* and ideally harmonious with it. Modern aesthetic attitudes, at least those of sufficient maturity for us to be aware of them, are

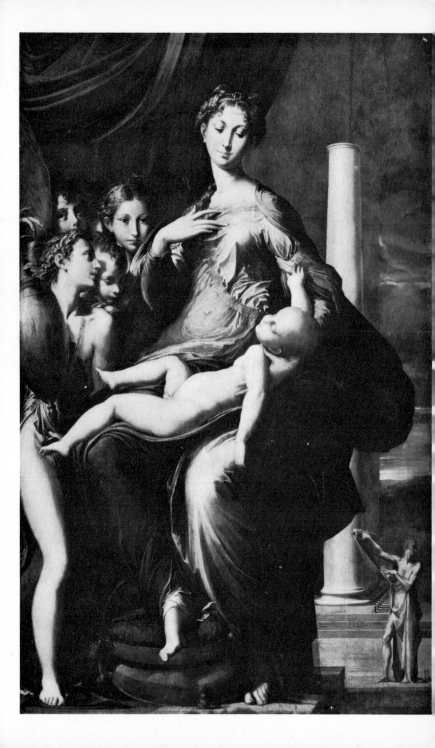

quite as effective an obstacle to the appreciation of Mannerist works of art as were those of Ruskin's era, and a frame of mind tolerant to them is not easily acquired. One reads, as we have seen, with surprise that artifice is a quality to be nurtured; yet there is clearly no reason why it should not be. Almost more important is the notion of difficulty, that is to say of difficulty overcome, which achieved during the Renaissance and Mannerism a significance which now seems hypnotic and irrelevant. Lorenzo de'Medici, in a Commentary upon his own sonnets, argued that this verse-form is the equal of any other because of its *difficultà* – because *virtù*, according to the philosophers, consists in (the conquest of) difficulty; to the philosophers he might have added Vitruvius who defined Invention as 'the solving of difficult problems and the treatment of new problems achieved by a lively intelligence'. Painters and sculptors each argued the superiority of their art over the other because it was more difficult. One of the qualities of Brunelleschi's trial relief for the bronze doors of the Florence Baptistery that his friend and biographer Manetti admired most was *difficultà*. It was, according to Raphael and Castiglione, to be found in antique architecture. Vasari praised Bramante for increasing it, together with beauty, to the great advantage of the modern style in architecture. This idea was important because it led to the appreciation (which we do not share) of facility as a very positive virtue; and it led also to those kinds of complexity and invention that are the result of deliberately raising more difficulties, so that dexterity may be displayed in overcoming them.

Today we take a somewhat priggish attitude towards virtuosity, but in the sixteenth century there were fewer inhibitions. Vasari defined perfection in the art of painting as richness of invention, absolute familiarity with anatomy, and the reduction of difficulty to facility; and Dolce went so far as to say that 'facility is the basis of the excellence of any art'. Already in the fifteenth century Landino praised Masaccio's 'great facility of execution', an attitude unlikely to be prominent in any modern monograph on this artist.

Castiglione, in the *Cortegiano* (published 1528, but written earlier), invented a word for the courtly grace revealed in the effortless resolution of all difficulties – *sprezzatura*, which is that kind of well-bred negligence born of complete self-possession that Van Dyck and Gainsborough not accidentally divined in the English gentleman – and this term was used

1. *Madonna del Collo Lungo.* Parmigianino

with enthusiasm by Dolce for works of art. As with 'facility', the opposite vice is the *visible* application of too much effort or any sense of strain in the performance.

The love of complexity rather than economy was another characteristic of the period. Lorenzo de'Medici, in the same Commentary, expressed his dislike of obscurity and hardness of style but valued copiousness and abundance. And finally we have to accept the validity of the caprice, the bizarre fantasy, or, as we sometimes call it, the conceit. This was so well understood in the sixteenth century that Vasari could praise as capricious, for example, the spectators crowded on columns in Raphael's *Heliodorus*, and as 'a most bizarre invention' an octagonal plan of Brunelleschi's – cases from earlier periods where these devices have different, and functional, purposes. Correspondingly, it was common for Mannerist artists to adapt artistic forms or compositional devices, originally invented with expressive functions, and to use them in a non-functional way, capriciously.

LIMITS OF THE FIELD

Mannerist art should not be identified with mannered art, for while the first is always to some extent mannered the second is not always Mannerist, since it may be anything but graceful and accomplished. If we were to reassemble our stylistic category from mannered works we should find ourselves associating works from virtually every period with nothing in common except one negative quality. A category that includes Crivelli, Magnasco and Ford Madox Brown is neither historical nor illuminating.

The whole meaning of *maniera*, with positive and negative aspects, is the origin of our term and it is this that must be the basis of our selection. Although no concept of a movement *manierismo* existed in the sixteenth century it was then, without doubt, that *maniera* was most appreciated in works of art. A chronological category has been made of this ideal, and we should, if we want to use it, determine at what points the ideal begins and ceases to characterize a style. Stylistic changes in the pre-Romantic periods were never violent or reactionary; they were complex, gradual processes. At a certain point one feels that the ingredients and intentions have changed in their relative proportion, so that a new set of values predominates. *Maniera*, in small proportion, is present in many periods, especially in the fifteenth century; there is no inconsistency if a

contemporary of Pisanello found *maniera* in his work, or if Vasari detected it in Ghiberti, for it is indeed there. But Vasari also said that the fifteenth century was relatively deficient in this quality when compared with his own century, and that was also an accurate observation provided that we allow flexibility in one respect. We must be prepared for more or less *maniera* between one artist and another, between one work and another by the same artist, or even between individual parts in the same work. It is an unrealistic tendency to regard periods of style, in themselves increasingly artificial as we go further back into history, as tidily homogeneous.

The 'stylish style' had its roots deep in the High Renaissance. It is important to remember that Vasari understood things differently from us, since he saw the works of his own period as more intimately related to those of Leonardo, Michelangelo and Raphael than were the latter to those of the earlier Renaissance. In many ways he was right, for it is not difficult to show that the High Renaissance was more revolutionary than Mannerism; but he was only wholly right if the High Renaissance is seen across the rather different prejudices and preferences of the mid sixteenth century. He and his contemporaries saw only a part and they thought it the whole; but that part was a constituent of real, and indeed growing, importance within the limitlessly faceted totality of the High Renaissance. Mannerism was latent in the preceding period to the same extent as were the many Baroque tendencies in sixteenth-century art, and it was as logical a sequel. One of the most characteristic things about Mannerism is that its birth was ideally easy and attended by no crisis.

A style drenched in *maniera*, and distinct from the expressive, communicative and dynamic proto-Baroque tendencies of the High Renaissance, first reared its beautiful head in Rome about 1520. We shall examine this event in more detail later, and may anticipate here by saying that in these early products [28] an insistently cultured grace and accomplishment is accompanied by the kindred qualities of abstraction from natural behaviour and appearances, bizarre fantasy, complexity and invention that were outlined above. This style was evidently congenial to patrons and connoisseurs for it spread with the rapidity of a fashion. The artists in this Roman group were, as it happened, travellers (their journeys were provoked by the plague of 1522, the artistically disastrous pontificate of Adrian VI, and the Sack of Rome in 1527) and,

of course, this greatly facilitated the dissemination of the style. Perino del Vaga introduced it publicly to Florence in 1522–3, Giulio Romano to Mantua in 1524, and Polidoro to Naples in 1527. A Florentine, Rosso, joined the group in 1524 and, working subsequently in central Italy and for a moment in Venice, finally transplanted the style with great effect to Fontainebleau in 1530; he was joined there in the early 1530s by Primaticcio, who came from the new centre at Mantua. Parmigianino, joining the Roman group in 1524, returned to Emilia in 1527.

Nearly all these artists worked very extensively for engravers, and Parmigianino was a graphic artist in his own right, so that Mannerism became, at least potentially, accessible immediately on a European scale. Soon, the same style in sculpture became almost as freely disseminated through the production, on an unprecedented scale, of small bronze and terracotta copies. The proliferation of engravings is related to the eventual triumph of Mannerism in Northern Europe, which was virtually complete, over other possible developments out of the High Renaissance; in Italy itself these alternative currents (which were much less frequently published in engravings) progressed with equal vigour, and Mannerism enjoyed no such total triumph.

Mannerism was essentially an Italian style, and wherever it appears outside Italy it represents the adoption of Italian standards. Its spread throughout the North was, in fact, one aspect and result of the Italian cultural domination of Europe that dates from the invasion of Italy by Charles VIII of France

2. Galerie François 1er. Rosso and assistants

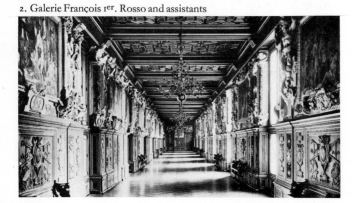

(1494): the domination that compensated artistically for the political and military subjection of Italy in the same period. The spread of such wholly Italian exports as the Galerie François 1er at Fontainebleau [2] raises no particular problem; but it is much harder to understand the indigenous product.

One preliminary difficulty arises from the almost total absence, north of the Alps, of anything equivalent to the High Renaissance – that moment which in Italy finally made Gothic not only the object of derision but also a dead language (dead in the sense that any subsequent case is a revival). A late-Gothic style flourished energetically in most countries outside Italy well into the sixteenth century with results sometimes very beautiful and sometimes merely peculiar.

Now it so happens that some characteristics of Gothic – especially of late-Gothic – align themselves easily with those of Mannerism: tendencies towards grace, complexity, preciosity and so on. And a very confusing situation arose when the late-Gothic style was superficially overlaid by Italian Renaissance influences, as in the case of the painters known as 'Antwerp Mannerists' or, in architecture, in the dormers, turrets and chimneys of the Château de Chambord. It is only when, as in some instances at Chambord, the motifs are specifically Mannerist, and executed with a certain necessary panache, that this kind of work should be given the title; oddity by itself is not a qualification. Most of the hybrid forms are better conceived as an awkward vernacular classicism. The analogy is accurate to the extent that a major contemporary phenomenon in literature, discussed articulately in France and

3. *The Death of Adonis*. After Rosso

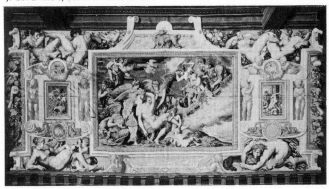

England, was the collision of the vernacular with Italian influence.

The dilemma raised by the affinity between late Gothic and Mannerism may be illustrated in another way; it will be recalled that *maniera* was (reasonably) detected in Pisanello and Ghiberti, two of the most Gothic artists of the Italian Renaissance, while, on the other hand, grace and 'style' were the qualities totally absent, according to Raphael and Castiglione, from Gothic architecture. Rather similarly Tasso, writing in 1571 after a visit to Paris, said that French (that is, Gothic) architecture was built 'without any regard to elegance or fitness', which at first sight seems absurd. It is clear, however, that the elegance and fitness required by Tasso were not of a general but of a particular kind – in fact, classical; and it was this particularized *maniera* that was demanded by Raphael. The solution to the dilemma is probably to be found in the concept of a 'universal mannerism' – that is to say, a tendency that may appear within any period and almost any category of style, similar in certain respects only to Mannerism proper, which is that of the sixteenth century; the latter is born of the rich experience of classical form, harmony and *gravitas* that is the High Renaissance, and however much it may later betray its parent the stamp of that experience is always there.

When put to the test, then, the Italianate late-Gothic style probably fails to qualify. More certainly a failure is another kind of Northern art that is pseudo-Mannerist, by default. Architectural exercises in the Italian manner but of uncertain competence, such as the Ottheinrichbau at Heidelberg (*c.*1555), are often hailed today as Mannerist because they are strange and unconventional: but they fail by the first test of all, which is savoir-faire. They are precisely not *manieroso*. When a Mannerist artist breaks rules he does so on the basis of knowledge and not of ignorance. A considerable amount of North European architecture of the sixteenth century must be excluded for these reasons.

In France a native Mannerist style was properly established in the 1540s, in the work of Jean Goujon [4] and perhaps some aspects of Philibert de l'Orme; it continued with that of Germain Pilon [5] and Jacques du Cerceau the Elder [6]. Even if the style of these artists was largely Italian in inspiration, the level of their artistic achievement was as high as that of their Italian contemporaries. In the Low Countries the ground was prepared by a group of artists, working around 1540, known

Titian ensured that Venetian art was primarily dedicated to the further exploration of the expressive and naturalistic aspect of Renaissance art in a direction that leads more directly than Mannerism to an artist such as Rubens. There was, to be sure, a central Italian invasion around 1540, led by Francesco Salviati, and Titian himself experimented inconclusively with Mannerist forms around the same time, but the effect was not lasting except perhaps in one case, that of Andrea Schiavone.

Tintoretto is often described as a Mannerist but it is questionable whether his aims and ideals may be properly construed in this way; his work is sometimes elegant and sometimes a little abstracted, but it is never polished and always fired with a disqualifying energy. The resistance of Venice, however, should not be oversimplified to produce a conflict of irreconcilables; it seems that there were no tendencies in sixteenth-century art that could not be combined with complete harmony, and this interchange may be seen at many points. In centres such as Ferrara and Bassano, caught in cross-currents of Roman or Emilian Mannerism and the Venetian style, an artist might vacillate, but without any apparent discomfort.

There was a certain natural antipathy between Mannerism and the Counter-Reformation, and in general the style became effete in Italian religious works from about the 1570s, continuing with somewhat reduced conviction in secular and

8. *Portrait of a Lady*. Isaac Oliver

9. *Venus, Mars and Cupid*. Hubert Gerhard

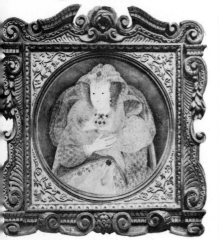

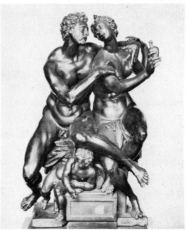

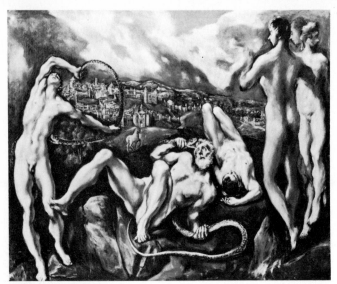

10. *Laocoön*. El Greco

decorative works into the seventeenth century in such an
artist as the Cavaliere d'Arpino. Again however, individual
personalities upset all generalizations, for if the style was a
declining force in Rome relatively early, it went on flourishing
late in Florence because of the overwhelming influence of
Giovanni Bologna [12] and to a lesser extent of Buontalenti
[77]. The last truly vigorous manifestations were in the North,
in a group of Dutch artists from the schools of Haarlem and
Utrecht, typical of whom was Wtewael [13] (d. 1638), and at the
court of Rudolf II at Prague where the dominant figure was a
former colleague of Goltzius, Bartholomäus Spranger [14]
(d. 1611). A similar figure in Dresden was Johann Kellerthaler.

THE SISTER ARTS

The purpose of the foregoing survey is to give some im-
pression of the scope, chronologically and geographically, of
Mannerism in the three major visual arts. If we were to con-
sider in the same way the so-called minor arts and styles of
ornament we would find a pattern similar in some respects, the
principal deviations being due to the location of particular
skills and the inherent fitness of Mannerism to different art-
forms; these lead, for example in metalwork, to a concentration

11. *Pietà*. Jacques Bellange
12. *Apollo*. Giovanni Bologna

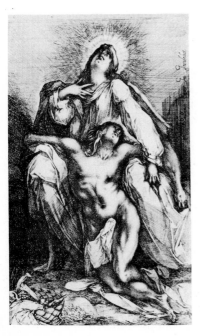

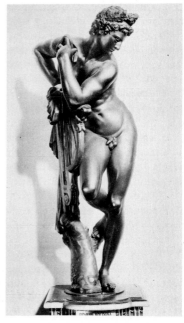

13. *The Marriage of Peleus and Thetis.* Joachim Wtewael

of production in the North and the survival of Mannerist conventions throughout the Baroque period.

Mannerism, as we have seen, is a term invented for a category in the history of the visual arts. Recently, as a result of the continuing cross-fertilization of critical disciplines, the concept has been transferred to other fields. This has led to some confusion, since there have also been transferred the varieties of meaning that art-historians attach to the term. However, the transference is not artificial, for equivalents really do exist; and a study of sixteenth-century literature and music not only provides illustrations of such similarities but also reflects a little light back on to the concept of Mannerism in the visual arts, which remains our primary concern.

The modern tendency towards increasing specialization in all branches of research and scholarship has discouraged comparative studies of the arts; and what we so seldom do we generally distrust. But our distrust of analogies was not shared by the sixteenth century, which inherited from antiquity a habit of drawing parallels as a matter of course.

Some examples of these analogies should be given; but there is another point to consider first, which to some extent explains them. Too little appreciated is the extent to which the

4. *Vulcan and Maia*. Bartholomäus Spranger

critical language of one of the arts in the sixteenth century was in fact common to all of them. This was only in part due to cross-fertilization; it was primarily due to the derivation in each case of critical techniques, frameworks and terms of reference, from the enormous body of ancient criticism which was, as it happened, mainly literary and rhetorical, to a lesser extent musical, and scarcely at all concerned with the visual arts.

For example, in Quintilian's *Institutio oratoria* Vasari found an outline sketch of the stylistic development of ancient rhetoric that he could adapt to his own purposes in his *Vite* (1550). The same historical scheme had already been adapted to Renaissance music by Glareanus in his *Dodekachordon* (1547); Glareanus, a humanist writing in Latin, also leaned heavily on Quintilian's terminology. No less important were the treatises of Aristotle, Demetrius and Cicero. The influence of all of these on later Renaissance literary criticism hardly needs to be recalled. In the sixteenth century there were remarkably few critical ideas that were *not* derived from antiquity.

Quintilian's sketch of the history of rhetoric was, moreover, preceded by illustrations of the same pattern of development in ancient painting and sculpture, as if he expected his reader to grasp the point more readily in these cases. Each orator could be paired off with a painter or sculptor. Cicero, Demetrius and Aristotle drew similar analogies. The latter, in the *Poetics*, illustrated a point of literary style by comparison with painters, among whom Pauson painted men worse than they were, Polygnotus better and Dionysius about right. In Trissino's *Poetica*, Book V (drafted about 1530), the same points were illustrated by Montagna, Leonardo and Titian, and he then extended the illustration to music and the dance. Cosimo Bartoli's *Ragionamenti* of 1567 contains chronological comparisons between composers and sculptors, pairing first Ockeghem with Donatello and then Josquin des Prés with Michelangelo. Tasso himself readily thought across from poetry to painting and sculpture (in the *Discorsi dell' Arte Poetica*, 1564) and to music and rhetoric (in *La Cavaletta*, 1587). The most striking example, however, is provided by Sperone Speroni, a dramatist and literary critic inclined to Mannerism; in a late work, *Sopra Virgilio*, he compared the Latin author's poverty of invention to Titian's and then to the Colosseum, or a pyramid, while Homer's poetry – adorned, amplified and rich in epithets – reminded him of Corinthian architecture

and Hellenistic sculpture (he cites the *Laocoön* and *Apollo Belvedere*).

This community of ideas, and its relation to Mannerism, will be the subject of Chapter 4. We shall see there the conscious relationship between the pursuit of a refined style in all the arts and the concept of an age more cultured than its immediate past. For self-conscious stylization is the common denominator of all Mannerist works of art. Undoubtedly this kind of stylization was stronger around 1500 in literature than anywhere else. When we turn to literature, however, we must take account of a point first made in one of the greatest critical works of our time, E. R. Curtius's *European Literature and the Latin Middle Ages*.

Curtius, borrowing the term from the history of art, defines moments of mannerism, that is of preciosity of style for its own sake, in almost all phases of European literature, including antiquity; he finds a constant oscillation in this direction or towards classicism, which is direct expression of the matter. This is a valuable concept, for all the arts are prone to such tendencies. In music, for example, there exists a number of compositions from the end of the Gothic period, around 1400, of a highly complex notation and rhythm, that can scarcely have been performable but were, rather, intellectual caprices. Similarly there was a moment, around 1200, of extreme sophistication in the evolution of the Byzantine icon. To such things the application of our term is legitimate, but only by extension, as we talk of 'baroque' moments within other stylistic periods; none of them represents a full-blooded period in itself, nor is it manifested in all artistic aspects of a civilization.

True Mannerism was such a thing, and, since the meaning of the word is that it is extravagantly accomplished, it must have fed upon a previous period of supreme accomplishment; these conditions were provided by the High Renaissance which reconquered the classical form and language. In the almost complete absence of antique music, the terms Renaissance and, to a great extent, Mannerism can hardly be defined for music except by analogy; but in literature and the visual arts an argument is possible.

In Italy the evolutions of literature and the visual arts are not strictly comparable before about 1500. It becomes natural however, to compare Sannazzaro's *Arcadia* and Raphael's *Parnassus*, and not only because of a similarity in their subject

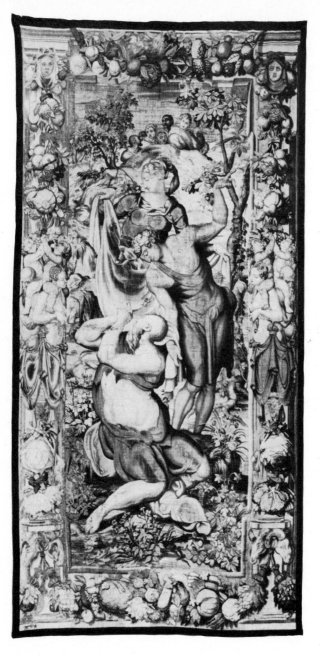

15. *Joseph's Coat brought to Jacob.* After Jacopo Pontormo

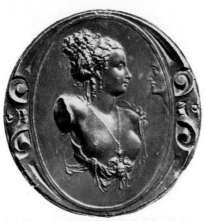

16. *Medal-portrait of a Lady*. Alfonso Ruspagiari

matter. Both are deeply inspired by antiquity and have re-conquered it to the same degree, and in both there is an ideal balance between artistic perfection, or an ideal of beauty in its own right, and technique in the service of an idea. But one notices less readily that *Arcadia* was begun about twenty years before the painting. There is an interesting literary development that we now call *Bembismo* which has about the same chronological relationship with Mannerism in the visual arts.

The history of Italian literature of the Renaissance is as much about Latin works as vernacular. The dominant literary move-ment in early sixteenth-century Rome was Ciceronianism – 'Il bello scrivere latino'; it reached its peak in Sadoleto, Bembo and Inghirami, and it was marked by an obsession with *style*. It led on the one hand to cultivated, elegant artificiality, and on the other to a natural interest in the notions of good style expounded in the rhetorical literature of antiquity. Alongside it was a sympathetic movement in the vernacular, also dedi-cated to the artificial cultivation of a past style, but with Petrarch as its ideal rather than Cicero. Bembo, whose position is a little ambiguous, was generally credited with the leader-ship, particularly by the Latinists who felt betrayed, though in fact it may have been a battle he led from behind; in any case this battle – the image is prompted by the contemporary pub-lished Dialogues on the subject – between Latin and vernacular is chiefly characteristic of Ciceronianism and *Bembismo* in that

it is itself artificial; the real function of the Dialogues was to provide a serious discussion of what style should be. In the vernacular movement also, style is the main preoccupation; matter is its servant.

A cycle in the ancient history of rhetoric is thus repeated, the inversion – in Asianism and later Roman rhetoric – of the 'classical' formula: *Rem tene, verba sequuntur* (roughly: concentrate on the subject, and let the style follow from that). Bembo, for example, held that if a brutal, ignoble or passionate *argumento* threatened by its expression to spoil the beauty of a work it was better to scrap it. This is the real sense in which *Bembismo*, like Mannerism in the visual arts, is un-classical: it is founded on a reversal of the normal relationship of form and content.

However, *Bembismo* also resembled Mannerism in the sense in which it was, by a perverse paradox, also classical. The perfect vernacular literary style was to have two sources. Bembo argued that it was right for every man to write in his own language, but he did not mean the spoken language, which he despised for its corruptness, but a dead language revived, the language of classics; by definition, they could not be Latin or Greek, so the ideal of eloquence was provided by Petrarch above all, Boccaccio less so, and emphatically not Dante. Secondly, the objective was to raise the vernacular to the highest level of latinity in matters of elegance, richness of ornament, figures of speech and copiousness of vocabulary, chiefly by a transference of forms from one language to the other. The process had, in fact, begun spontaneously long before Bembo, but it was now formalized – almost, one might say, institutionalized. In a word, what he wanted to give the language was *art*; it was Aristotle's responsibility that *art* had come to mean *rules*; and this was the sense in which Bembo wished literature to be *artificial*. Just as genuine sentiment, like all coarseness, was to be excluded, so necessarily the patterns of expression themselves must be divorced from those natural ones in everyday use. This looks like a prescription for disaster, but it was not.

A typical product of *Bembismo* was the enormously gifted Agnolo Firenzuola, who came to maturity in the Rome of Leo x (Pope from 1513 to 1521). Strangely, at first sight, he is most celebrated for translation, above all that of Apuleius's *Golden Ass* (soon after 1520): precious, refined and beautiful in marked degrees. Firenzuola's *L'Asino d'oro* is, however, much

more than a translation; it has some changes in the story, but above all it represents the creation for the vernacular of a *style* as polished and sophisticated as that of Apuleius himself, whose Latin was greatly admired for just these qualities. Firenzuola prefers translation, in fact, because it restricts the creative problem to matters of form, not of content; however un-classical this may be, he classicizes linguistically. The criticism that he is purely a technician misses the point; the statement that he is artificial is exactly the point, but today it is usually made under the influence of a prejudice, and makes negative something that was positive. *L'Asino d'oro* is a very sensitive, and legitimate, work of art.

The modern line of attack is, in any case, not new; G. B. Giraldi, whom we shall meet repeatedly as a middle-of-the-roader in criticism and theory, was not unsympathetic towards Bembo's aims, partly because they could be justified to a surprising extent by ancient authority, but he thought Bembo went too far. In his *Discorso* on the Romance (1549–54) he advised, for example, the imitation of Petrarch's 'necessary' and 'natural' rhyme but noticed that Bembo, with admitted grace, mixed this kind with those that were unnatural; the latter were without meaning and forced, present only to make a rhyme ('posto per ornamento, e non per bisogno'). Consistently, Giraldi disapproved of embellishments and technical improvements in the final revised version of Ariosto's *Orlando furioso* (1532).

Mannerism was as widespread in literature as it was in the visual arts (and probably lasted longer). Bernardo Tasso, especially in his Romance *L'Amadigi* [75] of 1560, is perhaps the most perfect Italian example; in Bernardo Tasso's earlier lyric style, by the way, Aretino recognized grace and *maniera*. For the North it may be sufficient for the moment simply to mention Philippe Desportes in France, and in England Edmund Spenser, George Pettie, and above all John Lyly, whose *Euphues* (1579) is directly linked in style with *Bembismo*.

CAUSES

There has been a great deal of argument over the causes of Mannerism. Disputes arise mainly because the historical factors which are thought to have determined the evolution of the style are so often of a kind very remote from the processes of artistic creation. The invasion of Italy, the Sack of Rome and

subsequent economic collapse were responsible, it has been suggested, for an intellectual and cultural climate of crisis peculiarly favourable to the development of Mannerism – the fact that similar political and economic conditions in other periods and places did not have similar artistic results being conveniently overlooked. In Venice, for example, the wars of the early sixteenth century ushered in a period of economic and social disturbance eminently suited, one might suppose, to the growth of a Mannerist style. Yet Venetian artists seem to have gone on working very much as before, in untroubled serenity, quite oblivious to the disastrous events which had overtaken their native city. Many other similar instances of the apparent indifference of artists to current conditions can be found. It is, in fact, very hard to determine how directly the political, military and economic events can ever affect artistic styles; and still more difficult to understand why they should be supposed to do so only in some periods and places but not in others. Of the creative process we still know very little but it is clear enough that most works of art are insulated in the mind of the artist even from his personal crises, joys and tragedies, as a child is protected in the womb.

More reasonable are explanations of Mannerism in socio-logical and religious terms; in these cases we may be near the function of the work of art, and it is not hard to show the influence of these factors on the life of artistic forms; more difficult, but not impossible, is their influence on the life of styles. Most relevant, however, to the real problem are factors within the artistic context itself: aesthetic convictions of the artist's environment, which may become fashions, and con-ditions of patronage.

In so far as we may distinguish between permissive and effective causes, we should place among the first the surprising licence given by the ancient critical tradition, particularly for pure decoration and non-functional embellishments. On the other hand the whole classical tradition repeats Aristotle's warnings of excess in these matters; ornamentation must be controlled by judgement and taste: two elastic yardsticks, as Quintilian observed. In interpreting ancient and sixteenth-century texts we must be aware of this problem of calibration, for the point at which affectation begins can clearly be shifted. In Vasari, there is an apparent conflict between moderation in theory and excess in practice. It is clear that Vasari did exercise a judgement, admitting the dangers of an excess of

maniera, for example, or blaming the followers of Michelangelo for an obsession with *difficultà*, both qualities of which, in principle, he approves more than we would. Similarly Zarlino writes in praise of polyphony, but rudely of extravagant polyphonic effects.

When we turn to the literature of manners, however, it becomes clear that the threshold of excess was placed abnormally high.

Giovanni della Casa's *Il Galatheo* (1551–5) seems, at first sight, to give eminently sensible and balanced instructions for our general bearing, but it is an indication of the artificiality he in fact expects that even the behaviour of one's horse may be proper or improper. Best of all is Stefano Guazzo's *La civil conversazione* (1574 – immensely popular, with thirteen more Italian editions before 1600, four French, two English). In the first three, theoretical, books he seems to observe the middle way as sensibly as Alberti or Palmieri in the previous century, firmly demanding decency, the integrity of the family, and the avoidance of affectation. The last book is an illustration of his ideas in practice, a report of a society dinner at Casale attended by real characters; it is presumably also a faithful account of typical society behaviour, and by our standards it is far from moderate in its artificiality. It is a picture of an insulated society, self-sufficient in its amusements and in conversation elaborately stylized (frequently quoting Aristotle, Cicero, Martial, Ariosto and above all Petrarch). They drink out of glasses shaped like boats. They play elaborate and artificial games, tests of invention and wit in which the matter of the answer is irrelevant and only an artful display is required; they expect quantity production of synthetic laments from an arbitrarily chosen lover to one of the ladies, and they then criticize them. Fundamentally neither the guests nor the author believe passionately in anything (except style, and style they certainly have). For instance Guazzo's earlier praise of the sanctity of marriage is illuminated now by a long passage in which the guests practise brinkmanship, at least, in the discussion of marital fidelity. Thus for Guazzo – and for Vasari – the exhortations to moderation, of classical descent, belong in great part to the genre and give it classical tone; for us they are a symbol of the Renaissance context, and for the author they are an ornament to his work, a literary convention that he cannot ignore; in other words they are themselves an aspect of style rather than of content. The same is true of Vasari's

stress on the study of nature and the expression of emotions, which at first reading seem to have more to do with Alberti than with the arts in Vasari's circle.

To return to the causes of Mannerism: it would not have occurred to any Renaissance scholar to query the ancient truth that taste and judgement should place a check upon excesses of style; but, on the other hand, there is not in antiquity, nor is there absolutely, a point at which the line may be drawn, or a scale of standard calibration. Opinions differed from one person to the next in the sixteenth century as at other times, and it is no more than a general tendency that accepts an uncommonly high proportion of ornamental graces and complexities. What matters is that it was as easy to justify these 'excesses', in the visual or literary arts, on the basis of ancient precept, as it was to condemn them.

In the visual arts it must have been important, in the Renaissance, that reading Vitruvius or Pliny could lead one to believe that in antiquity architecture and sculpture progressed towards elegance in proportion and refinement in detail. This is crucially important in relation to the concept of an intervening period of coarseness and lack of style: *L'età rozza* (the coarse age), as Vasari called it in his *Ragionamenti*. The proximity of this preceding period must have made artists conscious, as Vasari was, that the fifteenth century was still sub-classical in its plainness and lack of elegance, and that the High Renaissance represented a swing towards a good style; they could not see, as we tend to see now, that the High Renaissance was the moment of equilibrium, in the Aristotelian sense, between clarity and fitness to purpose on the one hand and embellishment by elegance and graces of ornament (arising naturally from the matter and never obtrusive, or without inner motivation) on the other. They could reasonably see Mannerism as a continuation of a refining process begun in the High Renaissance, and they had little incentive to notice that the swing had gone beyond the mean. There is certainly interesting adverse comment on this evolution in the sixteenth century, and the observers responded to it no more unanimously than the artists, but it was not until about 1600 that a completed cycle could be generally perceived, and a dispassionate choice could be made.

Among the effective causes of Mannerism we may place the literary movements outlined above. It is not accidental that these were centred on Rome, and that it was in Rome that

7. French armoire

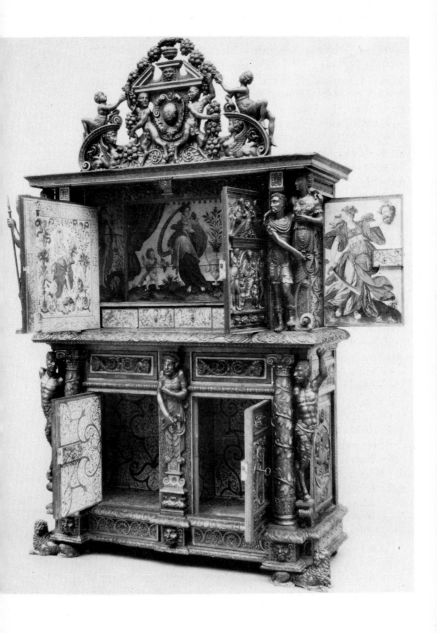

Mannerism was first established. There is no question that letters carried more prestige there than the visual arts, and it is also certain that Michelangelo and Raphael were closely associated there with the leading literary figures, so it is reasonable that the course of the one art should influence that of the others by a transference of ideals.

Then, moving to the circumstances of the visual arts themselves, we should notice a new development in patronage, which is, in turn, a symptom of a new conception of a work of art. Around 1520, and thereafter, we find that works are commissioned for no other reason than the desire of the patron to have, for example, *a Michelangelo*: that is to say, an example of his unique *virtù*, or his *art*; the subject, size or even medium do not matter. This is the birth of the idea of a work of art made, in the first instance, to hold its place in a gallery. In January 1519 Michelangelo heard from Paris that 'François Ier has no greater wish than to have some work, even small, of yours'; even more explicit is a reminder in 1523 from Cardinal Grimani in Venice, about 'that painting for a *studiolo*, already requested and promised by you, of which the choice of material and subject is yours, whether painting, or bronze, or marble – do whatever is most convenient to you'. In 1524 Castiglione is charged by Federico Gonzaga with obtaining anything from Sebastiano del Piombo, as long as it is not about saints, but graceful and beautiful to look at. The same commission is mentioned in 1527 in a letter to Federico from Aretino, who says that Sebastiano 'has sworn to produce something stupendous'. Later, there is a letter from Annibale Caro to Vasari about a painting of which the subject is left to the artist. The idea in these cases is, no doubt, a crystallization of vaguer notions that produced, for example, Leonardo's 'one-man show' when he exhibited his *Saint Anne* in 1501, and which probably existed in the fifteenth century and in antiquity. But they assumed an altogether new importance early in the sixteenth century, and they must have led to two results in the mind of the artist, both central to Mannerism: the concept of the work of art as an enduring virtuoso performance ('something stupendous') and the concept of the 'absolute' work of art.

This is emphatically not Art for Art's sake, which implies independence of, and even contempt for, the approbation of the public. On the contrary, Mannerism is based upon an obsession with a favourable audience-reaction, the stimulation

8.
Bowl and cover.
Pierre Reymond

of which is a more important part of the work's function than ever before.

We are concerned here with a shift in emphasis among the constituents of the function of a work of art: less devotional, practical, ceremonial, and more self-sufficient, or absolute; it is a tendency – widely but not universally approved – to reduce or elevate, according to the point of view, the function to that of simply being a work of art. The more Art the better.

It is now time to look at an example of this idea in practice. In 1522 a group of artists met in the Brancacci Chapel in Florence, and admired Masaccio's facility which showed his conquest of artistic difficulty (how typical is this remark of the period, and how irrelevant to ours!). Among them was Perino del Vaga, hot from Rome, who claimed that a modern artist could make figures as well, and more beautifully. When challenged, Perino began work on a fresco of an apostle next to one by Masaccio as an example of the new Roman style: not commissioned, for he had to ask the prior's permission, and not functional in any sense, except as a demonstration of *virtù*.

This notion is related to a new meaning of the idea of competition, and to a concept of 'classics'. Masaccio was put forward as a peak of perfection, to be over-reached. In the same sense Josquin was a 'classic' in music, for example to Glareanus, and Petrarch in poetry, for example to Michelangelo. In the visual arts the concept is a symptom of the long evolution in social status from craft to vocation; another symptom is the concept of the 'Old Master'. This is first encountered in the sixteenth century, and is reflected in the continuing demand for copies after Leonardo, Raphael or Andrea del Sarto. The establishment of classics, in this sense, naturally provoked the ambition to scale yet higher peaks, as in the case of Perino.

But competition between the living was as great a stimulant to the pursuit of a perfect style. A new idea was implied in the commissions given to Raphael and Sebastiano del Piombo (the latter backed by Michelangelo) by Cardinal Giulio de'Medici in 1517, for two altarpieces, respectively the *Transfiguration* (now in the Vatican Gallery) and the *Raising of Lazarus* (National Gallery, London). Competitions were not in themselves new, but the prize in this case was not employment, for both works were to be accepted. It was recognized by all parties that what was at stake was reputation. (Raphael's painting so triumphantly won that it was kept in Rome and

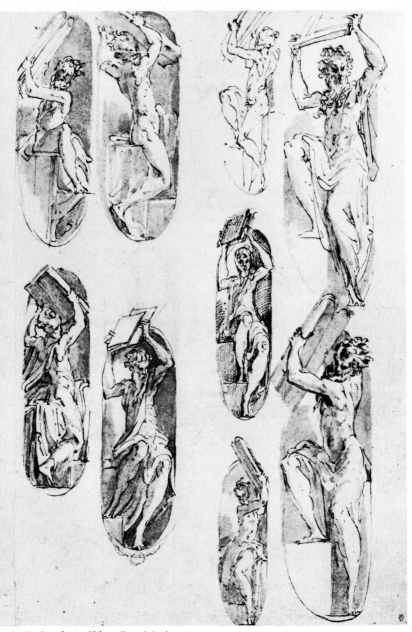

19. *Studies for a figure of Moses.* Parmigianino

only Sebastiano's was dispatched to its intended site at Narbonne.)

Raphael's *Transfiguration* illustrates another, rather similar point. Let us try to imagine the reaction of a cultivated observer, brought up to appreciate the style of the late fifteenth century, when faced with the painting that was, in effect, Raphael's artistic testament. What was not now, he might have asked, within the capacity of Art? What could not be described, what anatomical or expressive problems could not be solved, what difficulties had not been effortlessly overcome? There was a degree of achievement here that was itself something to be capitalized. But more important was the reaction that the artist was *divino*, in the sense that his relation to his material was god-like. As an idea this was not new, for the Vitruvian analogy of the creator of the universe as a divine architect had already been inverted by Alberti in 1435: 'any master painter . . . will feel himself another God'. After the completion of the Sistine Ceiling in 1512, however, this concept must have seemed to take on an altogether new reality and relevance. It is not surprising that there appeared, associated with the absolute work of art, the idea of the divine right of artists: the right to create, invent and manipulate even wilfully, not in imitation of nature but on the basis of nature already conquered in works of art. It is the same principle by which Tasso claimed that the divine poet might create varieties in the microcosm of his poem, and Sir Philip Sidney justified the poet's invention of fantasies not to be found in nature, but 'within the zodiac of his own wit'.

There is other evidence, some already mentioned, of the increasing self-awareness in the creative process. One remarkable new factor was publication through prints. The medium, naturally, was well-established but it was now put to a new use: to broadcast an artist's inventions, to bring his style to the attention of a public out of reach of the work of art itself. Publication in this almost literary sense was pioneered by Raphael. Yet there must also have been an interest in the creative genius that was totally isolated from other considerations, such as subject matter. It would be one thing for an engraving of the *Transfiguration* to be published; but it is surely startling when one appears, as it did about 1520, of a preparatory stage at which all figures were drawn nude. It could only bear witness to the role of the artist as creator, in which it must have been felt that a public was now interested.

2

The Arrival of
Mannerism in the Visual Arts

While it is not intended, in this little book, to give a historical
survey of Mannerism, it is important to focus attention upon
the early growth of the style because this, more than anything,
helps us to understand its true nature. If we watch the sequence
of events we find, for example, that Mannerism did not grow
up (as is so often claimed) in any sense as a reaction against, or
in opposition to, the High Renaissance but as a logical exten-
sion of some of the latter's own tendencies and achievements.

THE HIGH RENAISSANCE

This period, which we normally stretch from the maturity of
Leonardo about 1480 to the death of Raphael in 1520, is not to
be conceived as one of repose in implied contrast to a suc-
ceeding one of restlessness; on the contrary, it was itself
deeply marked by the strains of growth and change. The climax
of this period, the first decade of the Cinquecento, was domin-
ated by events in Florence and Venice, and these had an
astonishing diversity. Leonardo, for example, created almost
simultaneously his *Leda*, *Mona Lisa*, the *Battle of Anghiari* and
the *Angel of the Annunciation*. In the *Leda*, he established a new
canon of the female nude, which was a renewed classicism
emulating but not imitating the formal qualities of the antique
and far exceeding it in sensuousness. In the *Mona Lisa* he
established a new and more ambitious concept of portraiture:
to describe not only the exterior qualities of the subject but
also the inner qualities of mind. In the *Battle of Anghiari*,
never completed, he raised history-painting to an undreamed-
of level of energy and violence. In the lost *Angel of the
Annunciation*, he experimented with a new relationship be-
tween work of art and spectator, for the latter found himself
in the physical and emotional position of the Virgin Mary, as
recipient of the Angel's message: in other words, as part of the
painting's subject.

In Venice a corresponding exploration of new territories
was made by Giorgione. Partially influenced by Leonardo, he

49

animated the portrait in a similar way, and added a dramatic dimension also to landscape; his *Tempesta* is not so much a timeless, static record of nature's appearance, but nature in a mood – that is, in a specific meteorological condition. In his frescoes on the Fondaco de'Tedeschi he liberated the human figure from the inhibitions of posture and viewpoint that still remained at the close of the fifteenth century, and gave it – if we may trust early descriptions – a striking vitality of colour and realism of texture.

There is, however, another aspect of these developments. Giorgione's *Tempesta* was, at least in part, the answer to a challenge handed down from antiquity; for Pliny records that Apelles painted the unpaintable, a thunderstorm. A similar artistic self-consciousness is revealed by Leonardo's invention, so often followed in the High Renaissance and prefigured only in the work of Masaccio, of the pyramidal figure-group; this implies the subjection of natural movement to an abstract aesthetic formula – it is an intentional expression of the perfection of the work of art itself, and of its autonomy in relation to an illustrative or spiritual function. In the fifteenth century there are already indications of the notion that a work of art is partly a demonstration of its creator's *virtù*, but there is no clearer illustration of the renewed emphasis on this idea in the High Renaissance than the first one-man exhibition since antiquity. In 1501 the Florentine public was invited to admire Leonardo's *Saint Anne* cartoon, which had most probably been made with no commission in mind but solely with the intention of producing, in the most exact sense, a 'marvellous' work of art.

If we leave Michelangelo and Raphael on one side, for the moment, the artists coming to maturity in the second decade of the sixteenth century explored still further the animating, sensuous and realistic tendencies in the first decade (which, in retrospect, we see as tendencies towards baroque art) rather than those that would make the work of art the answer to an aesthetic problem. We cannot, naturally, make such a statement absolutely, but only as an impression of the placing of emphasis. In Florence the later works of Fra Bartolomeo (d. 1517) became increasingly energetic and substantial in the formal sense; more important, in the long run, were the paintings of Andrea del Sarto (such as the *Marriage of St Catherine* in Dresden, 1513, or the *Madonna of the Harpies* in the Uffizi, 1517), which were above all vibrant, expressive and communicative.

Sarto's highly individualistic pupils, Rosso and Pontormo, took this style as a new point of departure, sought first to imitate and if possible to surpass it and then moved, about 1520, to a point of sharpness, tenseness and even brutality that was again a new invention but always motivated by and keyed to the expression of the subject; not accidentally, the major works of this phase had subjects from the Passion – Pontormo's frescoes in the Certosa di Galluzzo (1522–4) and Rosso's *Deposition* at Volterra (1521).

Titian, in Venice, working within a style that was always more natural than theirs, was at one moment emphatically sensuous (as in the *Sacred and Profane Love* in the Borghese Gallery, Rome) and at another no less emphatically dynamic (as in the *Assunta* in the Frari, Venice). In relation to him, Lotto and Pordenone played a role not unlike that of Rosso and Pontormo in relation to Andrea del Sarto; their work appears sometimes strange, often awkward or violent, but always expressive and communicative in intention. Correggio, in Parma, came closest of all to a style that deserves the title proto-Baroque; it exploits a natural, sensuous grace, highly charged sentiment, and compositional or emotional devices that relate the spectator more directly to the action in the work of art than ever before. Most of these artists greatly admired the realistic and unidealized expressiveness of engravings from the North, by Schongauer, Dürer and Lucas van Leyden. Collectively they illustrate one of the logical sequels to the ferment of ideas around 1510, and one path out of the High Renaissance.

MICHELANGELO AND RAPHAEL

With Michelangelo and Raphael the situation is more complex; there is, at first, ambivalence in their choice of direction, and then increasingly a placing of emphasis on qualities rather different from those summarized above. We are concerned, also, with their part in establishing Rome as an artistic centre of primary importance.

In the first decade of the sixteenth century Michelangelo's work is bewildering in the variety of artistic ideals it expresses. The *Saint Matthew*, for example (begun 1506 and left incomplete), is tense with an unrestrained physical and emotional energy; the boldness of its torsion, the vitality of its movement and the passion expressed in its head have no precedents, except in antiquity. While it is true that these are artistic

conquests, and may be admired as such, they also express a specific dramatic and quasi-narrative situation, in this case the 'inspiration' of an Evangelist; and the emotional experience thus conveyed places the *Saint Matthew* in an intermediary stage between the inanimate, icon-like Saints of the greater part of the fifteenth century and those of Bernini. Michelangelo here makes the same animating change in this category of images as Leonardo does in the portrait, and Giorgione in landscape.

But when we turn to Michelangelo's *Doni tondo*, in the Uffizi (*c.*1506), and his cartoon for the *Battle of Cascina* [20] (1504–5), the emphasis seems really to be different. The torsions and movements in the first express nothing except the artist's virtuosity; the ambition lies less in expression than in the conquest of difficulty. The cartoon, made in rivalry with Leonardo's *Battle of Anghiari*, demonstrated far more comprehensively that Michelangelo's art enjoyed absolute sovereignty over the human figure; its message, to the sixteenth century, was that there were now no limitations in the complexity of postures and the variety of aspects in which the body might be re-created and seen. On the other hand it told them much less about the appearance of a battle than Leonardo's *Battle of Anghiari*; it was a professional manifesto, and not an illustration. This is the germ of an idea that later became so fully conscious that it could be expressed in writing. Vasari, conducting the young prince Francesco de'Medici round his decorations in the Palazzo Vecchio, remarked: 'I have made

20. *The Battle of Cascina*. After Michelangelo

this composition . . . with these foreshortenings of the figures seen from below, partly to show the capacity of art . . .' (*parte per mostrar l'arte*).

The ambivalence of intention in these works by Michelangelo is probably not more extreme than in the contemporary works of Leonardo; the immediate importance of that aspect of Michelangelo's style that emphasizes aesthetic autonomy lies in the form it takes: it expresses in particular the conquest of difficulty (which is not, as we have seen, in itself a new idea). Like Leonardo, however, Michelangelo – in the *Doni tondo* and the *Battle Cartoon* – is also working out a new standard, classical in inspiration, of grace and idealized beauty of form.

In the Sistine Ceiling (1508–12) these varied tendencies are pursued further; in this case the scale and complexity of the project is so great that there exists within it every nuance between the polarities of intention in the earlier work. Parts, such as *Jonah*, the early Creation scenes and the crepuscular figures in the lunettes, continue the line of expressiveness that encompasses *Saint Matthew*. In the *Brazen Serpent* these qualities are in equilibrium with a demonstration of artistic capacity even richer than that of the *Battle Cartoon*. But there are also parts, most conspicuously some of the *Ignudi* [21], in which the qualities of grace, elegance and poise are so intense that the beauty of the work of art becomes more nearly its subject than ever before. At this point, perhaps, we should judge that the quality *maniera* begins to characterize a style.

How easy and just was the transference of the word *maniera*, a term for an ideal of behaviour, to a work of art we can see if we look beyond the clearly appropriate idealization and polish of form to the deportment of such a youth. We recognize already an air of refined detachment, and – to descend to a detail – a formula for twisting the wrist and holding the fingers in an apparently easy and elegant tension, that will be endlessly repeated in Mannerist works to the end of the period [13, 45]. Was this how Castiglione's young courtiers relaxed, or did it take the imagination of a supreme master of the human body to invent a stylish deportment that is only too easily imitated in life?

But if these precociously Mannerist features may be found elsewhere in the ceiling, notably in some Prophets and Sibyls, the whole work is not characterized by them. This only begins to be true a few years later. Michelangelo's contributions to painting for the next decade and more were made only at

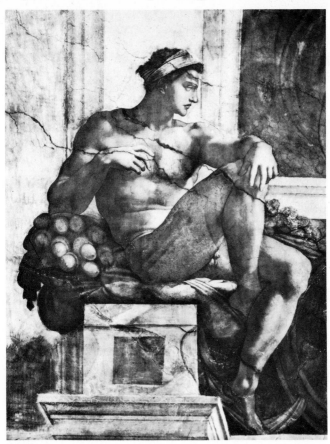

second hand, and chiefly through the medium of drawings he provided for his protégé Sebastiano. One of these was for a fresco of the *Flagellation* to be painted by Sebastiano in San Pietro in Montorio, Rome; Michelangelo's preparatory drawings [22] were made in 1516. Here the new spirit of refinement and grace informs the whole design, giving it an unreal, ballet-like beauty and reserve. It is hard to imagine a conception of this subject less expressive of its essential brutality, and hard not to believe that this purification of the content results from a preoccupation with style, as in *Bembismo*.

The same thing happens in Michelangelo's sculpture, though not in all of it. At about the same time as the Sistine

Ceiling he was working on sculptures for the tomb of Julius II
– the *Moses*, and the two *Slaves* now in the Louvre. These
vary between dynamism and listless grace, but each inflection
of style is expressive of the content of the figures – in fact makes
and describes it with absolute clarity. A few years later the
same is probably true of the four unfinished *Slaves* for the
same project now in Florence; had they been finished it seems
that their style would still have been the servant of an emotion
and a subject. But contemporary with these is a work in which
the servant seems to usurp the position of its normal master,
in which style seems to become subject and subject in the old
sense to be driven out; this is the *Risen Christ* [23] in S. Maria
sopra Minerva (1519–20).

But we must beware of underestimating the complexity of
the situation. In the case of Michelangelo, and of Raphael, we
should not interpret such idealization as a complete negation of
expression, but rather as the translation of expression to
another plane. That the beauty of Michelangelo's *Christ* has a
spiritual meaning and effect there can be no doubt, for such is
its icon-like stimulus that the forward foot must be protected
by a metal shoe from the kiss and touch of the devout. The
ambivalence of the beauty of this work is derived from its
double intention; it seems reasonable to believe that Michel-
angelo should have wished us to admire the capacity of his art,
but we know from his poetry of the period that beauty of form
was for him a manifestation of Divine Grace that moved him

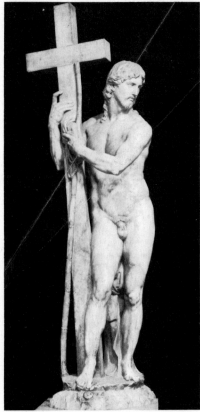

23. *The Risen Christ.* Michelangelo

most when he found it in the human body. This idea was meta-
physically based, and related to current Christianized Neo-
platonism. It was also, however, another aspect of the notion
of the artist as another god, his work another nature; for
Michelangelo believed that the Divine was most clearly re-
vealed in what was most perfectly created, and this is probably
the principal reason why his art was devoted to the human
form so exclusively, save for the abstract forms of architec-
ture.

Similar ideas circulated in the literary world around Raphael.
For example in the fourth book of Castiglione's *Cortegiano*
Pietro Bembo, talking of 'beauty, which is a sacred thing',
says that its source is in God, and external beauty is a symbol of

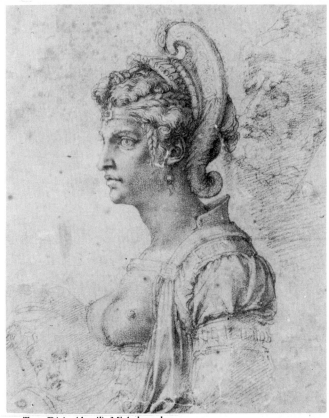

24. *Testa Divina* (detail). Michelangelo

goodness. Vasari, in 1550, gives the same justification for figures in altarpieces that are 'a little more graceful, beautiful and adorned than the ordinary'; in his case it is possible to doubt the sincerity of the argument, but not in Michelangelo's.

In the case of the Minerva *Christ* the expression of artistic accomplishment leads, perhaps for these reasons, to a heroic and neo-Hellenistic ideal of grace. A different aspect of the same pursuit appears in a group of drawings known as *teste divine* [24] of which the earliest probably come in the early 1520s. The idealism is equally emphatic in the shaping of the features themselves, but the most striking thing here is the elaborate fantasy in the *coiffure* and head-dresses; they are at once compact demonstrations of refinement and imagination.

As we must say so often, the type is to some extent prefigured in rare cases around 1500, but it is here classicized and formalized into a motif which was to be much imitated by the next generation.

Raphael's contribution was no less important than Michelangelo's. Maturing a few critical years later it was natural that his inventive role in the formation of the new style should have been less, but his seminal role was at least as great – partly because of his conspicuousness on the pinnacle upon which he was raised by an admiring Rome, partly because his work was intellectually and physically more accessible, and partly because he, unlike Michelangelo, had an important group of pupils and followers.

In the eleven Roman years before his early death in 1520 Raphael did, of course, produce many works that are so dynamic, expressive and realistic that they are irrelevant to our subject; but interspersed among them, and increasing in importance, are others that are incipiently Mannerist. Characteristic is the suave and coolly elegant Magdalene on the right of the *Santa Cecilia* [25] of about 1515; tall of stature, impeccably composed in emotion and movement, she compels admiration, which is her function. Her face is a portrait of Raphael's mistress, but even she was seen through a refining screen of preconceptions. Her clothing is brittle, formed upon the study of Hellenistic sculpture rather than real life, and metallic and a little unreal in colour; the whole transformation freezes humanity out of her, but in compensation saturates her in beauty to a very high degree. Since it is beauty that is willed and artificial it is, and must be, beauty of a particular kind; like any exaggerated ideal, it is a departure from the universal and hence vulnerable in the face of another convention.

A work in which these qualities characterize the whole is the *Saint Michael* [26] of 1517–18. Because of the perfect harmony of all its qualities and parts it is easy to overlook its essential complexity – easiest to grasp, perhaps, if we imagine the figures cast, as they so appropriately could be, into a bronze fountain-figure. There are two rotating systems of forms around the two heads, which are respectively of symbolic refinement and vulgarity. These elaborate patterns of movement and form in space are exactly counterpoised: too exactly, in fact, for there to be an effect of energy, and there results instead a suspension of movement (in the sense of getting somewhere, or performing some action), harmonious with the suspension

25. *Santa Cecilia* (detail). Raphael

26. *Saint Michael*. Raphael

of emotion. The torsions of the figures are extreme, yet accomplished without strain; they may be read as postures because they are so sensitively balanced. It is, again, an intensively *artificial* picture, whether examined in these general terms or in detail, where the beautiful head of Saint Michael or the elaborate ties of his leggings are vignettes of proto-Mannerist delicacy and fantasy. Parts of the *Transfiguration* (1517–20) are abstracted in a similar way above and beyond reality.

MANNERISM RAMPANT: ROME, 1520-27

What we witness in these works by Michelangelo and Raphael is, in effect, the formation of a new visual language; these two artists were the inventors of the first vocabulary of the Mannerist style, and also (for example in the *teste divine*) of its figures of speech, which were then greatly developed and enriched by younger men. Using the analogy in a more historical sense, what happens in the figurative arts is akin to *Bembismo*

in literature – its elegancies and intricacies, its disinvolvement from passion, and its tendencies towards abstraction from reality and towards classicism arise from an obsession with the problem of perfecting *style*. In painting and sculpture this development gathers momentum markedly in Rome in the hedonistic years between 1520 and the catastrophic Sack of 1527 – hedonistic but for the rude but momentary interruption of the pontificate of Adrian VI. Like Firenzuola's *L'Asino d'oro*, the works produced then were shaped by their immediate antecedents and by the remote past; as Firenzuola's language is consciously latinized in his pursuit of more complex and more elegant form, so an ever-increasing admiration for, and intelligent understanding of, ancient art is the essential background of Mannerism.

With Raphael dead and Michelangelo in Florence, events in Rome after 1520 were left in the hands of a remarkably talented group of young men. Certainly the headlong evolution of Mannerism is dependent upon the historical accident that this concentration of brilliant yet still impressionable minds was there at the right moment. A forcing-house is the image suggested by the rivalry among them, often friendly but occasionally murderous; and these conditions existed nowhere else but in Rome. Leisure hours, patrons, commissions and engravers were all shared. Not surprisingly, it is almost impossible to disentangle individual contributions from the net of mutual influences.

A striking case is Polidoro da Caravaggio. As Raphael's assistant his talent in decoration had already been exploited; on achieving independence Polidoro raised decoration, as it

27. *Perseus with the Head of Medusa*. After Polidoro da Caravaggio

were, to the aesthetic status of history-painting in his most typical productions, an astonishing number of monochrome house-façade paintings compressed into these few years. All of them were inspired in one way or another by antique works: for example, friezes of vases *all'antica* (but of a concentrated and convoluted fantasy never quite found in the original), trophies of piled-up armour (more extravagant than Roman trophies ever are), or, most characteristically, simulated reliefs normally of classical subjects in which he demonstrated that no one understood better than he the laws of antique relief-style [27].

Even here, it was not in effect an imitation, for Polidoro's very influential figure-style, derived equally from Raphael and ancient sculpture, had a svelte and luxuriant plasticity and a satirical wit that at once exceeded and mocked classical art. In all his works of this period Polidoro was inexhaustibly imaginative, within an admittedly restricted field, and he had exactly that combination of fertility and facility that was so much in demand in the Mannerist period.

Perino del Vaga was another associate of Raphael who matured immediately after the latter's death. When young he was unquestionably a major contributor to events in Rome, and produced in 1522–3 the most strikingly developed Mannerist composition that we know of this date; though by the accident of the Roman plague he produced it in Florence. It was the cartoon for a fresco, never painted, of the *Martyrdom of the Ten Thousand*; only the preparatory *modello* [28] survives, but this allows us to appreciate how elaborated are the compositional schemes of Raphael's history-painting, how poised, formalized, and fundamentally undramatic are the movements, how stylized and unreal the forms. It has a ritualistic rather than a catastrophic air. What we miss now is the quantity of the cartoon's detail, described so enthusiastically by Vasari:

... cuirasses in the antique style and most ornate and bizarre costumes; and the leg-pieces, boots, helmets, shields and the rest of the armour made with all the wealth of most beautiful ornament that one could possibly create, both imitating and supplementing the antique, drawn with that devotion and artifice that reaches the very heights of art.

As an extravaganza designed to impress, it worked; in Florence the connoisseurs were astonished by the new Roman

style, and the students copied it as they had previously copied Michelangelo's *Battle of Cascina*.

In a more intimate vein, Perino produced equally precocious examples of Mannerism in a set of designs made in 1527 for the engraver Caraglio, one of which represents *Vertumnus and Pomona* [29]. The scale of the figures being almost that of the whole design, we are more immediately aware of the freedom in the distribution of their parts, as if they were abstract and not figurative material; for the figures, interlaced one with the other, are also deployed in a remarkably decorative way over the whole surface. This freedom of disposition is obtained by manipulations of considerable torsion, achieved, however, with perfect ease in the figures themselves. Grace, not tension, is the result, and every form is refined to its perfect type; the male head is as much an ideal as the female. Perino's *Vertumnus and Pomona* is also typical of Mannerism in its approach to the erotic: described, more or less elliptically, but then neutralized, just as in Bronzino's *Allegory* [52] twenty years later. In art, as in human behaviour, *maniera* effects a sterilization of passion, as it does of all other germs of imperfection.

Of this group of artists the one most instinctively inclined to grace was Parmigianino [1]: so much so that in later art theory there is a word, *imparmiginare*, which is to submerge expression of the subject in elegance and delicacy. He came to

29. *Vertumnus and Pomona.*
After Perino del Vaga

30. *The Marriage of St Catherine.*
Parmigianino

Rome in 1524 and was immediately hailed as a prodigy; in him, it was said, was reborn the spirit of Raphael (to whom, in fact, his earliest works show him predisposed). The *Marriage of St Catherine* [30] is typical of the work he did there. Simply as a painter he is more sensitive than any of his colleagues and luxuriates in passages of breath-taking beauty, as in the head of Saint Catherine, one of the *teste divine* Raphaelized. In a different way it is an exceptional sensitivity that shapes this composition into curves that, like waves, flow together to climaxes, and then part again – curves so filled with their own aesthetic vitality that the illustrative meaning of the forms (curtains, arms, fingers) of which they are composed is partially lost. The head in the lower left corner (perhaps Zacharias) seems as much an element in a pattern as Saint Catherine's wheel or the circular window above, and when read realistically seems capricious and bizarre in this position; it is an interesting example of the exploitation for purely aesthetic effect of a device which had originally an expressive purpose, as in *Holy Families* by Correggio where such fragmentary figures suggest the closeness of the spiritual event to the spectator. This is not the reason for Parmigianino's head. Even so, the picture is not without meaning; while action and described emotion express the subject much less directly than in the High Renaissance, the theme is communicated in this and many Mannerist works on another, more symbolic level. With care the fingers exchanging the ring are placed dead centre, below a mullion in the window and framed by the door and the two shadowy figures, perhaps Prophets, deep in conversation.

Perhaps the most individual artist of this group was Rosso; his Mannerism has the intensity of the convert's, for it represents a marked change of direction after the vivid, direct and brutally expressive works he painted around 1520. It is about the time of Perino's sojourn in Florence (1522–3) and his own departure for Rome a year later that his inborn wilfulness and exoticism is channelled away from passionate communication towards fantasy. His work becomes very much more refined, and more elegant [32], yet it is not this aspect of Mannerism that Rosso illustrates so well but rather the complementary inventive facility: boundless, spicy and as designedly breath-taking as Parmigianino's porcelain delicacy of technique.

His chief painting of the Roman years is the *Dead Christ*, now in Boston [31], intricate, suave and ambiguous in a

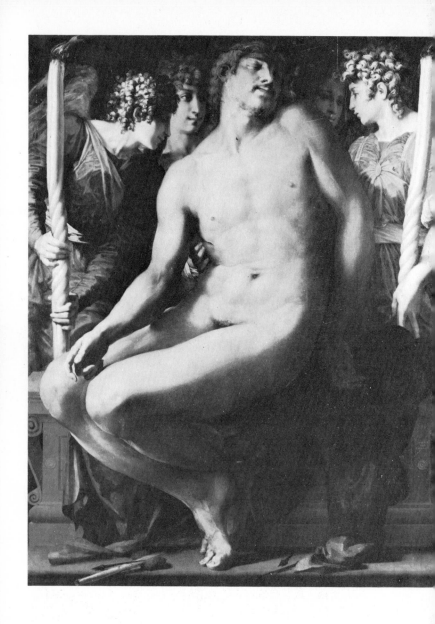

31. *Dead Christ with Angels*. Rosso

manner scarcely to be expected after the violent *Deposition* at Volterra, 1521. *Maniera* describes its new quality exactly. It has been aptly described as a Christian *Laocoön*, yet the analogy is exclusively formal for there are no emotional overtones of catastrophe. Spiritual meaning resides in symbols, the torches of everlasting life and the instruments of the Passion below, which alone prevent us from mistaking the subject for the *Dead Adonis*.

The natural result of a common consent, not only to release imagination from all restraints but also to raise it to a higher valuation, was a flood of inventions. Quantity became once again an index of quality, as it had not been in the earlier Renaissance, because it demonstrated a now positive aspect of artistic capacity inexpressible in the singular. A premium on variety pulls away from unity towards multiplicity. This is a development favoured by the expansion of the engravers' role. So Rosso contributed three designs to the series *The Loves of the Gods* [32], in which Caraglio also engraved a number by Perino [29], and for the same engraver designed a whole set of twenty *Antique Deities*, of which we reproduce *Juno* [33]. These are still only a fraction of his inventions in the three Roman years; like Polidoro's his is a case of the

32. *Saturn and Philyra*. After Rosso 33. *Juno*. After Rosso

happy congruity of a new kind of talent and a new demand. Rosso's drawings reveal that these serial productions were prepared with exquisite care. Mannerism preserved that high intensity of preparatory work demanded during the High Renaissance.

In *Saturn and Philyra*, Rosso is as extravagantly capricious in his manipulation of natural form as Perino in *Vertumnus and Pomona*, and even more wilful in its schematization; above all his wit is more piquant, giving us here a splendidly funny image of a horse in love. It is a delicious perversity, intended to entertain, that makes him represent Juno [33] with the anonymity of a back-view and *profil perdu*. It is entertaining also to see his horse as attenuated, as refined, as *manieroso*, as Philyra, or his peacock with the same tiny head and tapering legs as Juno. Yet it is, of course, more than witty; in the *Juno*, the two linked vertical bodies are set off with marvellous sensitivity against the asymmetrical curve that rises anti-clockwise round the peacock's tail and falls again through the goddess's bunched drapery; all forms and movements are beautifully poised in relation to the outline of the niche.

Rosso's most extravagantly Mannerist work in Italy was a *Mars and Venus* [34] designed in Venice for Aretino in 1530. This provides an extraordinary contrast to Correggio's erotic mythologies of the same date, for it is hardly a credible illustration of its subject. The subject itself is mocked: for example the ring of flying *putti* above (previously used by Rosso in an *Assumption*, circling the triumphant Virgin) loose off a great deal of ammunition and threaten to empty their cornucopias on the lovers, but Mars is revealed by Cupid as improbably triumphant and anything but master of the situation. What the work stimulates positively is not belief in a narrative, not the evocation of something real outside itself, but fascination in itself, in its complexities, its visual jokes, its *tours de force* of manipulation and technique, and its accumulated demonstration of artistic capacity. And, typically, it contains several ingenious variations on Michelangelo's *teste divine*.

This was the highly-evolved style that Rosso took to Fontainebleau. In terms of influence, he and Parmigianino were the most important of the Roman group dispersed at the Sack of 1527. Those that we have mentioned were not, of course, all; Giulio Romano and Sebastiano del Piombo contributed too, and Beccafumi in Siena was moving along a very

4. Mars and Venus. Rosso

similar path. Throughout the decade Michelangelo in Florence created type after type of the 'figures of speech' of Mannerism, and by its end Pontormo had become infected by many of its ideals.

THE PROBLEM OF ARCHITECTURE

It is obvious that if we are to use the term Mannerism of architecture we must do so in a slightly different way; yet if we recall that Raphael and Castiglione held *maniera* to be a desirable quality found in antique buildings, it is clear that its use in this context is equally legitimate. When we look for a similar imposition of artistic will upon received forms – always, essentially, on the basis of mastery of those forms – we need a substitute for naturalism, the point of departure in the figurative arts. In Italian architecture around 1500 this norm is provided by the Vitruvian vocabulary, the mastery of which had been fully regained by Bramante. With this adjustment we may look for developments that exceed the norm in respect of refinement, grace, complexity, demonstrative accomplishment or caprice. An obsession with style may again triumph over function; at first sight this point promises to be clearer in the case of architecture, an essentially functional art, than in painting or sculpture, but the position is in fact a complicated one.

Many of the elements on a Bramante façade – columns, entablatures, window-tabernacles – look functional when they are, in cold structural fact, decoration of the wall. Conversely, eccentricities can conceal a structural purpose. What matters, then, is the visual effect – whether it is of style in the service of a functional idea, or of style so emphatic, so autonomous, that justification by apparent function does not arise.

Pursuing the problem on these lines we may discuss architecture, as we have discussed the figurative arts, as normative or artificial (in either the originally appreciative or currently pejorative senses). But Raphael implies that *maniera*, conspicuously lacking in Gothic buildings, was characteristic of the antique; therefore Mannerist architecture, like Mannerist painting and sculpture, or Firenzuola's *L'Asino d'oro*, must be the super-sophistication of a *classical* style. Lastly, we should expect to find less Mannerism in architecture, since it is the nature of buildings that they can seldom be treated as pure works of art. The divine right of architects is circumscribed by practical considerations.

The situation is illuminated by Vasari's remarks on Michelangelo's architecture. No one was ever more convinced than Vasari of the necessity of knowing the rules, but what Vasari admired most was the genius that rose above them. He attributes to Michelangelo the initial demonstration of how this could be done, 'working somewhat differently' from those who followed 'the common usage, or Vitruvius. This licence has encouraged others to imitate him, and new fantasies have appeared, more like grotesques than regular ornament. Artists are perpetually indebted to Michelangelo who loosed the chains and restraints that inhibited those who walked along the common path.' Vasari is, in another place, aware of the dangers of this liberty, but there is here an implied disdain for blind obedience to the rules, only less obvious than his disdain for the period before the rules were reestablished.

This 'varied and more novel' style in architecture appeared at the same time and place as Mannerism in painting and sculpture. Michelangelo's first purely architectural work was the decoration of one exterior wall of a small chapel in the Castel Sant'Angelo, Rome (c.1515). In the centre is a window-tabernacle of regular components – half-columns, entablature and pediment – but unusual width. The window is quartered by a cross-shaped mullion; applied to the upper arm of the cross is a scroll-bracket which ostensibly supports the entablature at its centre but succeeds also in attracting attention to itself and its peculiar position. The lowest quarters of the window are barred by attenuated balusters; odd in themselves, they have an odd effect on the central mullion, the lowest arm of the cross, to which are attached two half-balusters that make it appear swollen in the middle. There are several other uncanonical details. The whole is executed in marble, not stone, and the lines are clean, the curves being beautifully set off by the rectangles. The effect is delicate, but chilled and rather severe. No single form is markedly irregular in relation to the antique, and no contemporary connoisseur could doubt that Michelangelo knew the anatomy of antique architecture as well as he did that of the human body. It is the incipiently wilful composition that is distinctive, and the artifice depends for its success upon an informed beholder: one who recognizes the departures from 'the common usage, or Vitruvius', and one who appreciates the artist's sovereignty over antique forms. In the same way, Ariosto, in his

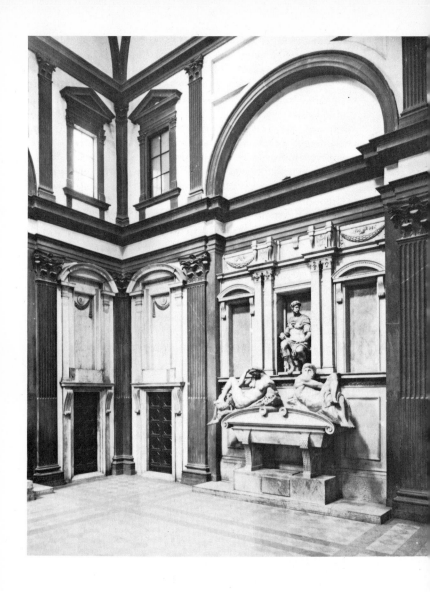

35. The Medici Chapel. Michelangelo

36. The Medici Chapel (detail). Michelangelo

Orlando furioso, relies upon a reader informed enough to recognize not only the quotations but also the transformations of classical texts.

In the next decade Michelangelo set the decisive standards of the new architecture in two buildings attached to San Lorenzo, in Florence: the Medici Chapel [35, 36] and the Laurentian Library [37]. The Medici Chapel is the earlier (the definitive design came about 1521), and here the licence operates on a relatively moderate scale. In the corners [35] the blind tabernacles and the (mostly false) doors are run into one unit, for they share the main horizontal member between them; the brackets at the ends of this horizontal may be read as supporting a lintel in the context of the door or hanging from a base in the context of the tabernacle. In detail the tabernacle [36] is peculiar. Between pilaster and pediment there is no capital (the lowest entablature mouldings take its place). The pediment breaks forward over the *recession* of the niche; the niche is framed by a moulding that meanders into corners, taking the recessed plane with it into the area of the pediment. A block, as if to support sculpture, occupies the bottom of the niche which is, however, too shallow for sculpture; it is flanked by two tiny reliefs of exquisitely fantastic vases. The whole

tabernacle-cum-door unit is fitted so tightly (so much more tightly than in common usage) into the principal members of the lowest zone of the chapel [35] that the plane of the wall is lost to view. This effect continues throughout this level, so that the wall is apparently replaced by a sculptural complex of advancing and receding forms; the plasticity in the architecture increases towards the middle of the wall, where are the figures (more were intended). To see the tabernacles set in the whole wall is also to realize that their pediments are so adjusted in scale that they belong to a continuous horizontal band of decoration running through the capitals of the main order and the attic-frieze in the central section, where their curvature is reversed in the swags. It is fascinating, cerebral, and stimulates in the beholder the recondite pleasure of sharing the architect's erudition; it is beautifully executed in marble, again, under Michelangelo's exacting supervision; it is stylish but also intensely serious, for the pure, cold forms have an air of death as chilling as the tombs themselves.

The severity characteristic of Michelangelo is combined with an appropriate solemnity in the *ricetto* (lobby) of the Laurentian Library [37]. The principal development here is the application of licence to *all* architectural members, major and

37. The Laurentian Library Vestibule. Michelangelo

minor. It is the first building that seems to have been turned outside in, for the massive treatment of the interior walls belongs by tradition to exteriors. The main order of coupled columns and almost hidden square-section piers is recessed *behind* the plane of the wall that carries the tabernacles; since the mouldings above and below the order break forward with the wall it seems that the wall is squeezed forward by the order, or as if the architecture had become organic, capable of movement. A similar understanding in terms of potential movement is necessary for the door-case inside the reading room, where one complete tabernacle is compressed in another and seems to break through it. In the *ricetto* the most obvious sense of movement is in the staircase, shaped in viscous curves that pour downwards from the reading room to the floor. In detail the tabernacles are more austere than those of the Medici Chapel but more profoundly wilful. What appears to be a pilaster is in fact, in relation to the norm, a pure abstraction: a shaft tapered from the top downwards with applied mouldings at each end that are not full width and therefore have not even the nature of capitals or bases. The seven flutes on the lower parts of the shafts are repeated in the brackets, at the foot of the tabernacle, which, being rectangular, are unmistakably reminiscent of triglyphs that belong at the top of an order. Strangest of all, and most conspicuous, are the enormous voluted brackets below the main order of coupled columns; because of the thin horizontal strips of blank wall between them and the columns they appear to support nothing, but perversely to hang from a moulding.

Today it seems most natural to read such licence as conscious irrationality, but this may well be a false projection backwards of a current aesthetic virtue. More convincing is the motive given by Vasari for an equally odd employment of such brackets on Michelangelo's final scheme for the tomb of Julius II; in this case he turned them upside down and placed them on bases, intended originally for sculpture, with their backs against herm-pilasters, 'to relieve the poverty of the lower part'. In Ariosto's *Orlando furioso*, fantasies, *mostri* and other forms of *varietà* relieve boredom, or so it was universally agreed.

Michelangelo's principal contribution, then, to Mannerism in architecture was the notion of imposing an all-powerful artistic will on forms of classical derivation, of converting in this sense the mastery of those forms achieved in the High Renaissance into a God-like relation to his raw materials.

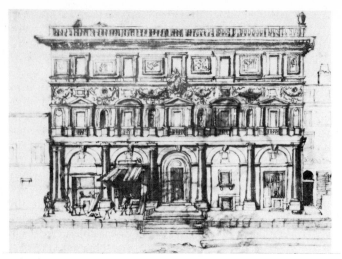

38. Palazzo Branconio dell'Aquila. Raphael

Raphael's contribution was ideally complementary: grace, lightness, complexity and material luxuriance. More illuminating in his case than any comment by Vasari is Raphael's own criticism of High Renaissance architecture, especially Bramante's, which he found fell short of the best antique style in decorative richness of materials. It is characteristic of the complex potentialities of the second decade of the century that this conviction led him to the sumptuous Chigi Chapel that is truly proto-Baroque and to the Palazzo Branconio dell'Aquila [38] that is proto-Mannerist; both were presumably thought to be more truly antique than what we now, perhaps too easily, call the 'classical' style of the High Renaissance.

Palazzo dell'Aquila (destroyed in the seventeenth century) was such a harmoniously elegant building that it is easy to overlook that it was a very adventurous piece of architecture. The ground-floor was sober: five regular arched openings framed by six robust half-columns in an arrangement as ostensibly functional as in any building by Bramante. In the *piano nobile*, however, it appeared that the supporting function of the columns was terminated in statues placed in niches, so that in the wall's own plastic pattern a concave form crowned a convex one, and in its structural pattern a negative was superimposed on a positive. The positive stress sidestepped to

76

the half-columns of the window-tabernacles, and became weakened as it was divided and diminished in scale; finally it was dissipated in the complex pattern of pediments and stucco decoration at the mezzanine level. In the topmost zone there was no trace of an order; the window-tabernacles were scarcely more 'architectural' in character than picture-frames, and indeed between the windows there were framed paintings. Thus as the structural pattern progressively diminished upwards it was replaced by a decorative and functionally abstract one; and articulation, or sub-division, was replaced by a woven, so to speak polyphonic, all-over texture.

The compositional sophistication operated in the horizontal dimension as well. The lowest zone was of five units, closed with firm accents at each end. The *piano nobile*, of eleven units, alternating in value, began and ended with a weak beat like an hendecasyllabic verse; in fact the terminal units were the weakest of all, for the first and last niches were narrower than the rest and in relief only, not fully hollowed. The mezzanine, with the looping swags, acted as a transition to the upper story in which the units dividing the windows were wider than the window-frames. Thus the rhythmic design was richly varied indeed, compared with a façade by Bramante; and the succession of forms through ground-floor columns, niche-and-statue, swag-and-portrait-medallion to framed painting was a strikingly complex transformation. In detail it was rich in yet another sense; the main door-frame, for example, was of coloured marble; the *stucchi* in the mezzanine must have been of the most refined quality, executed as they were by the greatest artist in this medium, Giovanni da Udine, and it seems that they were painted. The paintings above were probably in grisaille like Polidoro's, and the statues were surely antique. On the other hand Raphael seems to have treated the antique forms themselves, here as elsewhere, with far greater respect than Michelangelo. The Palazzo dell'Aquila does not survive, but we may see the same spirit in another of Raphael's inventions, the Villa Madama in Rome: today a beautiful fragment which, if it had been completed as projected, could have been the most significant secular building of the century.

The stylish and decorative complexity of Palazzo dell'Aquila has many sequels, none as intellectual and none so finely controlled; in Rome Palazzo Spada is an obvious example, Palazzo Crivelli in Via de'banchi vecchi is less well-known; and from this type derive Palazzo Negrone in Genoa [39] or

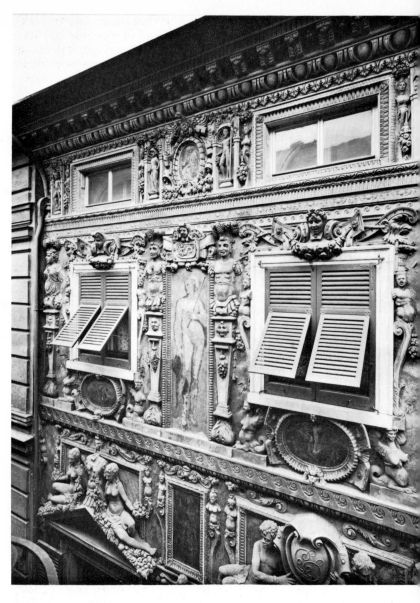

39. Palazzo Negrone (detail). Attributed to G. B. Castello

40. Santa Maria di Loreto. Antonio da Sangallo the Younger and Giacomo del Duca

the Maison Milsand in Dijon. The most distinguished example, which accentuates again the neo-classicism of Raphael's building, is Pirro Ligorio's Casino of Pius IV [79]. The liberating effect of Raphael's late architecture was different in kind from Michelangelo's but was scarcely less far-reaching; Giulio Romano's Cavallerizza, for example, or his Palazzo del Tè [81], both in Mantua, depend fundamentally upon Raphael's inspired injection of variety and prolixity into the 'common usage, or Vitruvius'.

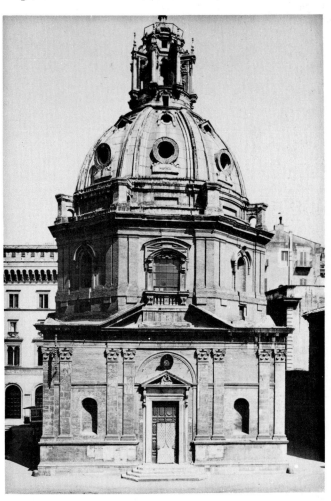

3

Characteristic Forms

As we have seen, Mannerist works of art are conceived in the spirit of virtuoso-performances. We can clarify and, perhaps, better understand this attitude if we investigate particular art-forms, the employment and in some cases the invention of which typify Mannerism as a whole. The selection is inevitably limited, but for this purpose detail is more revealing than the bird's eye view.

THE 'FIGURA SERPENTINATA'

There is no figure of speech more characteristic of the language of Mannerism than the *figura serpentinata*. The clearest discussion of it occurs in G. P. Lomazzo's *Trattato* of 1584; significantly, one of his points of departure is a quotation from Horace to the effect that painters and poets have equal licence to do as they like:

> Michelangelo once gave this advice to his pupil Marco da Siena, that one should always make the figure pyramidal, serpentine, and multiplied by one, two or three. And in this precept, it seems to me, is contained the secret of painting, for a figure has its highest grace and eloquence when it is seen in movement – what the painters call the *Furia della figura*. And to represent it thus there is no better form than that of a flame, because it is the most mobile of all forms and is conical. If a figure has this form it will be very beautiful. . . . The painter should combine this pyramidal form with the *Serpentinata*, like the twisting of a live snake in motion, which is also the form of a waving flame. . . . The figure should resemble the letter S. . . . And this applies not only to the whole figure, but also to its parts.

Later, he says more ambitiously:

> All motions of the body should be represented in such a way that the figure has something of the *serpentinato*, towards which nature is favourably inclined. In addition, *it was always used by the ancients*, and by the best moderns. . . . The figure will not appear graceful unless it has this serpentine form, as Michelangelo called it.

Michelangelo did, in fact, invent it, the first surviving example being his *Victory* [41], carved in 1527–8 for the tomb of

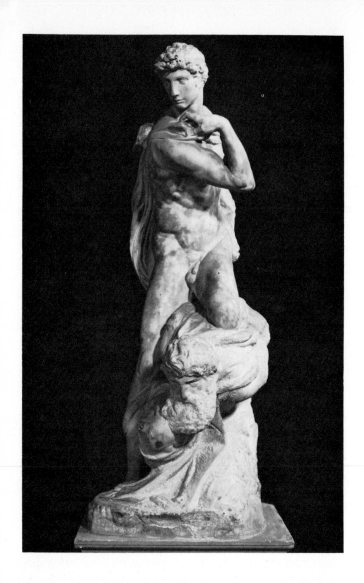

41. *Victory*. Michelangelo

Julius II. It was succeeded immediately by a very influential model of *Samson and the Philistines* in which the *figura serpentinata* was 'multiplied by three'. This form, however, is developed from the classical *contrapposto*, one of the most typical reconquests of the earlier Renaissance, and we must define the difference.

The word *contrapposto*, which is also used for a figure of speech much favoured by Petrarch, means in the visual arts a system of composing the human body that was characteristic of antique sculpture. The parts of the body were arranged asymmetrically, so that the turn of the head opposed that of the hips, one leg was weight-bearing and straight while the other was free and flexed, and so on – all asymmetries being reconciled in a final balance. This system, however, could be interpreted in various ways.

From Donatello to Jacopo Sansovino, *contrapposto* was understood as a displacement of the masses and structure of the figure: an organic and moderate displacement expressing energy, variety and contrast between the two sides of the body. Above all it was a means of articulation, and therefore exactly unlike a flame. In High Renaissance art after about 1512 the *contrapposto* became abnormally exaggerated, as in Fra Bartolomeo, but it still retained its naturalistically expressive character. Figures first became flame-like (or became so once more, if one remembers Gothic art) in Michelangelo's *Flagellation* designs of 1516 [22], where a movement does indeed seem to run fluidly, not in contrasted directions, through the body's members. This new kind of figure (new above all in relation to Gothic art, because it was derived from the Renaissance experience in antique forms) was shaped into a compositional type in the *Victory*, Michelangelo's current attenuation of the figure's proportions clearly assisting in this development.

The *Victory* is pyramidal, flame-like and *serpentinata*. The postures of both figures imply a suppleness and elasticity beyond what is natural. Torsions are not accompanied by effort, and thus they do not suggest energy. The *contrapposti* do not entail contrasts between static and dynamic functions in the members, nor between weight-bearing and free. Movements are completed, not arrested; and thus they seem neither to reflect a past action nor to anticipate a new one. The expression, as we have found before, shifts to a symbolic level, for the fluent upward surge itself suggests triumph. The

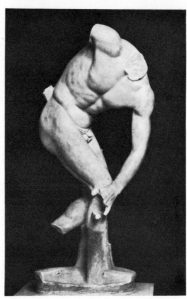

42. *Discobolos.*
Roman copy of Greek bronze
original by Myron

qualities of the classical form that remain are greatly augmented: the movements, free from all descriptive implications, even those of locomotion, seem dedicated to the Mannerist virtues of grace, complexity, variety and difficulty.

It is therefore revealing that Quintilian, already, should have desired these qualities, together with novelty, in the disposition of the human figure; his subject, in fact, was the use of figures of speech, and like Lomazzo he was talking of the flexibility necessary in the application of rules:

> It is often expedient, and occasionally becoming, to make some modification in the time-honoured order [in rhetoric]. We see the same thing in pictures and statues. Dress, expression and attitude are frequently varied. The body when held upright has but little grace, for the face looks straight forward, the arms hang by the side, the feet are joined and the whole figure is stiff from top to toes Where can we find a more extreme and elaborate attitude than that of the *Discobolos* of Myron [42]? Yet the critic who disapproved of the figure because it was not upright would merely show his utter failure to understand the sculptor's art, in which the very novelty and difficulty of execution is what most deserves our praise. A similar impression of grace and charm is produced by rhetorical figures, whether they be figures of thought or figures of speech. For

43. *Saint Andrew.*
Francesco Salviati

they involve a certain departure from the straight line and have
the merit of variation from the ordinary usage.

Lomazzo may have stretched a point when claiming that the
figura serpentinata was 'always used by the ancients'; but in
Quintilian he could have found an admirable authority for the
evaluation of the body's movement in aesthetic, rather than
realistically expressive, terms.

Vasari certainly knew the passage in Quintilian; he adapted
it for his distinction between the good, modern style, and the
medieval style, where figures stood rigidly on their toes and
'lacked all excellence and style [*maniera*] in essentials'. And it
is remarkable, yet logical, how popular the *Discobolos* pose be-
came in the sixteenth century: some artists, such as Pontormo,
found that it made a fine angel in an *Annunciation*, and
Bandinelli even took up the same position in his self-portrait
now in Boston. Titian, at the moment when he came closest to
Mannerism, used it for the suppliant grandson in his *Portrait of
Pope Paul III* (Naples, 1545). The qualities it brings to figures
are the same, in relation to the 'ordinary usage', as those that
distinguish Mannerist architecture; and again the extent to
which such figures deserve the epithet *manieroso*, transferred

from the literature of manners, can be seen if we recall that the contrast between a desirable grace and a despised rigidity was treated at length in Castiglione's *Cortegiano*.

The *Discobolos* is readily adapted to a *figura serpentinata*, though relatively moderate in its torsions. The degree to which the body could be elasticized is illustrated by a fresco by Francesco Salviati, of *Saint Andrew* [43], which is a little comic but also a little serious, for it answers an aesthetic problem, the free distribution of the members in the widest and most varied pattern. This manipulative ability was designed to be noticed. Paolo Pino, in his *Dialogo della Pittura*, 1548, says that 'the attitudes of figures should be varied and graceful . . . and in all your works you should introduce at least one figure that is all distorted, ambiguous and difficult, so that you shall thereby be noticed as outstanding by those who understand the finer points of art'.

It was expressly in order to 'demonstrate the finer points of art' that Vasari, in 1540, sent to Pietro Aretino a drawing of *The Israelites collecting the Manna*. Aretino, in reply, particularly singled out for comment 'the figure bending down to the ground which shows at once the back and the front so that it is, by virtue of its easy forcefulness and by grace of its unforced ease, a magnet to the eye . . .' This is a revealing comment. It was exactly figures that showed back and front at once (as in [13]) that had been condemned in Alberti's *Della Pittura* (1435) for their excess of variety. And secondly, Aretino's phrase 'in virtu de la forza facile e con grazia de la sforzata facilitade' is a stylish literary conceit very typical of him, and it is a 'figure' as convoluted, as *serpentinata*, as Salviati's *Saint Andrew* [43]; they are extreme examples of Mannerism in literature and painting: 'magnets' to the mind and the eye.

The truest and most inspired sequel to Michelangelo's invention, however, came in the work of another sculptor, Giovanni Bologna. As it happened, one of his earliest works was a pair to the *Victory*, and from that point onwards he constantly turned the problem over in his mind; in 1582 he produced the *Rape of the Sabine* [44], which is the *figura serpentinata* in triplicate. But while following Michelangelo in this respect, Giovanni Bologna gave his group a quality not to be found in the *Victory*.

In Hellenistic composition, as already in the *Discobolos* [42], it is not rare to find movement organized in a pattern independent of the movement itself, like the relation in this case of the

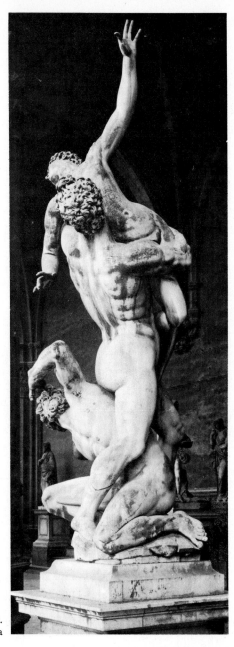

44. *The Rape of the Sabine.*
Giovanni Bologna

reversed question-mark, formed by torso and near leg, to the long arc formed by the arms and the further leg. It depends upon a linear pattern of forms. Giovanni Bologna took this compositional principle and applied it in three dimensions. In our view of the *Rape of the Sabine* [44], the curve that swells from the main figure's right foot through his body and then the woman's to her head is crossed, in superb balance, by the long flame-like line from the crouching man's left foot, through his torso and raised arm, to the woman's arms and left hand. What is astonishing is that this system works fully in the round, for as one walks round the group its elements constantly dissolve out of one pattern and fuse into another; it is always composed. This result depends upon an essentially sculptural imaginative genius, and it also represents one of the ultimate expressions of the artist's god-like relation to his material. If the material were abstract, the achievement would still be remarkable; that it is figurative increases its 'difficulty' immeasurably.

Giovanni Bologna's infallible touch is perhaps best appreciated in his small bronzes. They are made to be looked at

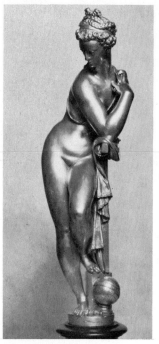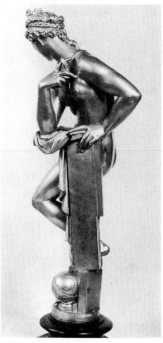

45, 46. *Astronomy*. Giovanni Bologna

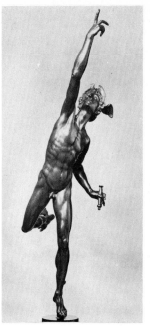 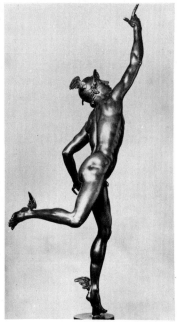

long, and also closely, for those that are autograph are wonderfully delicate in technique, and sometimes gilt. They are meant to be turned round in the hand, and then they give an aesthetic stimulus of that involuntary kind that sometimes comes from listening to music. Photographs are inadequate, but something may be seen from a comparison of front and side views of the *Allegory of Astronomy* [45, 46]. The difference between them, in fact resolved by an entirely mellifluous transition, excites the intended astonishment that one figure can be so composed as to encompass this wide variety. The photographs also show how fully spatial is the linear pattern of forms, but they cannot show that from no angle can a flaw be detected in its balance. Of course, it seems an effortless achievement, just as the figure exceeds nature in its grace, and in its elasticity. The *Apollo* [12], made for a niche in the *studiolo* of Francesco de'Medici [85] and therefore intended to be seen only frontally, shows how these qualities may be transferred without any diminution to the male body.

The *Mercury* [47, 48] is Giovanni Bologna's extreme attainment of artistic freedom. Bronze was the only medium that

could leave him so uninhibited, and the result is as volatile as imagination itself. Yet it is again composed, absolutely and fluently. The raised right arm, which, in the front view [47], soars like a rocket from the weight-bearing foot, is melodiously curved into the lowered left arm in the side view [48], and sprung against two other curves, from head to right foot, and from left elbow to left foot; turn it a little more and the raised arm flows into the right leg and the line from the left foot runs through the body to the head. Typically, the *Mercury* is inspired by the antique, by rare figures of running athletes and the Vatican *Ganymede*.

Giovanni Bologna's compositions had many imitations – some beautiful [49], but none so perfectly complex as his. Not surprisingly, casts from his models were still being made in Florence in the eighteenth century. But these inspired works are supremely artificial, and therefore especially vulnerable to prejudice, like the whole category to which they belong. Already in the sixteenth century there were voices raised in

49. *Psyche*. Adriaen de Vries

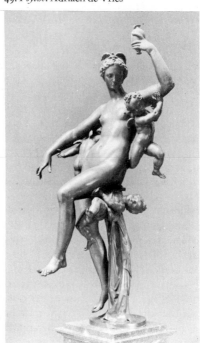

protest. For example Gilio, in 1564, pours abuse on a type of painter to which Vasari expressly, and Salviati by example, belong (though he is sniping at Michelangelo): 'It seems to them that they have discharged their debt when they have made a saint, and have poured into it all their imagination and diligence in twisting the legs, or the arms, or the broken neck, and made it distorted – of a distortion inappropriate and ugly'. Ugly! How bewildering are reversals of taste!

THE PASTORALE: GUARINI'S 'PASTOR FIDO'

Another enduring virtuoso-performance was achieved by Tasso's successor as court poet at Ferrara, Giovanni Battista Guarini; his major work, the *Pastor fido* (1586), is the most celebrated example of the dramatic genre of *pastorali*, which was an invention of the Mannerist period but long survived it. The *pastorale* is totally artificial: within the conventional world of Arcadia, perfect in all physical respects and peopled by ideal nymphs and shepherds, an entirely fictitious plot is given movement and resolution by love and its complications alone. The 'characters' are so thin and depersonalized that their names are frequently repeated from one *pastorale* to the next; most, indeed, were already used in Sannazzaro's *Arcadia* of 1489 and had been borrowed from classical eclogues. The first true *pastorale* was Agostino Beccari's *Sacrificio* (Ferrara, 1554); yet the art-form then codified was designed to satisfy a taste, or social requirement, that had existed since the time of Isabella d'Este and had previously been satisfied by the dramatic eclogue (especially characteristic of Mantua around 1500, for example Galeotto del Carretto's *Nozze di Psiche*) and by the rustic comedies of travelling companies. In part, the *pastorale* is the result of a process (so characteristic of Mannerism) of consciously raising both these to the level of 'art' where Tragedy already stood – 'art' in this case entailed the stiffening with classically derived rules and forms of expression. The new art-form, however, also had its roots elsewhere – in already re-established bucolic verse-forms and in the sixteenth-century tragedy itself; the latter was, in a conspicuous case such as Sperone Speroni's *Canace* (Padua, 1541), highly artificial in style and plot, and was enacted by totally abstract 'characters', so different to those of Machiavelli on the one hand and Marlowe and Shakespeare on the other. This particular Mannerist abstraction was, very revealingly, due largely to an overdose of Aristotle.

The *pastorale*, in the second half of the sixteenth century, virtually eclipsed tragedy and comedy at the courts, especially those of Ferrara and Mantua, and it was only in such sophisticated courts that it could have been invented. An innocuous entertainment, it had the social virtue of offering little scope for social comment and the aesthetic virtue of offering hours of suspenseful and graceful interludes with which the beholder could never for one moment feel emotionally involved. It was a diversion for an aristocracy already being made redundant by the growth of Absolutism in real politics, and was complementary to the Romances of medieval chivalry which enjoyed an equally astonishing vogue. But in the *pastorale* we do not see the quasi-historical and quasi-fantastic actions of the perfect *cavalieri* of the Romances, but another ideal Golden Age, a comfortingly classical dream-world where nymphs and shepherds speak beautifully composed periods with the silver tongues of courtiers. As in the Romance, variety is preferred to unity, and three or four concurrent affairs are interwoven and resolved in a polyphonic manner. It is perhaps an even more artificial, and certainly more anodyne, art-form than the madrigal, but the degree of fatuity of a convention is never a restriction upon the quality of the works produced within it. Torquato Tasso's *Aminta* and Guarini's *Pastor fido* are two of the masterpieces of Italian literature.

Aminta (Ferrara, 1573) is the most perfect thing that Tasso ever wrote. It is like a bronze by Giovanni Bologna: tiny, polished, exquisitely interlaced yet balanced and gracefully at ease. As one turns the bronze in the hand so one may read and re-read *Aminta*, continually satisfied by the discovery of new formal felicities. Guarini designed the *Pastor fido* from the start to surpass *Aminta*, but he set about his task in such a way as to produce something so different in character that it is not (happily) natural to compare them. The principal difference is in scale; the *Pastor fido* is Wagnerian in length, and it was said – maliciously, it is true – that at the first proper performance (Mantua, 1598) sixteen hundred lines were cut without anyone noticing. Guarini so desperately willed the masterpiece into being that it is heavily loaded with artifice – not overloaded, because the artifice is always effective and functional (its purpose is to induce delight and admiration, and it does so).

The story of the completion of the *Pastor fido* is strange but not exceptional in this century. Guarini, anticipating a master-

piece, also anticipated trouble; his manuscript was sent to specialists for comments, and trial readings were made. After publication came the attacks, the author's defence, renewed attacks and defences. The result of this controversy was the remarkable definitive edition of 1602 which includes a most elaborate preface and commentary. The notes at the end of each scene normally far exceed the text in length and in them Guarini (anonymously) rationalizes every twist to the plot, justifies every metaphor, and draws attention to every stylistic embellishment or classical precedent. This intense self-awareness must have existed during the creation of the work. It was accompanied, even more interestingly, by a precise theory of the development of the *pastorale* and of the historical position of the *Pastor fido* within it, and by an analytical approach, deliberating every novelty, that are much like Vasari's. Guarini, like other Mannerists, was so self-conscious at the moment of creation largely because of the anticipated criticism of a sophisticated audience.

A synopsis even of the main plot is necessarily long, and may seem tedious here, but it illustrates well the intricacy and extended ingenuity of Guarini; its very prolixity mirrors a quality of style that to him and his patrons was an important virtue. Silvio, of the *jeunesse dorée* of the shepherd world, prefers the chase to his fiancée Amarilli, which is portentous since Silvio's father, the priest Montano, and Titiro, the father of Amarilli, arranged the match to lift the curse of Diana upon Arcadia; the Oracle had said that this would happen when Cupid joined two descendants of the gods and when the original offence was corrected by a faithful shepherd (Silvio descended from Pan, Amarilli from Alcide). Amarilli, while an entirely proper fiancée, is as little interested in Silvio, but has a cautious eye for Mirtillo who is inconsolably in love with her. Corisca, the villain of the piece, is unscrupulously chasing Mirtillo, while the innocent Dorinda loves Silvio with equal determination and lack of success. The high point of the comedy is reached in Act III; Corisca persuades Amarilli that Silvio consorts with a nymph Lisetta in a certain grotto, and Amarilli agrees to hide in the grotto to observe the affair; Corisca's intention is that her rival should be found there in apparently compromising circumstances with another shepherd, Coridone, and thus liquidated by the priests, leaving Mirtillo without any object for his love but Corisca. The latter also persuades Mirtillo to hide outside the cave so that he sees

Amarilli's furtive entrance and is convinced that she, as Corisca has said, loves another. Mirtillo sees Amarilli enter, and resolves to follow and kill her, her supposed lover, and himself; as he enters (which Corisca had not intended) he mentions Corisca by name and is overheard by a satyr who has pursued her for some time; the satyr naturally assumes that Mirtillo has an assignation with Corisca, closes the mouth of the cave with a large rock, and runs off to fetch the priests so that she (Corisca, not Amarilli) shall be punished. At this point it appears to the spectator that not only Corisca's carefully laid plans but also Guarini's plot have been irremediably upset by the clumsy and lecherous satyr (like the cave, an essential feature of the *pastorale*).

In Act IV, however, the play moves from the comic to the tragic climax. Corisca returns to see if her plan has worked, finds the cave closed, assumes that Mirtillo has shut Amarilli and Coridone inside, and then runs off to fetch the priests. The latter, already conducted by the satyr to the cave by another route, seize Amarilli for adultery and Mirtillo for assaulting a priest. By law Amarilli should die, but Mirtillo is permitted to die in her place. In the final act Montano is about to perform this sacrifice; Mirtillo's supposed father, Carino, appears, whence it transpires that Montano is the real father and is about to sacrifice his son. It then occurs to Tirenio, a blind seer, that the Oracle's requirements are met in Mirtillo: he also is a descendant of the gods and in offering his life for Amarilli has proved himself the faithful shepherd. Thus the tragedy achieves a happy ending (a controversial invention taken from the tragedies of Giraldi); Mirtillo marries Amarilli, and Silvio, finally overcome by Cupid, marries Dorinda; only Corisca, who tried hardest, loses everything; her final words, it has been said, have the air of one about to enter a nunnery.

This impossibly complicated plot gives rise in turn to highly compressed patterns of ideas, equally intricate and ingenious. In Act III Mirtillo, repulsed by Amarilli, declares:

E sento nel partire	And I feel in parting
Un vivace morire	A *vivid death*
Che dà vita al dolore	That gives birth to a grief
Per far che mora immortalmente	That will make my heart
il core.	*die unceasingly*.

In a footnote Guarini calls 'the joining together of these *contrapposti* . . . a very graceful poetic figure', and gives a tortuous

explanation, itself full of verbal artifice; finally he gives a cross-reference to one of his madrigals. In the *Pastor fido*, just as in Speroni's tragedy *Canace* (1541) and Tasso's *Gerusalemme liberata* (1575), the verse tends to be most stylized in moments of supposed crisis.

But there are occasions when it is easier to believe that a complex word-pattern was invented first and sense achieved afterwards, as Carino's observation on Mirtillo, Act v:

Di quel che fa morendo	Of him [Mirtillo] who, in dying,
Viver chi gli dà morte,	Gives life to the one [Amarilli] who gives him death,
Morir chi gli diè vita.	And gives death to the one [Montano] who gave him life.

Guarini sorts this one out, too, in a footnote, but surely *ex post facto*.

Guarini much enjoys irregular verse-forms, and especially a repeated rhyme, a special case of the controversial rhetorical figure called *annominatio* (or paranomasia):

Ma solo una salute	But the only salvation to one
Al disperato è il disperar salute.	Who despairs is to despair of salvation.

The 'art' in these lines is underlined by the footnote: the whole idea is based upon a line of Virgil with the same kind of word-play but not the rhyme: 'Una salus victis nullam sperare salutem'. Wittier, and still further from 'ordinary usage', is the rhyme that is nearly repetitive, but not quite a rhyme:

. . assai più agevolmente oggi potremmo	We could rather more easily
Ristorar te del violato nome,	Restore your profaned name,
Che lui placar del violato Nume.	Than placate Heaven for a profaned deity.

And most artful of all is the reverse of these, two successive lines identical in all but the final words:

Supplice e lagrimoso a'piedi miei	[And should I, who ought to see him, like others,] suppliant and tearful at my feet
Supplice e lagrimosa a'piedi suoi.	[have to fall] suppliant and tearful at his?

These complex ornaments, woven not sparsely but densely into the text, are frequently of larger scope. In Act IV comes the astonishing conversion of Silvio by Cupid; twenty-two times Cupid picks up the last of Silvio's syllables as an echo that not only makes an intelligible answer but also closes the line impeccably. 'A very beautiful and graceful episode', says Guarini, quoting a fairly precise classical prototype, and indeed it is a breathtakingly ingenious *tour de force*, to be read in the spirit in which one watches a tightrope-walker. Guarini's footnote, his longest, goes on for two and a half pages of small type. Most celebrated, however, is the final chorus to this Act, *O bella età dell'oro*. It is a sixty-eight-line *canzone* based closely on the first chorus of *Aminta*; after repeating Tasso's first line, Guarini retains all his rhymes while approximately reversing the sense of the whole. This, certainly, requires an indomitable technique and a real imaginative resource. In his analysis he quotes Tasso's source in Virgil, describes his modifications, and, while modestly declining to say which chorus he thinks the more beautiful, asserts that his own is the more difficult, more artful, and in consequence worthy of higher praise. He observes proudly but quite correctly that his betrays no sign of effort (which is that virtue of *sprezzatura* that is here a genuine achievement), but is so natural that no one could say which chorus came first; and just as accurately he claims to have 'filled it with most pure and most beautiful poetic forms'.

In conclusion we may add that the *Pastor fido* is Mannerist in two other respects. It is a demonstration of the author's 'art' in the genre before it is the exposition of a certain plot; and grace and finesse are continued down to the minutest detail. Every line seems ready to be set to music, and a great many were; at the last count it was estimated that 550 madrigals, by over a hundred composers, have texts extracted from the *Pastor fido*, parts of which were, of course, intended to be sung in performance.

SIXTEENTH-CENTURY POLYPHONY AND THE MADRIGAL

Analogies between Renaissance music and the other arts are false if they do not take account of two characteristics peculiar to the medium: a natural tendency towards constructivism, and a pre-history on the theoretical side a good deal richer than that of the visual arts. A continuous literary tradition linked it through the medieval period to antiquity, and this induced a far stronger and more analytical self-awareness in

the musician before 1500 than existed in the artist. It is this aspect of sophistication that produced the freakish complexities of the fourteenth and fifteenth centuries, which were not, of course, a true musical Mannerism. They do not represent a pervasive *stylistic* phenomenon.

At first sight it looks as if all Netherlandish choral polyphony, the dominant musical style until the end of the sixteenth century, answers the requirement very well. Pietro della Valle gives a typical early seventeenth-century, negative, assessment; he calls polyphony 'the mode of singing with too much artifice', over-subtle, bizarre, and ostentatious of virtuosity; above all he finds polyphony opposed to expression of ideas, and accuses some of its greatest exponents of inverting the proper relation of form and content. This line of attack is not uncommon, and as we shall see most of the complaints were already made in the sixteenth century. It is not, however, legitimate to draw a direct equation between polyphony and Mannerism. The fact that their opponents use the same terms of reference is largely due to a common source for them in antique criticism, especially of poetry and rhetoric. In the sixteenth century it was commonly held that polyphony began about the time of Dufay, that is around 1430, and Dufay is scarcely a Mannerist.

The problem is perhaps susceptible of another solution. On the one hand there was, in the sixteenth century, a sense of distance and improvement between Dufay's generation and contemporary polyphony, and on the other there were 'classical' and 'post-classical' phases in its development. The watershed came about the time of Josquin des Prés (d.1521) and it was felt that the polyphonic style then achieved a notably enhanced content of 'art'; it deserved the complimentary epithet 'artificial'. The distinction is remarkably similar to that drawn by Vasari between the still rigid and insufficiently eloquent or stylish early Renaissance and the achievement of perfection in his own century, beginning with the period of Leonardo (d.1519) and Raphael (d.1520). For example, it was this distinction in artistry that the Flemish composer and theorist A. P. Coclico had in mind when contrasting the *musici mathematici* like Dufay to the *musici poetici* like Josquin and Isaac (*Compendium Musices*, 1552). Like Vasari, Coclico then distinguished between the early sixteenth century and his own day, not in the sense that they had changed direction, which he thought continuous, but as a different phase of

refinement. Josquin was the first and best, but musicians around 1550 'compose more suavely, more ornately and with more artifice' (which is true: compare the motets of Josquin and Lassus). Josquin is not, of course, a 'classical' composer in the sense that his style is *all'antica*; it could not be. The title 'classic' that was given him by the humanist and musical theorist Glareanus (*Dodekachordon*, 1547) referred to a level of attainment, and not to a style; he wrote of Josquin as Quintilian did of Cicero. But Glareanus also talked illuminatingly about Josquin's style, and it was a classical artist that he described, in the sense that there was an ideal balance, as in High Renaissance art, between his new facility and demonstration of genius, on the one hand, and his natural passion, majesty and expression of the text on the other. It seems a very just assessment; Josquin's motet *De profundis* is one of which Glareanus gives a remarkable analysis, and this surely is a work as deeply and powerfully expressive as it is eloquent; its artistry is unprecedented, yet controlled and unobtrusive, and its structure has a noble, uncluttered grandeur like the architecture of Bramante.

Glareanus is particularly interesting because he is violently opposed to developments since Josquin; indeed the fault he finds even in his hero is that he introduced licence, and departed from the rule. He deplores the current pursuit of novelty and the descent into 'so much wantonness' (*lascivia*, also a popular term of abuse for Mannerist art); there was, he says, no less true genius in Gregorian Chant, even though it was less ornate, than in these modern congeries. But while Glareanus deplores this development, Coclico is not alone in approving of it. Hermann Finck (*Practica musica*, 1556) reads the achievement of the new generation as a refinement and embellishment while maintaining the artistic standards established soon after 1500, and greatly admires the more complex, denser style of Gombert (d. 1556). He is, naturally, enthusiastic about polyphony, and so is Zarlino (*Le istitutioni harmoniche*, 1558) for whom, typically, the characteristic device of imitation in successive voices, 'at which every good composer works with all artifice', brings a 'certain beauty, grace and elegance'. Zarlino, like many of his time, believed that music should above all please the ear; it was only normal to enter a *caveat* about excesses and not obscuring the text.

There may, then, be some justification for extending the term Mannerism to the luxuriant, beautiful and often

unintelligible polyphonic Masses and motets of the post-classical sixteenth century before the restraining influence of the Counter-Reformation; but better still is its application to an offshoot of that style, the madrigal.

Like the *pastorale*, the polyphonic madrigal is a wholly new art-form (the first to be published with this title were of 1530), created for a new social demand; like the *pastorale* again it represents the elevation to a higher level of 'art' of earlier more spontaneous forms (such as *frottole*), the 'art' in this case being transferred from the most sophisticated of all sources, the contemporary Netherlandish polyphony. Like many other Mannerist forms, it was in some ways a revival of Gothic courtly ones (especially of Burgundian *chansons* of the middle of the fifteenth century, which were equally popular at Italian courts), but its *style* was derived from a specific 'classical' achievement. The madrigals were, obviously, connected textually with the *pastorali*; more important, the development of the whole genre was connected intimately with the literary movement, *Bembismo*. Not accidentally the creators of the type were associated with the main centres of Mannerism around 1530; Verdelot was effectively a Florentine, Costanzo Festa effectively a Roman, and Arcadelt, the youngest of the trio, was first in Florence and later (1539–49) in Rome. But above all the madrigal seems to qualify because it is so thoroughly artificial: artificial in style and as an idea, for the notion it communicates is of the most personal kind (normally amorous, almost always sentimental), yet it is sung by four or more accomplished virtuosi, usually seated round a table. It is a social entertainment, and its context is that kind of rarefied evening described in Guazzo's *La civil conversazione* (see Chapter 1). We have met the moderate, non-Mannerist Giraldi before; consistently, he was satirical about a madrigal recital:

> It is a remarkable thing that these young men lament so much about love . . . some are alive with death, others die with life; this one burns in ice, that one is frozen in fire; this one cries out while keeping silence, that one is silent while crying out, and all those things that are impossible in nature appear to be possible for them

An art-form, however, is not a style. The madrigal did not die in 1600; not only did it survive long after in England, but Monteverdi and above all Schütz made it passionately expressive and gave it a Baroque dramatic energy. Moreover,

this forceful and direct expression was foreshadowed in the sixteenth century in the madrigals of Willaert and Rore in Venice; Gesualdo is probably best interpreted as a link in this non-Mannerist chain. It is true that the moment when an art-form is called into being is revealing, and seldom more so than with the madrigal; but we are not concerned primarily with the whole genre, but with the style of the madrigal from Verdelot (beginning in the 1520s) through Corteccia and Alessandro Striggio to, approximately, Marenzio (d. 1599) and de Monte (d. 1603).

It would be superfluous to summarize here the characteristics of this type so ably set out in Alfred Einstein's *The Italian Madrigal*, but for illustration we may look briefly at two features that happen to be illuminated by contemporary comment and raise interesting questions of motivation. The first is the rather strange device of subdividing a text so that its phrases are incomplete in any one voice and the sense is made only in the polyphony; it seems to appear first in the work of Francesco Corteccia, appointed *maestro di cappella* to Cosimo I in Florence in 1542. It is included in 1572 by Girolamo Mei, the humanist, first real historian of music and violent opponent of polyphony, among the 'superfluous kinds of artifice' that please only the ear and destroy the expression of the words; it is 'an immodest impertinence'. Corteccia, as it happened, did it again in a group of hymn-settings of 1543, and in dedicating them to Cosimo he explains why: ' . . . I have judged it possible to give more *delight* with this *varietà*'. This confirms Mei's diagnosis, but puts a positive complexion on it, in familiar terms.

The second example lies right at the heart of the madrigal: the quality of the expression of the words. The sixteenth-century madrigalists expended more ingenuity in this direction than anywhere else, and this seems to contradict one of the principal tendencies of Mannerism. But what matters is how they did it; they used two techniques designed to satisfy the Aristotelian concept of imitation and thereby to bring a higher content of 'art': 'word-painting' (musical patterns of line or rhythm that provide equivalents for *lament*, *arise*, *laugh*) and 'eye-music' (putting *night*, *death*, for example, in black notes). The natural result is that the expression is restricted to small phrases, or single words. The parts are contradictory, and thus mutually neutralizing, in expression, and the whole has no characteristic mood or effect equivalent to

the whole meaning of the text. In fact the tenor of most six-teenth-century madrigals is remarkably uniform. A broader expressive character was rarely achieved before Monteverdi.

This point was most acutely observed by Mei's convert, Vincenzo Galilei (*Dialogo della musica*, 1581); he attacks the mimesis of details, leaving the whole idealized, as a species of virtuosity, which is exactly what it is. In just the same way we may wonder why artistic theory of the period is full of the importance of expressing emotions, and yet the works actually produced seem to have all emotion anaesthetized. If we look at Salviati's *Deposition* [50] we do see isolated passages of specific expression, but not a total expressive effect keyed to the subject such as we find in Barocci's later picture of the same subject [51] or in Rosso's, earlier, at Volterra. Bron-zino's erotic *Allegory* [52] is, as a whole, undifferentiated in appearance from his contemporary *Christ in Limbo* [53] and both pictures have the same cold, polished and unreal colour. Bronzino employs expression in the same way as Marenzio in a madrigal (for instance, *Oimè il bel viso*); it is an artifice, an ornament, a component of *style*, and not, as in truly classical works, a factor that controls all these. It illustrates wider Man-nerist paradoxes, for it is in another sense classical, being based on antique precept; and while its function is partly to add internal *varietà* its effect is to induce a superficial sameness. These strange results occur in the North as much as in Italy; there are textually erotic, even blasphemous, madrigals by Lassus set in polyphony so elaborate and formalized that they are quite passionless, and as genial as the elegant little scenes of mythical *dolce vita* by Joachim Wtewael [13].

In secular music this madrigal style was opposed at the end of the sixteenth century by the monody of the Florentine *Camerata*, which represents the triumph of the anti-hedonist views of Mei and Galilei. The result was opera, but that was to some extent accidental; what they meant to achieve was not a new art-form but a revolution in style, so that music became more genuinely antique in the manner of expressing content. In fact the first operas were evolutions of the *pastorale*. The result, as in Peri's *Euridice* (1600), was as beautiful as almost any madrigal, but too austere to last. Thus early Baroque music continued much of the luxuriance and virtuosity while re-taining the once more 'proper' relation of form and content. The terms of this compromise were explained by G. B. Doni (1635): it is a *moderate* employment of the varieties and artifice

50. *The Deposition*. Francesco Salviati

51. *The Deposition*. Federico Barocci

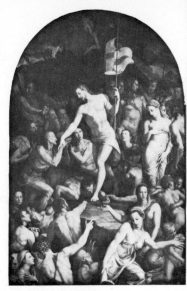

52. *Allegory*. Bronzino 53. *Christ in Limbo*. Bronzino

of the *maniera madrigalesca*. By that term he meant not only the
madrigal but all post-classical choral polyphony, and in itself
it was, he felt, rightly deplored: there was too much confusion
and artifice to the detriment of the words, and in liturgical
works it was introduced rather as a private caprice of the com-
poser than with any proper authority. From the purely musical
point of view, he said, the *maniera madrigalesca* could hardly be
more pleasing, but from the expressive angle it was very im-
perfect, trivial and affected.

INTERMEZZI

In many ways the sixteenth-century intermezzo was the
most comprehensive manifestation of Mannerism. It grew
immediately out of secular interruptions in the miracle-plays
of the fifteenth century; at the same time it was surely known
in the sixteenth century that entr'actes and end-pieces were a
part of Greek and Roman theatre, and no doubt they pre-
ferred to think of the antique rather than the Gothic precedent.
At all events there was no question that the art-form was most
carefully and fruitfully cultivated in the sixteenth century, and
that it suffered a progressive decline after about 1600.

The real home of the Renaissance theatre was the court at Ferrara, and it was there that intermezzi began to acquire the status of a conspicuous, independent art-form. Other courts, notably at Urbino and Rome, played their part. But it is significantly of a performance at Ferrara that Isabella d'Este, writing rather cattily of the wedding of Lucrezia Borgia (1502), said that she had been bored by the *commedia* and found only the intermezzi interesting: it was a remark destined to be often repeated. At first, of course, the *commedia* was the *raison d'être* of the intermezzi, but by about the middle of the century it seemed to be the other way round. Grazzini (il Lasca) said a little bitterly: 'Once we used to make the intermezzi the servant of the *commedia*, but now it is the *commedia* that serves the intermezzi'. By the end of the century their status had risen so high that different *commedie* served as the intervals in repeat performances of the same intermezzi. By then the centre was Florence, where they had a social and political function, in addition to that of entertainment. For it was a deliberate policy of the Medici, since their restoration in 1512, to keep the young aristocracy amused and their energies satisfied by elaborate entertainments in which they did the work. It is an interesting foretaste, and not the only one in Florence, of the techniques of the absolute monarchs of the seventeenth century.

Intermezzi at Ferrara about 1500 were relatively discreet: short recitations, choruses (e.g. *strambotti*) or dances (*moresche*), with simple narrative or allegorical subjects (Vulcan and the Cyclops, or Fortune pursued by an idiot). The sequence, normally of five, was disconnected in theme. As this mild entertainment became more highly charged artistically, the result was the familiar one; it became complex and loaded with artifice.

At Urbino, in 1513, it was necessary at the end to explain the allegory that had united the four previous intermezzi, now more ambitious also in the visual and musical senses. The next major expansion came with the wedding of Duke Cosimo I and Eleonora of Toledo in Florence, 1539. The intermezzi were again consecutive in theme, and thus appreciable independently of the *commedia*; at the same time, as spectacles, their variety was enormously richer (for example, pastoral, maritime, nocturnal) and the music (by Francesco Corteccia) was instrumentally and vocally of great diversity, and obviously very diverting. From this date, which marks their

firm establishment at the Florentine court, intermezzi are recorded at regular intervals until the end of the century.

At the next important Medici wedding, in 1566, one principal entertainment was an astonishingly elaborate *mascherata*, with allegories invented by Vincenzo Borghini and floats and costumes by Vasari [54]. Another was a performance of a *commedia* in the Gran Salone of the Palazzo Vecchio, with intermezzi rather loosely on the theme of Cupid and Psyche. The music was partly by Corteccia, partly by Alessandro Striggio, the stage machinery was probably the first major contribution of a new genius, Bernardo Buontalenti. The orchestra had at least fifty-two players (some on stage, in costume), and twenty-four different types of instrument.

In the first intermezzo the sequence is as follows: a perspective of a concave Olympus is revealed, from which appears, moving forwards and growing larger, a cloud supporting Venus, the three Graces, and the four Seasons; her chariot, from which issues an instrumental harmony, descends, leaving Jupiter and the other gods in Heaven; with the arrival of Venus at the front of the stage, the hall is filled with sweet and precious odours; Cupid appears from one side, with the four Passions; a *ballata* follows; in the first two verses (the music in eight parts, four sung and four instrumental) Venus complains of Psyche while her attendants dance round her (at the same time the chariot goes back to Olympus, which closes over); the third verse (in five parts) is sung and danced by Cupid (promising revenge and loosing off arrows into the audience), together with his attendants.

In the other intermezzi there follow choral dances and madrigals; the floor grows into seven mounds, each of which produces two monsters; the mounds are replaced by smoking craters; Psyche descends to Hades, feeds Cerberus and crosses the Styx; and finally there is a 'new and most vivacious dance' round Mount Helicon, with *canzonette* in praise of Hymen. It is the new resources of scenography that are important at this point. The possibility of invisibly-effected changes before the eyes of the audience produced a sequence of 'marvels' of a wide variety; the calculated audience-reaction was surely that of a firework display rather than of real theatre (fireworks were a speciality of the period, and of Buontalenti). Similarly the spectator assailed by scent when Venus appeared must have been primarily conscious of the producer's ingenuity, as in comparable experiments in the

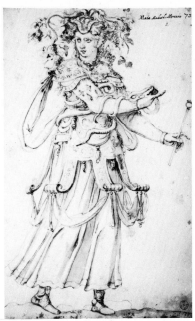

54. *Maia*: Costume Drawing.
After Vasari

modern cinema; the difference is that the reaction was in the first place proper and intended, in the second a miscalculation.

Scenes of Olympus and Hades in transformation, clouds descending, traps opening on stage, become the conventional forms; to them are added aquatic and pastoral 'novelties', and in 1569 the guests saw peasants converted by a witch into animals. At another wedding, in 1586, the third intermezzo showed a parched and frozen landscape in which, with the arrival of Spring, Zephyr and Flora, leaves appeared in the trees while birds sang and water poured from fountains down rivers into lakes. In the fourth, by a rocky shore, with coral and fountains, Thetis rose dripping from the sea and tritons and other monsters bathed the audience in 'most odorous waters'; Thetis began to sing, the sea became rough and 'with marvellous artifice' she and the tritons were swallowed up by the waves; a great number of boats were tossed about in a storm raised by wind-gods; tritons did a few circuits of the stage, Neptune appeared, shook his trident, and calmed the sea; the rocks changed into green banks, nymphs fished and

55. Intermezzo: *Apollo and the Dragon.*
Agostino Carracci after Bernardo Buontalenti

picked flowers, and there was general sport in the water with 'a miraculous effect of ripples exactly as when people swim'; finally the whole scene vanished before the audience, whose every sense (except taste) had been satiated. The music and madrigals were by Malvezzi. In the fifth intermezzo the sky darkened, the moon was obscured, Juno in her chariot appeared on a cloud, there was thunder, lightning and torrential rain; Juno (with an appropriate change of music to harps and lutes) cleared the sky, there was a rainbow, dawn appeared, and clouds and figures disappeared into the distance. The music was by Striggio. And so on; no wonder the acts of the comedy became the intervals.

The most splendid spectacles of all came in 1589, for the marriage of Ferdinando de'Medici and Cristina of Lorraine. The apparatus for the intermezzi was by Buontalenti, as in 1586, but the concentration of other talent was on a greater scale than ever before. The music, for instance, was by Marenzio, Malvezzi, Emilio de'Cavalieri and Giulio Caccini. Preparations began in earnest six months before, and the expense became a scandal. In this case the engravings [55, 56] of two intermezzi make descriptions unnecessary; the principal changes from earlier examples were notional rather than visual. The

56. Intermezzo: *Hades.*
Epifanio d'Alfiano after Bernardo Buontalenti

subjects, elaborately symbolic, were heavy with classical learning; even Buontalenti's intricate costumes, rather surprisingly, were thought to be *all'antica* (although one witness more guardedly said 'tending to the Greek'). The third intermezzo [55] was a much admired reconstruction of a performance at a Delphic feast. This acquisition of tone, however, was not allowed to inhibit the varieties, fantasies and 'marvels', each of which drew attention to itself, like the 'marvels', the conspicuous metaphors and hyperboles, and the *deus ex machina* in Tasso's *Gerusalemme liberata* (1575).

There were three performances of these intermezzi in May 1589; another set, religious but with machine-effects of the same kind, was given with a sacred drama, the *Exaltation of the Cross*. But for many the climax of this first *maggio musicale* must have come in the (deliberately) astonishing nocturnal spectacles held in the courtyard of Palazzo Pitti. The Medici had recently employed Ammanati to convert the fifteenth-century palace into a *villa suburbana*, with ideas borrowed from the Villa Imperiale at Pesaro and the Farnesina in Rome; from the latter, especially, came the projecting wings enclosing a space for theatrical performances. As in an antique theatre a *velarium* was stretched over the courtyard [57] and supported

57. Sea-battle (*naumachia*) in Palazzo Pitti. Orazio Scarabelli

by ropes. The audience was placed in the balconies and in tiers of seats under the ground-floor loggia. The illuminations, including fireworks, were as brilliant as could be.

The evening began with a *mascherata* of such allegorical obscurity that the audience was thoughtfully provided with printed explanatory notes (the same custom is found in French court entertainments). During the subsequent banquet a stockade in the courtyard was flooded with six feet of water. Artillery and war-like fanfares summoned the guests back again. Twenty ships, varying from galleons to frigates, were introduced; rather more than half were Christian, the remainder Turkish, defending a castle erected on the garden side over the grotto. A Christian frigate reconnoitred the defences, was shot at but not hit, and retired to the main fleet; six Christian ships engaged four Turkish; there were salvoes, fires, and terrible noises of wounded Turks (shouting in Turkish); swimmers fought in the water; there was more artillery, and the water was filled with men and pieces of boats; the Turks appeared to be losing and sent out three more ships; the battle grew fiercer still, and was joined by six more Christian ships; one Turkish galley was burnt and the rest captured. The Christians withdrew to regroup and then assaulted the castle with ladders, planting their standard on top. The courtyard was then rapidly emptied of water, and

there followed a battle of illuminated triumphal floats; music, choruses and dances rounded off the entertainment, which lasted the entire night.

The sea-battle in Palazzo Pitti was not unprecedented in the Renaissance, for Leonardo, already, had intended such things for the court of Francis I. It may have been directly inspired by the naval spectacles arranged for Catherine de Médicis at Bayonne in 1565, or by a battle on the sea itself which entertained the bored courtiers (and frightened the ladies) of Ferrara in 1584. In a somewhat extravagant way it illustrates the qualities of surprise, variety, ostentatious ingenuity and expertise emblematic of Mannerism, and, at the receiving end, that insatiable appetite for the spectacular which made Mannerism possible. No less typically, but less obviously, it was a reconstruction of an antique entertainment, the *naumachia*. The sites of these in Rome had recently exercised archaeologists, while the descriptions of the *naumachia* that formed part of the triumph of Julius Caesar would have aroused no less interest.

The *naumachia* of 1589 was a freak; not so the intermezzi, which were the culmination of a long tradition. Spectacles very similar in spirit, though normally different in form, were just as common and almost as lavish at the italianate courts in England, and above all in France (for example, the Fontainebleau *fêtes* of 1564). It is, of course, true that many elements created in the intermezzo tradition recur in the subsequent art-form we call opera. But opera is no more a later phase of the same phenomenon than the seventeenth-century ballet is a straight evolution from the French court entertainments such as the *Ballet des Polonais* (1573) or *Circe: le Ballet comique de la Reine* (1581). Certainly the seventeenth-century forms satisfied a social and artistic demand created by the earlier ones, but their nature was essentially distinct. Intermezzi were *tableaux vivants*, dependent upon novelty but paradoxically highly schematized. Above all it was the relation of these tableaux to the spectator that was different, and characteristic of Mannerism – different both from the fifteenth-century *sacre rappresentazioni* and from Peri's *Euridice* (1600) or Monteverdi's *Orfeo* (1607). With these, as with *Hamlet*, the spectator was emotionally involved, and achieved that willing suspension of disbelief that constitutes poetic faith. But with the intermezzi, as with *Gerusalemme liberata*, a madrigal by Marenzio, a bronze by Giovanni Bologna or Speroni's *Canace*, the possibility of his involvement in this sense does not arise;

emotionally detached, he is invited to admire the performance and its style. With all these it is his desire for stimulation, and his sophistication, that are played upon (and taken for granted). So long as these requirements were uppermost, intermezzi clearly met them very well. They were not, and were not intended to be, dramatic.

SET-PIECES

The sixteenth century saw the birth of scenography as we know it. In part, of course, it was yet another revival of antiquity and in part a continuation of medieval traditions. But it was also a symptom of a general tendency to admire the 'set-piece'. The same tendency, working in reverse, led to a similar attitude towards works of art that were not, in fact, created with this idea in mind. Sebastiano del Piombo, when asked to produce *anything* (or in other words, 'a Sebastiano') for the Duke of Mantua, swore to paint 'something stupendous' – that is, a set-piece of his virtuosity. But earlier works of art, and non-Mannerist contemporary works, were also collected and exhibited as *meraviglie* and, symptomatically, there were many instances in North and South Europe in the Mannerist period of paintings, drawings or bronzes displayed in 'cabinets of curiosities' alongside 'marvels' of nature: astounding geological specimens, incredible biological freaks, thunderbolts or zoological rariora (for example, in the *Kunstkammer* of Rudolph II at Prague). The work of art, whether or not it was designed primarily to do so, was valued for its capacity to excite wonder; the point is equally true in literature. The scenographic art is peculiarly adaptable to this attitude, and that is why its status as an art-form was enormously heightened. Buontalenti's seemingly magical machines, working miracles of illusion, metamorphosis and movement, enshrined in transient form the same values that were made permanent in painting and sculpture and their effects were likewise appreciated over and above their justification as illustration.

The rise of scenography illuminates the creation of other art-forms as 'set-pieces' of artistic genius. One of the most obvious contributions of the Mannerist period to the history of art is the elevation of the fountain to a conspicuous position among art-forms. Most familiar is the pyramidal type, with a central figure raised on an elaborate socle and peripheral figures round the basin, represented by the Neptune fountains

of Montorsoli at Messina (*c.*1551), Ammanati in Florence [58] (1560) and Giovanni Bologna in Bologna (1563). Some of the finest are in the North: Hubert Gerhard's fountains of Mars and Venus made for Hans Fugger at Schloss Kirchheim (1584, fragments now in Munich) and of Augustus at Augsburg (1589), or the Mercury and Hercules fountains at Augsburg (1596) by Adriaen de Vries.

More surprising, however, is the creation within the sixteenth century of the scenographic fountain, the type most naturally associated with the late Baroque period (the Fontana di Trevi). They first appear in Italy around 1560, for example in the main loggia at Caprarola and, in the open, at Soriano al Cimino, the villa of Cardinal Madruzzo. These are crude, however, in comparison with the one designed at the same time by Ammanati for the Palazzo Vecchio in Florence. At the north end of the enormous Gran Salone, Bandinelli had erected for Duke Cosimo a dais and interior façade, with sculptures, that served for state ceremonies; it was a deliberate application of theatre to the requirements of absolutism in politics. Opposite this, across the south end, Ammanati began a fountain-façade: an architectural setting of pilasters and niches enclosing sculpture. At either side there were to be standing figures emblematic of Florence and temperate, mature council, framing an allegory of the generation of water. At the centre of the latter stood Ceres [59], the Earth, from whose breasts spouted jets of water; she was set in a circle of stone (the rainbow), supported at either side below by figures of the Arno and the Fountain of Parnassus; and seated on the top of the rainbow was Juno, the sky, to whom Ceres served as a caryatid. This splendid project, which would have been so congenial in the frigid Gran Salone, was inspired in part by Michelangelo's not entirely executed plans for the Medici tombs [35], but its scenographic character arose from its context, opposite Bandinelli's dais, and in the hall where intermezzi were presented with similar allegories and aquatic fantasies. It was a tragedy that Ammanati's masterpiece in sculpture was not, in the end, set up, for reasons that are now quite mysterious. The sculptural parts were erected unsatisfactorily at Pratolino, then in the courtyard of Palazzo Pitti, and finally dispersed about the Boboli Gardens.

Staircases present a not dissimilar case. If we say that with Mannerism the staircase became an art-form, we do not mean that no earlier staircases (such as those in medieval monastic

58. Neptune Fountain (detail). Bartolomeo Ammanati and assistants

buildings) were works of art; we mean that it was given an unprecedented architectural emphasis, and it was intended to be as much a work of art in its own right as a functional structure. In the earlier and High Renaissance the place of the staircase in architectural design was menial; it was thought of as a necessity that was artistically rather inconvenient, and so it was relegated to positions of minimal emphasis. The reversal came in the 1520s, when in Michelangelo's *ricetto* for the Laurentian Library [37] a prominent architectural unit became subservient to the staircase, to which it owed its existence and

59. *Ceres*. Bartolomeo Ammanati

to which it was related as a chapel is to an altar, or a tomb. The staircase is an elaborate and emphatic work of art, and Michelangelo's drawings show preliminary ideas of even more arresting complexity. Only a little later, about 1530, we meet a similar development in the Château de Chambord – a grand double spiral staircase that ascends the full height of the main block and is seen on each floor at the meeting of broad axial corridors as if it occupied the crossing of a church. Once again the transformations of the Palazzo Vecchio for Duke Cosimo yield an interesting example. Vasari began, in 1560–1,

to provide a better ascent from the first-floor level of the Gran
Salone to the upper floors, and soon had the ambition to pro-
vide an imposing approach to this from the ground level. The
Duke replied that the existing stairs were sufficient, and
Vasari should get on with something that needed doing.
Functionally he was right, but aesthetically – and perhaps
socio-politically – he was wrong, and Vasari soon had his way.
What he built was, in difficult circumstances, very ingenious,

IO METRES

but it was also of considerable historical importance since it
contained the idea of a type of grand double-branch staircase
that often appears in the seventeenth century. Unlike the
Baroque form, this one does not allow the visitor to grasp
visually the whole unit, but only its successive parts; these
have an element of surprise as, when ascending to the left,
one meets a choice at the second landing of proceeding left or
right, or, when ascending right, one reaches the third landing
to see ahead a repeated descent and ascent, like a roller-coaster.
One of a group of villa plans by the Florentine architect
Dosio [60] illustrates the complexity and emphasis possible
by the end of the century; the triumph of mixed aesthetic
and social values over function is well exemplified by Dosio's
note on another drawing *en suite* with this one: 'This kind of
staircase, beginning at the letter S, ascends progressively to-
wards greater light and does not go directly into the room as
in the houses of peasants, which should never happen in any
palace'.

The rapid development of the architectural staircase so that
it may be the most striking feature of a building cannot be

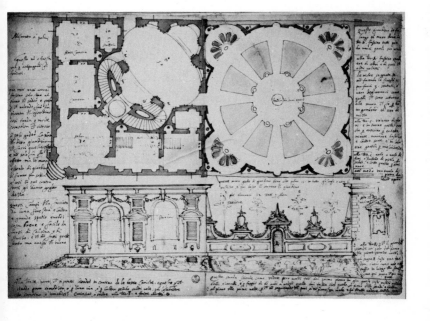

separated from parallel experiments in garden architecture. Projects such as the Farnese Gardens on the Palatine in Rome were an inspiratory source, and a typical structure on this borderline is the approach to the Villa Farnese at Caprarola [61]. There is another common frontier between the staircase and scenography. Some impressive staircases that seem theatrical, such as those of the great Genoese palaces, probably themselves influenced the theatre. But exactly in the no-man's-land between is one of the strangest Mannerist works – the altar-steps designed by Buontalenti in 1574 for S. Trinita and now removed to S. Stefano in Florence [62]. Their most obvious oddity is that the steps on the front face are in fact carved illusionistically in relief; the visitor who has just decided that it is not a staircase finds that, after all, it is, for he can ascend at either end, on the transverse axis. These real altar-steps are derived from those of Italian Romanesque

62. Altar-steps. Bernardo Buontalenti (S. Stefano, Florence)

churches in position and function, but the illusionistic ones have a different background that cannot be understood without reference to Buontalenti's whole project. In a preparatory drawing [63, *lower left*] he planned an architectural screen to go behind the altar, closing off the choir of S. Trinita. Thus the liturgy was to be given a complete theatrical setting – set against a *scenae frons* and raised on a stage; the steps on the front of the stage are those that in ancient Roman theatres

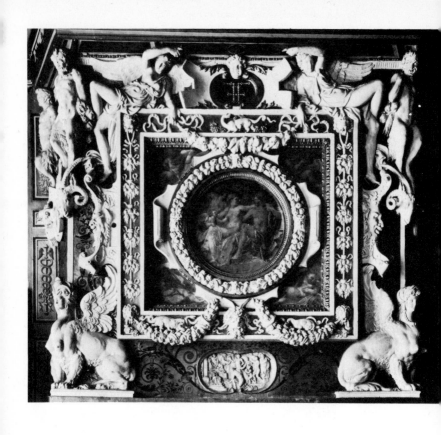

64. Overmantel. Primaticcio (Chambre de la Reine, Fontainebleau)

were called the *pulpitum* and that in the sixteenth century were normally revived, as authentically antique ornaments of the proscenium that were scarcely, if ever, functional. They were frequently very complex in form, and were either real or simulated in stucco or paint. The remaining sketches on Buontalenti's sheet are for a redecoration of the Baptistery in Florence for the baptism of Prince Filippo de'Medici (1576); the *pulpitum* steps recur, and this project illustrates just as well that the marriage of liturgy and scenography was not, as is so often said, an invention of the Baroque era, but of the Mannerist.

The staircase was not the only architectural unit that was treated as a *tour de force*; equally typical of the general phenomenon were fireplaces and doorways. For obvious reasons the most striking fireplaces are in Northern Europe, one of the most lavish and influential being Primaticcio's at Fontainebleau [64] (*c*.1535). The rediscovery about 1520 of the antique medium of stucco had its own liberating effect upon decorative design, and encouraged, as in this case, the invention of exotic and peculiarly fluid conjunctions of forms that may be strictly classical, or fantasies such as 'strapwork' (the tongued and twisted leather-like motifs that became the European currency of Mannerist decoration). As a 'set-piece' of virtuosity it may be compared with Salviati's slightly later *sopraporta* decoration in the Palazzo Vecchio [89]. Fireplaces of this degree of fantasy and sophistication exist in surprising numbers in England (for example at Hatfield, or Charlton). They are found also in Northern Italy, as for instance the one by Scamozzi and Aspetti in the Doge's Palace in Venice. And naturally the genre produces its bizarre freaks, such as that by Vittoria [65] in Palladio's Palazzo Thiene at Vicenza (*c*.1553). This entertaining adaptation of the mouth of Hades almost certainly precedes the more famous retreat (dining room?) in the Sacred Grove at Bomarzo, and is considerably earlier than the similar doors and windows designed by Federico Zuccaro for his palace in Via Gregoriana, Rome.

Doorways provide a natural place for this kind of luxuriant interweaving of motifs, and for the most spectacular manipulation of purely architectural forms. Again, the distribution of the finest examples illustrates the complete internationalism of the Mannerist style. The apparently dream-like inventions of Wendel Dietterlin [67] are nearer actual practice than one expects; the problem of designing a door is often thought of

65. Fireplace. Alessandro Vittoria (Palazzo Thiene, Vicenza)

as if it were the same as designing a title-page. Since the emphasis on doorways persisted into the next century it will be as well to make another distinction here; a doorway on a Mannerist palace façade, for example, may be a focus of decoration, and of artifice, but it never becomes a dynamic and dramatic focus as it does in Baroque architecture.

The garden was certainly a well-established art-form long before the Mannerist period. On the other hand the cult of artificiality in the sixteenth century made this an artistic activity especially suitable for expansion, since it is precisely artificiality that separates gardening from horticulture. The insufficiency of visual records of fifteenth-century gardens makes generalizations hazardous, but it appears that there was then a balanced delight in the beauties of nature and of art. The sixteenth-century garden is more obviously a product of man than of nature; it seems that the garden artist's material is not organic, or rather that it has no life that he does not give it. It is characteristic, for example, that the vine trained upon trellises went out of fashion, and the most common medium became the box, with leaves so small and dense that it might be clipped to resemble green stone. The analogy may work in reverse, for the strange giants and fabulous animals in the

66. Doorway. Vignola 67. Doorway. Wendel Dietterlin

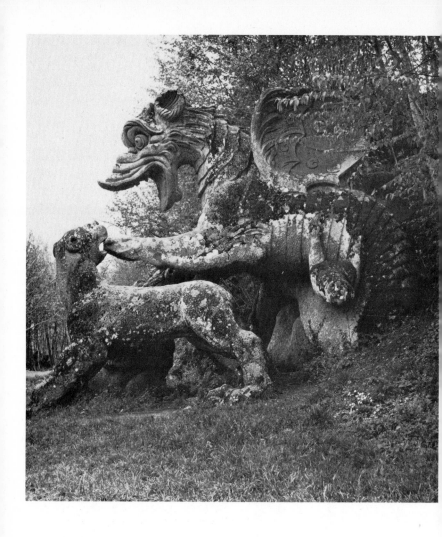

68. *Dragon and Lions* (Villa Orsini, Bomarzo)

Sacred Grove at Bomarzo [68] (*c.*1550–80), carved from outcrops of natural rock, should probably be interpreted as a kind of stone topiary; such fantasies had long been a garden feature, but clipped from living material.

The Bomarzo curiosities, rightly famous, are only a freakish case of a general sixteenth-century tendency to focus the attention of the visitor to the garden upon the stunning set-piece and the achievement of the impossible, the contrived or the unexpected. His relation to the garden is that of an audience to a performance; he sees a succession of 'marvels' (of art, *not* six-foot marrows), almost as if he watched a set of inter-mezzi, with the difference that these marvels are stationary (normally) and it is he that moves. In this lies the distinction between the Mannerist and the Baroque garden in which so many features were, of course, repeated; the former is not usually to be grasped as a unity, nothing predominates, and there is no dramatic focus, even in the villa (contrast the rela-tion of villa to garden in the Villa d'Este at Tivoli and the early Baroque Villa Aldobrandini at Frascati). The successive, cumulative impression is more important than the immediate – the grand vista. This is the limitation with which the new scenographic talent is applied. Vignola, for instance, showed a splendid sense of theatre when he aligned the steps and grot-toes of the Farnese Gardens on the Palatine with the great arches of the Basilica of Maxentius across the Forum; but it is a relationship that is appreciable only on an intellectual level, for he did not give us any point from which the elements may be seen in this dramatic conjunction, as a Baroque artist would have done. It is no more than an ingenious 'point' that one notices in a succession of ingenuities.

The garden-fountain is an obvious focus of artistry in such a sequence, and those of the sixteenth century were scarcely less elaborate (or costly) than those designed for public places [69]. The new cult of grottoes served the same artistic purpose. Their revival is particularly interesting since on the one hand they were a known feature of ancient Roman gardens, and therefore exactly the right ornaments to have, and on the other hand their essential duality is so typical of Mannerism as a whole. For instance, Primaticcio's Grotte des Pins at Fon-tainebleau [71] (*c.*1543) seems to be made of rough stones that can as well assume human as architectural shape; the capacity to make figurative forms is represented as belonging to the material itself, yet the visitor never doubts that it is an artifice.

69. The Fountain of the Labyrinth.
Tribolo and Giovanni Bologna
(Villa Medici, Petraia)

The interior of these grottoes is normally like that at Villa
Medici, Castello [70], made sometime around 1570; they are
encrusted with porous tufo, mother-of-pearl, shells and pumice,
often in dripping formation suggestive of stalactites, yet they
have a sophisticated, classical shape. The visitor can amuse
himself by speculating whether it represents a cave cut in
architectural form out of the rock, or, alternatively, architec-
ture overlaid with the dense accretions of time. He is not en-
lightened by groups of naturalistic animals that come to the
fountains to drink, or by the birds that perch on the walls.
This diverting duality is well expressed in an inscription on a
casino at Bomarzo that was built already leaning rather more
than the tower at Pisa: 'Tell me then whether all these marvels
were made to deceive, or are they art?'

The visitor to a grotto such as the one at Castello was, more
likely than not, soaked to the skin by myriads of jets which his
host caused to spring from the floor. This tedious conceit was

126

70. Grotto (Villa Medici, Castello)

current at the Burgundian court early in the fifteenth century, and it appears all over Italy around 1500. It was acceptable even to soak the Emperor Charles v. By the end of the century such 'wetting sports' (as they were called by an English traveller, Richard Lassels) were, far from being surprises, so universal that the sophisticated visitor could expect nothing else; the surprise consisted only in the doubt whether it would happen as he looked at the flowers (as at Bagnaia), entered the grotto (at Castello), passed up a tunnel (at the Villa d'Este) or sat on a bench (at Pratolino). The joke in the last case was a little refined since half the benches were safe. Montaigne got just as wet when he visited the Fugger Villa at Augsburg.

One of the greatest figures in sixteenth-century garden practice was Bernard Palissy ('the Huguenot potter'); like Buontalenti he combined the imaginative fecundity of an artist with the resource of a practical technologist. In each case something startling was almost bound to happen. Palissy's

most remarkable idea was a complete garden-project that he offered, in *Recepte véritable*, 1563, for the consideration of connoisseurs. He despised 'wetting-sports' of the common or garden spray kind, but he advised a statue that held a vase in one hand and a text in the other, ready to empty the former on the head of the visitor who stepped forward to read the latter; he would also have liked mechanical music here and there in the garden. There were to be topiary *cabinets* in architectural form (for dining) alongside natural forms (including animals) imitated in faience – a fascinating ambiguity of realities.

In his ideal garden Palissy projected four small grottoes, crawling with reptiles, and formed in *rocaille*. Palissy was, in fact, engaged on a magnificent grotto, begun in 1556 for the Duc de Montmorency, which he described in another book published in 1563; it was finally erected in the garden of the Tuileries in Paris, near the river-bank, about 1570. The grotto was entirely lined inside with faience and was about thirteen metres long. In the lowest zone, on three walls, was a sequence of columns and niches (all apparently composed of stones and shells), with swags of fruit and vegetables over which ran snakes and lizards. In the upper zone there were rustic herm-pilasters, seemingly decomposed by the action of air and frost, which framed windows that appeared to be rough holes in rock accidentally broken through from outside; they gave the grotto the air of a 'discovered' cave. A tortuous and monstrous cornice supported a misshapen vault alive with birds and cats. On the end wall was a terrace with coral, ferns, crabs, lobsters and snails, and spouts of water that fell into a pool lined

71. The Grotte des Pins. Francesco Primaticcio (Fontainebleau)

2. Dish. Bernard Palissy

73. Villa Medici, Pratolino. Painted by Justus van Utens

with fish in relief – and as the water moved, the fish appeared to wriggle. Palissy claims the greatest realism in details such as fish-scales and leaf-veins, and a few surviving fragments (especially those in the Musée de Sèvres) bear him out; all natural colours, even of the individual stones, were imitated. There was, in fact, a delicate balance between the semblance of reality and the semblance of a work of art, with no bias either way. The effect may be visualized, to some extent, by studying Palissy's wonderfully capricious dishes [72].

Buontalenti's greatest triumph in garden-art was Pratolino [73], begun, just to the north of Florence, for Grand Duke Francesco de'Medici in 1569. Richard Lassels is a genial guide who still reacted in 1670 to the set-pieces in the right way (now there is virtually nothing left):

Here we saw in the Garden excellent *Grots, Fountains, Water-works, Shady-walkes, Groves,* and the like, all upon the side of a Hill. Here you have the *Grotte* of *Cupid* with the wetting-stooles, upon which, sitting down, a great Spout of water comes full in your face. The *Fountain of the Tritons* overtakes you so too, and washeth you soundly. Then being led about this garden, where there are a store of Fountains under the Laurel Trees, we were carried back to the *Grottes* that are under the *Stairs* [of the villa] and saw there the several *Giuochi d' Aqua*: as that of *Pan* striking up a melodious tune

130

upon his Mouth-Organ at the sight of his *Mistress*, appearing over against him: that where the *Angel* carries a Trumpet to his mouth, and soundeth it; and where the *Countrey Clown* offers a dish of Water to a *Serpent*, who drinks of it, and lifteth up his head when he hath drunk: that of the Mill which seems to break and grind Olives: the *Paper Mill*: the *Man with the Grinding Stone*: the *Sarazens* head gaping and spewing out Water: the *Grotte of Galatea* who comes out of a Dore in a *Sea Chariot* with two *Nymphs*, and saileth awhile upon the Water, and so returns again at the same Dore . . . [etc., etc.] . . . and all this is done by water, which sets these little inventions awork, and makes them move as it were of themselves

Even if, at Pratolino, you decided to take the Grotto of Galatea first, you were still soaked when, having descended the steps immediately under the villa, you passed through the Grotto of the Deluge (with bronze animals in niches, a door right to a bathroom with hot and cold water, and one left to a dining-room). Straight ahead, then, was another grotto, lined with shells, mother-of-pearl and coral, the whole of which seemed about to collapse into a pool. From among the rocks appeared first a triton, sounding a conch-shell, and then another rock in the centre opened and from it issued Galatea seated on a golden shell, drawn by two dolphins spouting water (inevitably) from their mouths. A nymph appeared at either hand and accompanied Galatea to the front of the watery stage, holding branches of coral that spouted more water. Lassels missed one interesting feature of the Pan grotto (unless it no longer worked): as Pan played his pipes, Syrinx was transformed into reeds. These *tableaux* were, in effect, like instant intermezzi, that could be produced by the host at the turn of a tap; Buontalenti's many activities constantly overlap in this way.

But the Pratolino *tableaux* had another and more serious aspect, for they were, of course, automata. As such they have their place in the uninterrupted history of court-art from the Roman and Byzantine Emperors through the Gothic period. In the sixteenth century it was more natural to forget this continuity through the unmentionable dark ages, and to think of automata as direct recreations of a Hellenistic art-form. In Bernardino Baldi's preface to his edition (1589) of Hero of Alexandria's *Treatise on Automata*, he makes this connexion directly between Greek and modern examples; he adds that the principal virtue of these 'marvellous and delightful machines' is that they have no practical use. Like music, they are

74. The Fountain of Venus. Giovanni Bologna (Boboli Gardens, Florence)

solely for the recreation of the mind (which is a revealing attitude towards music). Buontalenti's automata are not, in fact, of the Gothic kind, but they are strikingly like reconstructions of Hero's celebrated *tableaux*.

Buontalenti's resources in garden-art were by no means exhausted at Pratolino. In the grotto in the Boboli Gardens (1583), where Giovanni Bologna's earlier Venus fountain [74] occupies the inner chamber, the first chamber had a circular skylight, like the Pantheon, in which he placed a glass fishbowl. The next hard winter the fish-bowl froze, but nevertheless the idea was so fascinating that it was imitated even in Poland. If Buontalenti's automata were illusions of reality, his real fish must have seemed provokingly like illusions of artifice. And he was not alone. The effects of sound that he produced at Pratolino were probably slight compared with the spectacle; but in the gardens of the Cardinal d'Este at Tivoli (mainly invented around 1570) the proportion was at some points reversed. Here Italian and Northern specialists achieved hydraulic wonders that are still largely those we see today, with some later augmentation, and most striking among these at the time was the Organ Fountain; air-pressure for the pipes came from the flooding of a sealed room, and the mechanism of the keys, like a barrel-organ, was moved by a water-wheel. It is not surprising that it is so rare for an early visitor to a sixteenth-century garden to mention the flowers; his attention was monopolized by Art.

4

A 'More Cultured Age' and its Ideals

The works of art described in the previous chapter must, obviously, have been created in and for a cultural world with ideals remote from our own. The purpose of this chapter is to illustrate some of the more important of them. This can best be done, it seems to me, by letting the sixteenth century speak for itself as much as possible.

Since about 1920 it has become common to interpret Mannerist works of art in terms of 'tension', 'reaction', 'irrationalism', or 'crisis', and to see in them an *intention* to shock in a discomforting way. There is much talk of anxiety (in the mind of the artist), spiritual malaise, conflict, and several more questionable psychoanalytical catchwords and concepts of the same kind. If the reader has dipped into modern literature on Mannerism he has, more likely than not, met this approach and begun to wonder what common ground there can be between it and what he has met here. But if we stand back a little we should be able to see that 'tension' and the rest already have an early twentieth-century period flavour, and in fact the historian knows perfectly well that the expressionistic interpretation of Mannerism is an invention of the Expressionist period. The equally popular notions of 'anti-classicism' and 'reaction' also have their historical contexts in the twentieth century, rather than the sixteenth; and sometimes these interpretations have additional overtones of Surrealism and Dada.

Works of art are ambiguous things; and in fact one of the factors contributing to the ever-changing course of the history of art is their capacity for reinterpretation, or downright misinterpretation, by later artists who come back to them. The greater the work of art the more it can sustain interest or sympathy from diverse angles of approach. Thus our problem is not a simple one; and it should not be surprising if Mannerist works do bear, to some extent, the interpretations that it is now fashionable to put upon them. There is, after all, a strong incentive for the modern spectator to find such interpretations acceptable since through them he can

meet the works of art on his own terms. Perhaps it does not at first seem very important that no one has ever cited evidence of 'tension', or the urge to discomfort, from the age to which these works belong; but the age in question was by no means inarticulate.

The assumption, once made, that Mannerism was a phenomenon that can be explained by modern terms of reference – our prejudices and problems – leads in extreme cases to the assertion that in Mannerism is the beginning of Modern Art. This deduction is perfectly logical, and its obvious silliness should be traced back to the premiss on which it is based. The purpose of history is surely the opposite of this – to show that the past is not the same as the present. Contemporary standards do not give the right guidance to understanding a past age; indeed in most cases they are a positive hindrance. In decoding messages from the other side we get more meaningful results if we use their code rather than ours.

To be realistic we should acknowledge that we cannot entirely avoid the influence of the patterns of thought of our own time; yet it is possible to minimize the distortion they bring with them. Wherever possible a work of art should be interpreted by throwing it back into the nest of ideas in which it was born. The sixteenth century was unusually argumentative, and it is not difficult to find what the important ideas were, for they were obsessions. If in the end they do not completely satisfy us as interpretative keys, we have the right to add to them, but to ignore or contradict them would be a kind of hubris.

It seems worth while, then, to inquire into the aesthetic controversies of the sixteenth century, most of which cut across all the arts, so as to see what ideas were then in the air. In reading these texts there is a built-in danger which we have met already. Because of the common origin of most critical terms in a single source, antiquity, discussions of the problems of the various arts have a degree of similarity that is to some extent misleading; it may disguise differences for which no terms of reference happened to be at hand. The reservation is important, but in this case it is less crucial than it would be if we were trying to argue identity in analogies; we need only the reasonable conclusion that literary debates, for example, do explore ideas that were real in a society to which artists or musicians belonged as contributors and receivers.

The sixteenth century was diffuse in its opinions, not con-
centrated or focused; it was, typically, an age more addicted
to the dialogue than to the single, organically whole thesis.
Mannerism was not the style of the whole of sixteenth-century
art, but it was like one part of a dialogue; similarly the ideas it
fed upon were not unopposed. It is partly because opinion
was divided that it became sharpened to the point of complete
consciousness and was thus set out in a way that is useful to
us. There was another reason for these controversies, and for
the most self-conscious and informative to be the literary ones.
Many of them were inspired by a passage in Aristotle's
Poetics which suggested that the proper context of a great
piece of writing was a controversy; and when listing the
legitimate lines of defence Aristotle made this rather peculiar
statement: 'In general any "impossibility" may be defended by
reference to the poetic effect, or to the ideal, or to current
opinion.' That gave considerable licence, but it was especially
the last phrase that led to so many sixteenth-century apologies
(some of which follow here) that directly relate the style of a
work to the taste of its time.

Whenever possible, however, statements have been selected
here so as to illustrate the terms of these debates in all the arts;
this is partly in order to suggest that Mannerism is indeed a
broad cultural phenomenon. We must continue to use the
term in the first place for a style in the visual arts, but equiva-
lents do exist in music and literature. Naturally the whole
scope of aesthetic discussions of the sixteenth century cannot
be summarized, but only certain significant ones, which take
the form of antitheses. We have already met some of these –
such as Licence and Rule, or Facility and Difficulty – and they,
perhaps, need not be underlined again.

SUPPLY AND DEMAND

The title of this chapter is inspired by a striking preface of
1536, written by the madrigal-publisher Francesco Marcolini
da Forlì. He says that in the '*present more cultured age* . . . Josquin
[and others] have lost their reputation; so that the things
published by Petrucci [Marcolini's predecessor] are aban-
doned as things that once one used to praise'. There is, thus,
a consciousness of a currently more refined taste, and of works
that are an improvement upon those around 1500, which
we must set against the notion that what is produced now ex-

tends the achievement of Josquin (or, *mutatis mutandis*, of Raphael, Bramante, Sannazzaro). What is produced in 1536 is the same, only better, and it belongs to a more refined society.

The sixteenth century was intensely, and fascinatingly, aware of itself in a way that no earlier post-antique century had been, and we find on all sides this kind of comment that helps us to find our bearings as we try to interpret its products. Giovanni Andrea Gesualdo (*Il Petrarca*, 1534) noticed that in his day Petrarch was universally recognized as the greatest Italian poet, whereas in the fourteenth century he had been ranked second to Dante, 'perhaps because they did not yet appreciate the brilliant passages of eloquence, nor the ornaments of the ideas, nor the figures of speech; it being understood, naturally, that we always appreciate what is most in conformity with our own habits, and cannot enthuse over something we do not understand'. This is a strikingly objective comment on the tastes of the generation to which Marcolini referred; to the particular appreciation of Petrarch's figured elegance it was common to oppose Dante's disqualifying lack of polish.

The counterpart of this distinct taste is an intention on the part of the artist to satisfy it, or to rebel against it, as the case may be. The interrelation between the consumer's taste and the producer's will is always complicated; it is probably true that no aesthetic ideal can be formed in a vacuum, but is nearly always prompted by what the artists themselves have shown the connoisseurs. Some work of art is the origin of every nuance of taste, and then that new way of looking at past works of art is transmitted back from the realm of taste to influence the artist once more.

Looking at antiquity and the High Renaissance with a certain bias, and also with a certain blindness, produced a frame of mind receptive to Mannerism. There were some surprisingly explicit remarks on this biased, partly blind, receptivity and upon the way it might be satisfied. Let us recall Paolo Pino's advice to painters, in 1548: 'in all your works you should introduce at least one figure that is all distorted, ambiguous and difficult, so that you shall thereby be noticed as outstanding by those who understand the finer points of art'. In the same way Lodovico Dolce (*Eleganze*, 1564) advised authors 'to write with discipline, much ornament, many figures of speech, and artificially' if they wanted to 'be read and praised by those competent to judge'.

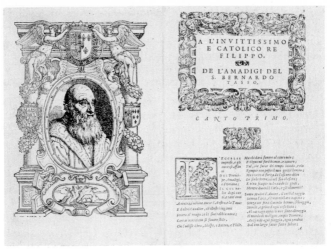

75. *L'Amadigi*. Bernardo Tasso. Frontispiece and first page of text

One author's confession is particularly revealing. Bernardo Tasso wrote of his quintessentially Mannerist Romance *L'Amadigi* (1542–60);

> In the beginning I had decided to make it one unified action . . . and on this basis I composed ten books; but then it occurred to me that it did not have that *variety* that customarily gives *delight* and is desired in this century, already attuned to the Romance; and I understood then that Ariosto [i.e., in *Orlando furioso*] neither accidentally nor for want of knowledge of the art (as some say) but with the greatest judgement *accommodated himself to the taste of the present century* and arranged his work in this way . . . I have followed this example, which I find more beguiling and delightful.

Three observations: Ariosto's abandonment of the Aristotelian concept of unity was the theme of a lively debate that lasted the whole century and was typical of the exhaustive discussions of matters of style; Bernardo Tasso's motives were identical with those by which Corteccia justified his musical artifice (see above, p. 100); the younger Tasso, Torquato, confirmed that the courtiers to whom the first, unified form of *L'Amadigi* was read found it insufferably boring. Bernardo is a helpfully articulate author; he wrote, for example, some time before 1549, of the quality that he had tried to achieve in verses for madrigals: 'the greatest possible artifice, so that they

shall satisfy universally'. We begin to learn from such quotations not only the nature of a taste very remote from our own and very directly related to the Mannerist style, but also how consciously this relationship could be constructed.

VARIETY AND MONOTONY

The need for variety is a very human one, in almost every period and society. It is the exaggerated pursuit of variety (prompted, no doubt, by the exceptional opportunities for boredom in the courtier's life) that is so essential a feature in the cultural background of Mannerism. The reciprocal quality is unity; an increase in what is normally meant by the one leads most naturally to a decrease in what is normally meant by the other. The Florentine intermezzi of 1586 illustrate the point well; de'Rossi said a little wistfully that the librettist had at first intended (like Bernardo Tasso) to follow one theme throughout the whole set 'but it was judged essential to the principal intention of the spectacle that above all we should seek variety, and the result was that it was necessary to sacrifice unity'. Nevertheless the sacrifice, as we have seen, was performed with gusto. The requirement, moreover, was European. Thomas Morley, in *A Plaine and Easie Introduction to Practicall Musicke* (1597), tells the composer of madrigals 'to

76. Nympheum. Vasari and Ammanati (Villa Giulia, Rome)

77. Designs for windows. Bernardo Buontalenti

shew the verie uttermost of your varietie, and the more varietie
you shew the better shall you please'. Similarly, Edmund
Spenser appended to the first part of *The Faerie Queene* (1590)
a letter addressed to Sir Walter Raleigh, in which he explained
that the poem had a disguised moral purpose 'Which for that I
conceived shoulde be most plausible and pleasing, being
coloured with an historicall fiction, the which the most part of
men delight to read, rather for variety of matter, than for
profite of the ensample'. The recommendation to seek variety
had already appeared in Vida's *De Arte Poetica* (1527).

In the visual arts, too, variety was regarded as a no less
essential quality. Typically, Vasari found a culpable lack of it
in his own master, Andrea del Sarto, while Giulio Romano, an
artist after his own heart, was 'learned, bold, sure, capricious,
varied, abundant and universal'. Serlio, an architectural
theorist close in spirit to Giulio, said that 'It is a splendid thing
if an architect is abundant in inventions, because of the con-
sequent diversity of things that happen in the structure
Variety among the elements is a source of great pleasure to the
eye and satisfaction to the mind'. The concept is convincing as
a motivation for the licence in the architecture of Giulio [81],
Buontalenti [77], Michelangelo [35] and Raphael [38]. Also,
of course, it explains much of the enthusiasm for the *figura
serpentinata* [45], for the prolix forms of such beautiful metal-
work as the *Farnese Casket* [78] or an ewer by Jamnitzer [80],
for the set-pieces of sixteenth-century gardens, or indeed for
almost everything reproduced in this book.

Let us go a layer deeper into the problem. Ariosto's *Orlando
furioso* (1516, the definitive edition 1532) provoked a furious
argument which polarized the greater part of literary criticism
of the century. Its interweaving of multiple narrative, like

78. The *Farnese Casket*. Manno Fiorentino and Giovanni Bernardi

79. Casino of Pius IV. Pirro Ligorio

literary polyphony, and its successive diversions (technically called *meraviglie*) were elaborately attacked and defended on the basis of antique theory. Ariosto was seen principally as the exponent of variety against unity; Torquato Tasso, who strove for a compromise, conceded that strict Aristotelian unity was opposed in his time 'by the universal consensus of the ladies and *cavalieri* of the courts ... whose champion is Ariosto ... departing from the paths of the ancient writers and the rules of Aristotle' (a comment that recalls Vasari's appreciation of Michelangelo's departure from the rules of Vitruvius). He tells us what we really need to know, that an author who *did* follow Aristotle on this point (Palladio's patron Trissino, in his *L'Italia liberata dai Goti*) remained absolutely and rightly unread. Tasso's compromise – a unified plot with attendant *meraviglie* – is not, of course, a truly classical one; he gives himself away

80. Ewer. Wenzel Jamnitzer

81. Palazzo del Tè. Giulio Romano.

when he remarks that it is more difficult that way, more praise-worthy, 'more wholly dependent upon the poet's artifice'.

Now the taste that was so abundantly satisfied by the succession of *meraviglie* in *Orlando furioso* was just as well provided for in Giulio Romano's Palazzo del Tè [81], and surely this is what best explains that extraordinary building, erected and decorated for Federico Gonzaga around 1530. Every façade is different, and each is spiced with unexpected systems of balance, stimulating and novel conjunctions of classical forms, and enlivening changes of texture. Each room inside, visited *en suite*, is deliberately and extravagantly different: capricious, as in the Room of the Giants which seems to collapse, with the Giants, about the spectator; exquisitely refined and very antique, as in the Room of the Stucchi; delicately artificial, as in the Room of the Eagles; challengingly illusionistic, lecherous, chaste and so on – and all manifestly inventive. The variety in Giulio's *meraviglie* is cumulative, quantitative, and to be appreciated in the act of perambulation; the building has no structural unity, and it can never in fact be seen as a whole; without doubt Giulio sought to give delight with his variety, and the building was a conspicuous success, much imitated.

To compare *Orlando furioso* with a palace would not have seemed improper in the sixteenth century. Camillo Pellegrino (*Caraffa*, a discourse on epic poetry, 1584) preferred Tasso's

element of unity in *Gerusalemme liberata* (1575) to Ariosto's variety:

> ... the palace [*Orlando furioso*] with more numerous, more beguiling, and visually richer rooms, gives complete pleasure only to the simple-minded, not to the understanding; where the experts in the art discover in it the faults, the false ornaments and enrichments, they remain dissatisfied, and what gives them greater delight is the architecture of the smaller structure [i.e. *Gerusalemme liberata*], which is a body better conceived in all its parts.

A reply, from one of the Accademici della Crusca in Florence, defended Ariosto's 'most magnificent, rich and ornate palace' against Tasso's 'miserable little hovel'. As it happened Pellegrino was very fond of artistic imagery; in another passage he usefully compares Tasso's 'artificial locution' with the 'artifice in the matter of foreshortenings, muscles, torsions, postures and clothing' of painted figures. If Ariosto's variety has more in common with Mannerist art, the latter's cultured artificiality certainly has the better parallel in Tasso.

What is the stylistic result of the pursuit of variety? The prototype of all literary *meraviglie* was Homer's elaborately detailed description of the shield of Achilles. Attention to detail is what is needed for the greatest effectiveness of each successive invention; and so the *meraviglie* in the Romances, in Salviati's Palazzo Vecchio frescoes (such as the *Allegory of Peace* [89] over the door) or in the *Farnese Casket* (for example in the narrative scenes engraved in the oval crystals) are all in sharp focus, and meant to be seen isolated. Such jewel-like effects are the very reverse of those sought by Baroque artists. And visions of more generous scope characterize the greatest epic of the seventeenth century, *Paradise Lost*, or the grandiloquent decorations of a Rubens or a Pietro da Cortona.

The emphasis on the parts rather than the whole in so many Mannerist works is in these terms positive and functionally expressive of a desired quality; it also has one very positive result, a generally beautiful and refined level of execution. As a rule, Mannerist painters did not pursue the interest in atmospheric effects that is found in the High Renaissance; most, like Bronzino [52], excluded atmosphere to gain clarity of detail, and it was chiefly in Venice that the High Renaissance experiments were continued through to the Baroque period. When the quality of finish in Mannerist works is not tight, more often than not the looseness expresses that other virtue of

42. The Del Monte Chapel. Ammanati and Vasari

facility. The emphasis on the parts is also, of course, a negative aspect of the preference for variety rather than unity. It has to be admitted, for example, that if we look in turn at the very best chapel decorations of the High Renaissance, Mannerism and Baroque, such as Raphael's Chigi Chapel, the Ammanati–Vasari Del Monte Chapel [82] and Bernini's Cornaro Chapel, the Mannerist one is in this respect weak.

However, we still oversimplify. Any considerable work of art has a unity, of a kind. Unity does exist in a Mannerist façade [79], Salviati's *Allegory of Peace* [89], the Fontainebleau fireplace [64], or Cardinal Farnese's candlestick of 1581 [83], but it is of a special kind compatible with variety and its consequences, *meraviglie* and elaborate detail. It is decorative, it is an all-over interwoven consistency of emphasis; that is the beauty of it, not easily attained. There is a similar unity in polyphony. By chance, the altar-set to which the candlestick [83] belongs was enlarged in 1632; in the approximately matching baroque candlesticks the motifs were reduced in number, more broadly shaped and executed, and enlarged. They were treated not with even but with selective emphasis which provides the eye with foci of energy and structure. The unity of Mannerist works was neither structural nor energetic as Baroque unity was to be, and as, to a great extent, High Renaissance unity already had been. The loss of these qualities becomes quite clear if we contrast the façades of Palazzo dell'Aquila [38] and Bramante's earlier House of Raphael, or two fresco-designs like Perino's *Martyrdom of the Ten Thousand* [28] and Leonardo's *Battle of Anghiari*. The retrieving of energy and organic unity was one of the main achievements of the generation of Caravaggio, Rubens, and Monteverdi.

As the nature of unity is mutable, so is that of variety, for it is, of course, obvious that variety exists within High Renaissance and Baroque works. If we try to define the variety characteristic of Mannerism we can, perhaps, see what ultimately went wrong. First, it is a variety that finds expression in multiplicity rather than in contrast; like Mannerist unity, it is decorative, not energetic. It is revealing, for example, to see from this point of view the role that Venice plays as the main centre of continuity between the High Renaissance and the Baroque. Titian's colour is forceful in contrasts *and* unified in its structure, while Mannerist colour tends to bring insulated, unfused elements into decorative relationship. Or in architecture, for example, Sansovino's Library of San Marco

and the Mint are full of variety of form, certainly, but this variety is organized in more powerful patterns of advance and recession, light and shade, than in Mannerist equivalents. Sansovino's buildings have a dramatic, instantly impressive unity, not one that is revealed cumulatively. The complexity of Michelangelo's place in Mannerism is well illustrated by the fact that while his inventive licence continues to grow beyond the point reached in the Medici Chapel [35] it coincides with a reverse tendency towards more energetic organization, and unity with contrasts, in the Laurentian Library [37] and the Porta Pia [84].

But what more fundamentally distinguishes Mannerist variety from that of the preceding and following periods is the fact that it becomes, itself, an ornament of style, in the same sense that we found expression to be an ornament of style in Bronzino's altarpieces and the Italian madrigal. These are not factors so central to the work of art that they affect style, they *are* style. In Raphael's art of the period of the Stanza d'Eliodoro (1511–14), variety (prompted by the illustrative problem) controls a rich and effective harmony, and, paradoxically, at

84. Porta Pia. Michelangelo

this level it yields a greater diversity than when it is more deliberately pursued as a desirable article of stylistic clothing. In the latter case, as in Mannerism, variety inevitably ends by defeating itself. Satiety is one danger, but more insidious is the perverse tendency for variety treated as an aspect of style to make things look, read or sound alike, in accumulation (*plus ça change, plus c'est la même chose*). It leads progressively towards monotony; variety only leads to true and effective diversity when it arises as the response to an expressive problem.

ABUNDANCE AND BREVITY

In literary criticism the preferences for abundance or brevity were argued by reference to Homer and Virgil. The most significant discussion of this point comes in Sperone Speroni's *Discorsi sopra Virgilio* (*c*.1562). Speroni admires much in Virgil, but finds him 'neither as florid nor ornamented as he should be; and he is therefore more of a historian, than a poet. He was studious of brevity, which the poet should avoid if he wants to delight his readers ... brevity is incompatible with ornamentation, which is all superabundance ...'. He admires the 'floridity' of Homer, who 'certainly gives delight by pleasingly ornamenting and amplifying his works'. This preference leads to a curious justification, full of period-flavour, for Aristotelian unity: 'since poetry consists in superfluous and redundant ornament, if the poet treats multiple actions poetically the poem, if it is to be perfect, will grow to infinity' (an outstanding illustration of tortuous classicism).

These views were consistent with the Mannerism of Speroni's tragedy *Canace*, and they were not uncommon; moreover the same difference between Homer and Virgil could be observed by others with a preference for Virgil's restraint. It is characteristic of Tasso that he followed Speroni very closely in his *Discorsi*, which he wrote to prepare himself for the task of composing his own epic. This conscious stylistic decision is related, as cause to effect, to the almost suffocating intricacies of *Gerusalemme liberata* (paradoxically, often abbreviated in diction), and then to the terms in which its style was immediately praised. Tasso himself thought his *meraviglie* even richer than Homer's.

It is in the context of this contemporary difference of opinion, equally evident among musical theorists, that the admiration for abundance and the disdain for poverty in the visual arts should properly be considered. That preference was already

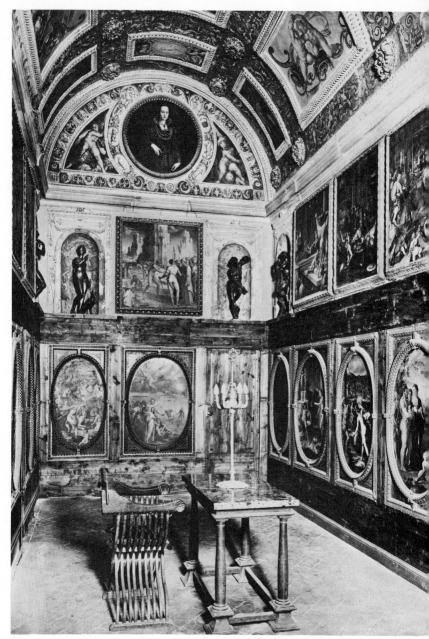

85. The Studiolo. Vasari and his circle

expressed by Raphael, and most naturally by Vasari. Perhaps the concept was already a factor in Michelangelo's planning of the Sistine Ceiling (he later claimed that the Pope's plan for seated apostles alone would have produced an impoverished work of art, and that he was fortunately given a free hand); it would be surprising if it was not half-consciously present in the mind of a fifteenth-century artist such as Ghiberti, and controlled abundance was already approved in Alberti's *Della Pittura* (1435).

Abundance was not a virtue solely in the quantitative sense; it meant density of motif as well as prolixity. Part of the beauty of one of the vintage Florentine intermezzi lay in the fecundity that, like variety, was packed into a relatively small compass. It also precisely characterizes one of Vasari's most inspired creations, the tiny *studiolo* [85] invented for Francesco de'Medici in 1570; for here is an abnormal abundance and high concentration of exquisite paintings [93], bronzes [12], rich materials, and superfluous and redundant ornament (in its original state), just for the beauty of it. In spirit (and, incidentally, in function) it is like the *Farnese Casket* [78] turned inside out. And just as abundance in the sense of prolixity is so well represented by Rosso's long series of fantastic masks [86], so abundance in density is one of the virtues of his *Mars and Venus* [34], or a Mannerist cup [87], or even a spoon [88].

86. Mask designs. Rosso

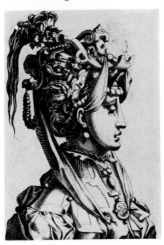

There is absolutely, and there was in the sixteenth century specifically, much truth in the epigram of Celio Calcagnini (d. 1541) on the *Discobolos* [42]:

> Sunt quaedam formosa adeo, deformia si sint:
> Et tunc cum multum displicuere, placent.

> (There are certain things that are beautiful
> just because they are deformed,
> and thus please by giving great displeasure.)

It is essential to remember how widely appreciated was this rather special kind of beauty, because the taste for it – an aspect, certainly, of variety – accounts for so many of the odd features of Mannerist works that seem, at first sight, to consort awkwardly with the more familiar taste for ideal beauty. But it was, in fact, part of a court artist's function to produce oddities, and, moreover, he was in most cases very happy to do so. Giulio Romano's predecessor at Mantua, Lorenzo Lionbruno, writes to Federico Gonzaga in 1522 that if the Marquis will provide what the artist needs 'it will give me new life and inspire me in such a way that I shall produce bizarre inventions never seen before'. And Giulio, in fact, spent a good deal of his time at Mantua producing *bizzarrie*, such as the designs for, as it seems, a chamber-pot with fish in relief on the bottom and bull-rushes round the walls (like a foretaste of Palissy-ware [72]).

There is a respectable tradition from antique literary criticism that fantasy is a source of beauty; this is probably the basis of the epitaph of Piero di Cosimo, the early specialist in fantasies, especially zoomorphic ones:

> If I was strange, and strange were my figures,
> Such strangeness is a source both of grace and of art; .
> And whoever adds strangeness here and there to his style,
> Gives life, force and spirit to his paintings.

This is not necessarily a clue to understanding Piero's paintings, but it is revealing for the taste of the society in which it was written (1521). That taste had already been roused by Boiardo's *Orlando innamorato* (*c*.1483), and was abundantly satisfied by Ariosto's more obviously fictitious and more urbane enchantments, such as the hippogryph, and by Riccio's capricious little bronze caskets and ink-wells.

When antique authority was so eagerly followed, with one interpretation or another, it was important to cope with the objection to fantasies and monsters in Horace's *Ars Poetica*; and in the gloss to Francesco Luisino's edition of 1554 there is an evasion of this authority that reveals much about the sophisticated, disbelieving detachment of the period. The poet, wrote Luisino, is free to invent whatever he likes, because his invention is a fiction that does not affect us, 'and in just the same way we are not moved by pictures, whether they represent frightening things or pleasant, since it is clear to us that they are fictitious . . . '. It makes much better sense of Giulio's monstrosities – the collapsing Hall of the Giants, or the slipping keystones of the Palazzo del Tè [81] – to suppose that the sixteenth-century beholder did not believe them for a moment, that he remained unmoved except for a *frisson* of delight in a peculiar kind of beauty.

The century had an enormous appetite for amusement of all imaginable kinds, and it would have thought rather funny, and also rather capricious, our modern interpretation of such things as menacing, discomforting, or expressive of spiritual anxiety. They aroused admiration for the artist's wit and ingenuity in just the same way as Alessandro Vittoria's fireplace in Palazzo Thiene, Vicenza [65], or the horrific (but not horrifying) Florentine intermezzi [56]. Ben Jonson's *The Masque of Queenes* (1609) is one of the English derivatives of that kind of entertainment; he explains that he arranged, as an *hors d'oeuvre,* 'an ougly Hell', complete with witches,

because her *Majestie* (best knowing, that a principall part of life, in these *Spectacles*, lay in their variety), had commanded me to think on some *Dance* or shew, that might praecede hers . . . not as a Masque, but a Spectacle of strangeness, producing multiplicitie of gesture, and not unaptly sorting with the current, and whole fall of the devise.

One of the most explicit comments on a really significant monstrous fantasy, or 'Spectacle of strangeness', is Bernard Palissy's on the faience grotto that he finally erected at the Tuileries. He describes in great detail, and with excited pride, the rustic herms that seemed decomposed by time, by the winds and frost, breaking open to reveal stones and shells inside and sprouting weeds from the crevices, or the misshapen, tortured and ruined vault, or the weirdly-formed cornices.

And what was the lucky owner supposed to think of it? One herm was so monstrous, Palissy said, that one *had* to laugh. It was '*un oeuvre sourcilleux*', full of '*phantasmes*'; 'it seemed to me that it was a dream, or a vision, on account of the monstrosity of the building'. He also thought it was strangely, but very, beautiful.

Vicino Orsini meant the visitor to his Sacred Grove at Bomarzo to be quite clear about the spirit in which his monsters [68] were invented. There are numerous inscriptions, as for instance the dedication: 'You who wander through the world avidly seeking great and stupendous *meraviglie*, come here, where there are terrible masks, elephants, lions, ogres and dragons'. And he wrote on a pilaster, as a key, 'Sol per sfogar il core': solely for the recreation of the spirit. Orsini's dragon should be appreciated in the same frame of mind as those of his friend Bernardo Tasso: for example the steel dragon that belches mounted amazons, and has an apartment inside, in the unfinished Romance *Il Floridante*; they are incredible, delightful, and, above all, *manifest* fictions – products of artistic and literary escapism.

CLARITY AND OBSCURITY

Giraldi, who makes such a useful yardstick of moderation, declared in his *Discorso* of 1549–54 that by the art of poetry he did not mean complexities, enigmas and monsters; he wanted clarity, that made the way easy to follow and direct, not difficult and complicated. Many disagreed with him; once again this was a debate that embraced all the arts, but it so happens that the most remarkable conclusions were drawn in literary criticism.

Giraldi's opponents got off to a good start with Aristotle. Strange as it may seem now, Speroni (through the medium of his pupil Tomitano's *Quattro libri della lingua toscana*, 1545) stated that Aristotle's *Rhetoric* taught all the 'figures, colours, ornaments, artifices, and forms of speech and thought . . .' necessary to a writer. But in the *Rhetoric* there was indeed the advice that 'we should give our language a "foreign air"; for men admire what is remote, and that which excites admiration is pleasing'; Aristotle added that such unfamiliarity was even more appropriate to poetry than to rhetoric. Demetrius, who was much studied by Tasso, had much the same idea: 'The diction employed in the elevated style should be superior,

distinguished and inclined to the unfamiliar. It will thus possess the needed gravity, whereas usual and current words, though clear, are unimpressive and liable to be held cheap'. The influence of Demetrius in this respect combined harmoniously with the elevating, latinizing process of *Bembismo*. Demetrius also liked allegory for its obscurity: 'things that are clear and plain are apt to be despised, just like men stripped of their garments'. There is an echo of this idea in Spenser's letter to Raleigh again, explaining his

continued allegory, or darke conceit. ... To some I know this Methode will seeme displeasaunt, which had rather have good discipline delivered plainly in way of precepts, or sermoned at large, as they use, than thus clowdily enwrapped in Allegoricall devises. But such, me seeme, should be satisfide with the use of these days, seeing all things accounted by their showes, and nothing esteemed of, that is not delightfull ...

But it is above all in Tasso that obscurity is most eloquent. In his *Discorsi* he reasons the use of little used, new and foreign words because they, like figures of speech and other ornaments, bring sublimity. It is a base style in which there are 'few adjectives, and those more necessary than ornamental'. True, he says the epic must not be obscure, but today few readers of *Gerusalemme liberata* would calibrate the scale of obscurity quite as he did. The poem is dense with arcane references, hidden and revealed imitations of ancient epics, exotic words (some newly-shaped out of Latin), and figures of speech that convolute the sense:

> Nè qui gregge od armenti a'paschi, a l'ombra
> Guida bifolco mai, guida pastore. (XIII. 3)
>
> (Nor does any cow-herd or shepherd ever lead his flock,
> Or his drove of cattle, to this shaded pasture.)

And the combination of these, with unexpected word-order, hyperbole and irregular rhyme, certainly draws more attention to the magnificence of the verse than to its sense.

Not everyone approved, but there is a most intelligent, if biased, apologia in Tasso's funeral oration delivered in 1595 by Lorenzo Giacomini (Malespini):

Tasso ... understanding that perfect clarity is nothing but superabundant ease towards too sudden understanding without giving the listener the opportunity to experience something for

89. *Peace*. Francesco Salviati

90. *The Story of Furius Camillus*. Francesco Salviati

himself ... with elaborate care sought for his poem nobility, strength and excellent grace, but not the greatest clarity He avoided that superfluous facility of being at once understood, and departing from common usage, and from the base and lowly, chose the novel, the unfamiliar, the unexpected, the admirable, both in ideas and in words; which, while artificially interwoven more than is normal, and adorned with varied figures suitable for tempering that excessive clarity, such as caesuras, convolutions, hyperbole, irony, displacement ... [etc.] ... resembles not so much a twisted ... muddy alley-way but an uphill stony path where the weak are exhausted and stumble. [A conscious contradiction of Giraldi?]

The perceptive observation (in fact Ciceronian) of the stimulation given to the mind by difficulties in reading the information fed into it, is universally true, even if it is doubtful that Tasso (or any sixteenth-century artist) was entirely conscious of the point. What is not universally true, but very true in relation to Tasso, is that obscurities do have a positive aesthetic effect, inducing admiration and a special kind of delight; the reader is flattered when he shares the author's sophistication. It is interesting that the only painter whom Tasso is known to have admired was Salviati [90], whose artificial style is dense with visual figures of speech (*contrapposti*), hidden

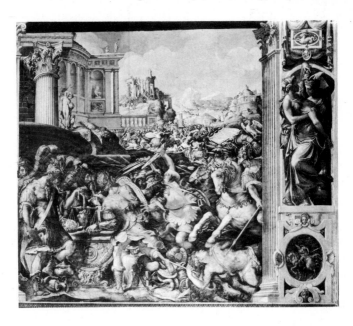

classical references, hyperbole, refinements, interlacing of forms, the unexpected, and departures from common usage. Certainly Salviati, too, 'avoided that superfluous facility of being at once understood'; and the same stimulating obscurity, flattering to the connoisseur who can interpret it, is characteristic of Mannerist architecture [39] or stucco decorations [82]. It is with these that the complex and exotic aspect of Tasso's obscurity may be compared, underlining the Mannerist component in his style that is to be set against the obvious tendencies towards the Baroque (for example in the long magniloquent periods or the broad, imprecise handling of images).

FORM AND CONTENT

A tendency in Mannerism to place the expression of artistic qualities before that of the subject has already been met at several points – in *Bembismo* in literature, and in polyphonic madrigals, as much as in works of art. This phenomenon, too, was openly discussed. What is rather surprising is the degree of consciousness of it that was eventually achieved. The most remarkable case in the visual arts concerns Giovanni Bologna. In Raffaello Borghini's *Il Riposo* (1584) we learn of jibes that the sculptor

was very good at making beautiful little figures, modelled in varied attitudes with a certain grace; but that in executing large marble statues, in which real sculpture consists, he would not succeed. Being thus put on his mettle, Giovanni Bologna decided to show the world that he knew how to make not just ordinary marble statues, but also multiple ones of the most difficult kind possible in which one would see the whole art of making nude figures (exemplifying wasted old age, robust youth and feminine delicacy); and thus he made, solely to show his excellence in art, and without having any subject in mind, a bold youth who snatches a most beautiful girl from an old man [44].

When the Grand Duke had liked it so much that he decided to set it up in the piazza (in its present position), the problem of subject arose, since public statues must have titles. It was Borghini, and not the sculptor, who suggested the one we now use, the *Rape of the Sabine*.

One may detect the slight thrill of being involved in rather wicked events in the humanist Borghini's account of this incident, and it leaves the interpretation of the artist's intentions a little ambiguous. But all doubt is removed by a remark made by the artist himself. It concerns one of the small

bronzes, a group that was in fact the origin of the sculptural ideas of the marble statue; Giovanni Bologna dispatched the bronze to the Duke of Parma, Ottavio Farnese, in 1579 with a covering note in which he describes it as 'the group of the two figures . . . that might represent the Rape of Helen, or perhaps of Proserpine, or even of one of the Sabines, chosen to give scope to the science and accomplishment of art.' This letter makes it quite clear that Giovanni Bologna's approach was not directly through the expressive problem but through what were then considered the terms of artistic accomplishment.

What was so conscious around 1580 must surely have been half-conscious earlier; and in fact this inversion of the classical (and Baroque) relation of form and content was a perfectly natural result of the conditions of patronage becoming normal around 1520 whereby major works of art were commissioned solely as examples of their creator's *virtù* – the subject being thought so unimportant that it was often unspecified. On the artist's side this approach is to some extent foreshadowed in Leonardo's *Saint Anne,* which seems not to have been commissioned at all, but it is clear from the drawings that that picture was one of several High Renaissance works in which form and subject were evolved simultaneously; that, however, was already a step towards the Mannerist situation.

The proper context of Borghini's story about the *Rape of the Sabine* is a dispute which involved all the arts in the sixteenth century. The musical theorists were the most vocal; armed with the authority of Plato, to the effect that music *must* follow the words, some of them attacked the opposite sequence so fiercely that it must have been thought fairly common. Monteverdi, very conscious of his own Platonism in this respect, is quoted in the *Scherzi musicali* of 1607 as saying that all polyphonists from the beginning of the style until about 1560 (the period he called *prima practica*) made harmony the mistress of the words. One celebrated case in which this happened occurred in Florence in 1589, in the composition of the 'Grand Ballet' at the end of the intermezzi: the music was created first by Emilio de'Cavalieri, the words were fitted to it (not very well) by Laura Guidiccioni. Giovanni Battista Guarini tells with pride a similar story of the *Ballo della cieca* (Act III, Scene 2) in the *Pastor fido*; he first had the dance arranged, then the music composed by Luzzaschi, and finally he himself invented words that would fit both. 'Which would appear impossible', he says, 'if the poet [himself] had not done it on many

other occasions with even greater difficulty.' These, no doubt, are special cases, peculiar to the choral ballet, but they are only extreme examples of an unclassical process much commented upon at the time. Pietro della Valle, looking back over the sixteenth century, remarked that among the best polyphonists 'it is said that quite often they made compositions of pure notes to which, when finished, they afterwards adapted whatever words came best to hand'.

The equivalent process in literature, severely censured by Giraldi, was the production of beautiful verse that expressed no meaning, because it started from the intention to achieve a beautiful style, not expression. Bembo was much criticized in this way, not only by Giraldi. Unclassical as Bembo was in this respect, it is curious once more how easily his position could be defended by careful editing of classical authority. Demetrius, for example, discussed *epiphoneme* (language that adds ornament rather than carrying sense) and particularly praised Homer for it; he said 'it resembles those things on which the wealthy pride themselves – cornices, triglyphs and bands of purple. Indeed it is a mark of verbal opulence'. It was exactly this kind of ostentation that Giraldi found culpable in Speroni's *Canace*; it was the same phenomenon to which Glareanus (*Dodekachordon*, 1547) referred as *ostentatio artis* (or *ingenii*) in polyphonists from Josquin onwards; and it was in these terms too that Aretino attacked Michelangelo's *Last Judgement* in his notorious letter of 1545. They all relied upon a mode of attack used in ancient criticism of the Asiatic school of rhetoric (cultivating style at the expense of its expressive function); but they must all have been reacting to a kind of Asianism that was real around them.

Aretino's attack on the *Last Judgement* seems to apply only to one facet of that work, in which an expressive intention cannot seriously be denied. But had he been consistent, or honest, he might reasonably have attacked Vasari or Salviati in these terms. In such a typical Mannerist painting as Pellegrino Tibaldi's *Adoration* [91] there is a degree of apparent activity that belongs to an altogether more dramatic subject, and there can be little doubt that it was not thought of by the artist as expression so much as *ostentatio artis*. In architecture the disjunction of form and meaning can also occur. For example, the rustication of columns and walls in Ammanati's Palazzo Pitti courtyard [57] was derived from Jacopo Sansovino's Mint in Venice; but on the Mint the rustication was on

91. *The Adoration of the Shepherds.* Pellegrino Tibaldi

the exterior, and carried the sense of impregnable strength, whereas in Palazzo Pitti it appears inside the court and in any case can scarcely express the nature of a surburban villa. It is a capricious and decorative ornament.

STYLE AND DECORUM

The problem of form and content – sometimes in inverted relationship, sometimes just dissociated – brings us finally to the most serious charge that could be brought against Mannerism: the frequent offence against the Horatian and Aristotelian concept of decorum, fitness to purpose. It seems, in fact, that no one in the sixteenth century directly opposed this principle, but that many dared to forget it, or to twist its meaning.

An exactly classical view of decorum is neatly defined by Andrea Gilio as 'that proportion, correspondence or conformity that style has with the subject'. It is quite obvious, then, that decorum is missing from a great number of sixteenth-century works, and this was duly noticed. While Guarini was writing the *Pastor fido,* the ground was being cut from under his feet by Castelvetro, in a commentary on Aristotle's *Poetics* (1570); the characters in a pastoral, Castelvetro said, should speak like ignorant rustics. Each one of Guarini's, on the contrary, seems to have been brought up on Castiglione's *Cortegiano*, so polite is his behaviour and so polished his speech.

Giraldi, once more, complains in these terms of Speroni's *Canace*, and not without reason. What he objected to was Speroni's unnatural, inappropriate and 'affected modes of speech . . . the pointless embellishments, far from the nature of the subject'. They are exemplified by this rhetorical figure at the end of Deiopea's supposedly desperate attempt to save the lives of her children:

> Viver dopo lor morte
> Non potrei, s'io volessi,
> Non dovrei s'io potessi.

> (To live after their deaths
> I could not if I would,
> I should not if I could.)

The same criticism was made of the not infrequent appearances of such affectation in English poetry, as in the very strange *St Peter's Complaint* by the Jesuit martyr Robert Southwell:

> I feared with life to die – by death to live;
> I left my guide, now left, and leaving God;
> To breath in bliss I fear'd my breath to give;
> I feared for heavenly reign, an earthly rod.
> These fears I fear'd, fears feeling no mishaps,
> O fond, O faint, O false, O faulty lapse!

'Now good St Peter weeps pure Helicon', as Joseph Hall instantly and rightly remarked in his *Toothlesse Satyrs* (1597).

The literary argument is naturally the most informative, and it warns us of complications. First, many authors found a way of reconciling artificiality and decorum, by externalizing the latter in the same way as they externalized expression; decorum could easily become an ornament of style, rather than

a principle tacitly acknowledged. Edmund Spenser provides a good example; to his pastoral *The Shepheardes Calendar* (1579) there is an introductory Epistle (signed by 'E.K.') which underlines not only 'his wittinesse in devising . . . his complaints of love so lovely', but also 'his pastoral rudenesse . . . his dewe observing of Decorum everywhere . . . ' . But the decorum consists only in the use of a rude and out-of-date English vocabulary (itself an affectation), and it does not restrain his style, because it *is* style:

> I love thilke lasse, (alas why doe I love?)
> And am forlorne, (alas why am I lorne?)

The true nature of these lines is better characterized by their *Glosse*: 'a pretty Epanorthosis in these two verses, and with all a Paranomasia or playing with the word, where he sayth I love thilke lasse (alas . . .).'

Decorum could also be given a quite restricted meaning. Tasso knew the ancient authorities as well as almost anybody, and therefore wrote at length on this particular point; the result was an interpretation of decorum that separated degrees and kinds of artifice according to different categories of verse (epic, lyric and so on). He applied it to the central problem which, once again, was the perfection of *style*. After all, his observation that French (that is, Gothic) architecture lacked decorum only makes sense if he thought that important buildings such as cathedrals ought to be classical. Decorum is therefore a subjective, not an objective principle for Tasso.

There is an illuminating letter from Bishop Cirillo Franco that illustrates the beginning of another special application of the idea of decorum, this time by the prosecution; and since it introduces the idea that probably had most to do with the eventual decline and disappearance of Mannerism it is worth looking at closely. Bishop Franco, a humanist, and an administrator of some importance in Rome, dispatched the letter to a friend in 1549 expounding ideas that had occurred to him over the previous twenty years; it was widely read and eventually published in 1567. He was talking of those respects in which modern music fell short of the expression and incitement of emotion that characterized the music of antiquity; he saw none of it in his own day, even though it was claimed that music had reached an 'extreme and unprecedented perfection'. Modern music, he declared, was devoted solely to demonstrating skill; the proof was in the modern treatment of the *Kyrie*

in the Mass, which should have been different (because the feeling was different) from that of its other parts, or from hymns or psalms – but they all sounded the same (an interesting observation on the disjunction of form from content, with much truth in it). He ridiculed the use of secular material in liturgical music; the latter should conform to the meaning of its own words, so as to move the listener to piety, *because everything should be appropriate to its subject*. Modern composers put all their effort into fugal devices and interweaving of phrases of the text, and it was only in the *Pavanes* and *Gagliards* that music performed its function, since they forced people to dance. In the middle of this outburst, which he explained was the result of re-reading Plato, he switched easily and naturally to illustrate his point in the visual arts:

> I hold the painting and sculpture of Michelangelo to be a miracle of nature; but I would praise it so much more if, when he wants to show the supremacy of his art in all that posturing of naked limbs, and all those nudes . . . , he did not paint it on the vault of the Pope's Chapel [21], but in a gallery, or some garden loggia.

Bishop Franco was far from isolated; he illustrates what we may call the Resistance to Mannerism (and polyphony) both in general and in the particular context of religious art. His comments recall Pope Marcellus's rebuke (1555) to his choir for their inappropriately hedonistic Passion Week music, and the intention of Pope Adrian VI (1522-3) to destroy the Sistine Ceiling which, says Vasari, he called 'una stufa d'ignudi' (roughly: a *baignade*). Objections to Mannerism in the religious context came swiftly to a head, and one result was the pronouncement of the Council of Trent, in 1564, in which religious, humanistic and, surely, aesthetic purposes were all fused in the condemnation of 'superfluous elegance' in paintings in churches.

Mannerism in religious art is a double offence against the classical concept of decorum. First, it is art that does not primarily express the subject; as Bishop Franco observed no expressive differentiation, but uniformity, in the different sections of the contemporary polyphonic Mass, so we might say, with only a little exaggeration, that altarpieces are all treated in a very similar way, irrespective of their subject matter [50, 91]. Second, Mannerism so often leads to exhibitions of nudity and artifice that are not only superfluous, in the functional sense, but also contrary in effect to what is proper to their position. This offence is admirably described

92. *Cosimo I*. Benvenuto Cellini

in an indignant letter of 1549 that records the unveiling 'of the ugly and filthy figures in the Duomo in Florence made by Bandinelli, which were an Adam and Eve [both nude, incidentally] which were severely censured by the whole city, and not only they but also the Duke Cosimo for setting up such things in a Duomo on an altar where the Blessed Sacrament is placed ... ' . The writer goes on, revealingly, to attack Michelangelo, 'the inventor of obscenities, who cultivates art at the expense of devotion'.

It is perhaps because the lack of decorum is doubly objectionable in religious art that Mannerism becomes effete in religious works long before it does in secular ones. A change in style in religious art became apparent around the decade 1560–70. Thus Bronzino's last altarpiece, in S. Maria Novella, has in relation to his earlier ones a striking sobriety, simplicity of form, sombre and more realistic colour, and a mood unmistakably pious. Borghini, very much a man of the Counter Reformation, approved of this development, which he interpreted as Bronzino's effort to clear himself of the reputation of sensuality that his earlier works had gained him [53].

It makes sense on one level to differentiate Mannerism's fitness to purpose in religious art from that which it has in secular art. And so in general the style continues with undiminished vigour and conviction in secular and especially decorative works in Italy until about 1600, and in the Northern courts (especially Paris, Munich and Prague) until about 1620 [14]. Then again, it makes sense that the rather limited fitness of Mannerism to figurative or illustrative art of all kinds should have been distinguished from its fitness to purely decorative objects; and this perhaps explains the persistence of Mannerist conventions long after 1620 in metalwork, masques or grottoes, for example, where its qualities may be displayed with perfect decorum. It is rather the same natural development by which polyphony, in general disrepute in vocal music by about 1600, continues thereafter in instrumental music.

5

Mannerism in the History of Art

There is as little necessity as excuse for an explanation of Mannerism in terms of tension or collective neurosis. It was, on the contrary, the confident assertion of the artist's right, which he seemed to have regained in the High Renaissance, to make something that was first and last a work of art; and as we have just seen, there were enough related aesthetic convictions asserted with confidence in Mannerism's own cultural context to suggest to us that what was done was thought to be absolutely the right thing to do. Nothing forces us to make the effort of understanding; but reason should at least prevent us from dressing up the wicked fairy of art-history in non-period corset and costume to make her more attractive to our eyes.

Mannerism is a style of excess, since its underlying convictions are almost all extreme degrees of those that in moderate degrees are common in other periods; as such it could only flourish in an atmosphere of self-assurance. And one reason for this assurance was the conviction that artists were – so far from being in reaction against anything – in the main stream of advancing perfection that was apparent, in retrospect, in the Renaissance. There was, certainly, a resistance to Mannerism (and to *Bembismo* in literature, or polyphony in music) from a circle of moderate (and in this sense classical) critics whose persistent pleas for restraint formed one half, as it were, of a continuous dialogue. But, as in a dialogue, it would clearly be wrong to identify opposition with lack of confidence.

This confidence is beautifully illustrated by a text which, in the abstract, would seem to provide the perfect test case. It is a humanist's dedication to an arch-Mannerist of a new edition of the primary codification of early Renaissance theory; the humanist is Lodovico Domenichi, the Mannerist is Francesco Salviati, the book is Alberti's *Della Pittura* (1435), and the date of the dedication is 1548. Domenichi is at first a little apologetic:

Not that any precepts to be found in such a work will be a surprise ... to you; for the marvellous artistic creations from your hand remove all doubt of that – and especially the Hall of His Excellency [89, 90], where soon we shall see finished the *Triumphs of Camillus*, which will testify to your qualities And although in this book your level of accomplishment is not to be found, you may however humbly rejoice, seeing in that accomplishment the conclusion that the author [Alberti] perhaps could not reach himself. And similarly you will recognize the gifts granted you by nature and polished by art.

It was Vasari, however, who became Mannerism's most eloquent exponent. The Preface to the Third Part of the *Lives* (1550) deserves to be read and re-read for his assessments of Renaissance achievements; they are very different from ours, and perhaps no more objective, but they are brilliantly interpretative, sympathetic and hedonistic. In the compressed version that follows the reader will recognize several of the critical terms examined in the last chapter, and a slant on the High Renaissance as significant for the understanding of Mannerism in what it omits as in what it emphasizes.

Vasari is reflecting on the stage in perfection regained by the artists mentioned in his Second Part, beginning roughly with Masaccio and Brunelleschi; they had, to some extent, he thought, added the qualities of rule, order, measure, creative capacity (*disegno*) and style (*maniera*). But in their rule there was lacking a certain licence; their order lacked an abundant invention in every respect, and a certain beauty pursued down to the last detail which reveals that order with more adornment; in measure there was lacking correct judgement, and a grace that goes beyond measurement; in creative capacity there was not a graceful and fluid facility; and in style there was not enough delicacy in making all figures svelte and graceful. He also missed in that period the variety of many bizarre inventions, and the beauties of colour. He exemplifies this dryness of style, still limited by difficulties in achievement, by Verrocchio; the renewed study of antiques was, he says, one of the springboards out of the fifteenth century into the sixteenth.

Vasari sees an end to this poverty with Leonardo, who had 'good rule, better order, correct measure, perfect creative capacity, and divine grace,' and was most abundant in artistic riches with a profound knowledge of art. Leonardo was followed by Giorgione, Raphael, Andrea del Sarto, and so on; Vasari appreciates in Raphael above all his selection of the

ideal, his facility of invention, his variety and his grace [25, 26]. He praises Correggio's lightness and grace as if he were really describing Parmigianino, but he thought that the latter [1, 30] had still more grace and adornments, and a most beautiful style. In Polidoro he sees 'attitudes that seem beyond the bounds of possibility ... one wonders how it can be possible, not to describe with the tongue, which is easy, but with the brush, the tremendous conceptions which were put into execution with such mastery and dexterity, in representing the deeds of the Romans exactly as they were' [27]. And finally he comes to the peroration, in which he praises Michelangelo's perfect grace and conquest of all difficulties in all the arts as the triumph even over antiquity. Vasari's own painting [93], one may assume, is meant to carry on the good work.

93. *Perseus and Andromeda*. Giorgio Vasari

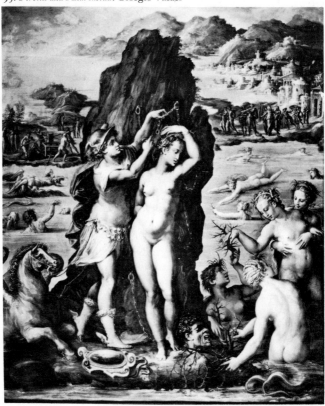

The confidence, even over-confidence, of Mannerism also appears if we consider the relation of this style to nature. The term *maniera*, stylishness, implies a departure from naturalness whether we use it of human behaviour or of works of art; and the opposition of style and nature has always obsessed the critics of Mannerism. One of the most influential of the really rude criticisms came from that ardent classicist Bellori, significantly in a *Life of Annibale Carracci* (1672); he was discussing the decline, as he saw it, in the sixteenth century when 'the artists, abandoning the study of nature, poisoned art with *maniera*, that is to say a fantastic ideal based on knack rather than imitation' (of nature). Bellori was not, in fact, very inventive (his approach was remarkably anticipated in musical theory by the Platonic anti-polyphonists of the sixteenth century), and moreover he distorted the problem. To read any sixteenth-century theorist is to realize that the study of nature was then considered as necessary a part of an artist's *education* as it has been in any other period in the history of art. The counterpart of the theory appears in drawings of the Mannerists; Parmigianino, for instance, made a celebrated study of a dead mouse that is style-less in its objectivity, and the equal in naturalism of any animal drawing by Dürer. Naturalism does not appear in the public utterances of Mannerist artists because they believed it was the business of art to improve upon nature, not because they were incapable of seeing nature. The same contrast appears in sixteenth-century literature; Bernardo Tasso, for example, makes his professional products intensely and artificially stylized, yet in private letters could evoke with directness and even passion the beauties of his beloved Sorrento.

It does not, in the end, help our understanding of Mannerism if we over-conceptualize, by shaping it in our minds with a false homogeneity, or rigidity, or with profiles so sharp that they insulate it from the past and the future. The capacity of artists to manipulate for their own ends forms invented in a different spirit is one of the facts of life that helps to explain how Mannerism grew out of the earlier Renaissance. Then, in turn, Mannerist forms were re-used as Mannerism was dying by artists whose passion and sensuousness essentially distinguished them. El Greco is one very obvious case [10], and Bellange [11] is another. In the same way it would be absurd to question the genuineness of feeling of Robert Southwell, part of whose *St Peter's Complaint* was quoted in the last

chapter, and yet that feeling was expressed, or perhaps petri-
fied, in abstract stylizations of the most extreme kind. It
would be as much an oversimplification to deny the possible
combination of affectation and warmth of emotion in works of
art as in human beings; they are merely qualities that are
mutually inhibiting, and in combination they can produce
results of peculiar piquancy. The madrigals of Carlo Gesualdo,
Prince of Venosa, fascinate us for this very reason – because
they tremble, as it were, on the brink of one or the other
commitment.

Like all phases in the history of art, Mannerism is connected,
however indirectly, with those that precede and follow it. The
continuity in Mannerism of some of the tendencies of the
Renaissance has been repeatedly mentioned. Just as certainly,
but just as partially, there are continuities from Gothic art.
Readers of the *Gothic* volume in this series will be struck by the
re-emergence in the sixteenth century, in a new disguise, of
earlier tendencies towards refinement and preciosity, and it is
not obvious how these are to be reconciled with the general
agreement in the Mannerist period that Gothic art was un-
speakable. But what Raphael, or Vasari, or Tasso despised
was Gothic *style*, and the stylistic clothing of Mannerism is not,
of course, Gothic but Renaissance in origin.

The connexions that are real between Gothic and Mannerist
art depend upon the extent to which both were courtly. Man-
nerism was not, in fact, by any means exclusively a court art;
Parmigianino's work in Parma in the 1530s [1] was very
little connected with courts, and the Schools of Haarlem and
Utrecht [7, 13] were further exceptions. Mannerism is better
described as art for connoisseurs than as art for courts. Most of
the former, however, were to be found in or around the latter,
and this is a fact of social history in the sixteenth century that
certainly had an effective, if long-range, influence upon the
course of Mannerism. Another important development in
social history is the transformation into courtly centres of the
vital, fashion-setting artistic centres of Florence and Rome. In
neither case was this transformation sudden; but it was during
the pontificates of Julius II (1503–13) and Leo X (1513–21) that
the papacy assumed the manners of a principality; and
Florence, which had been a theoretical oligarchy in the fif-
teenth century, and was in fact a republic from 1494, became
in effect a Medici principality in 1512, the capital of a Duchy in
1530, and of a Grand Duchy in 1567. In Florence, especially,

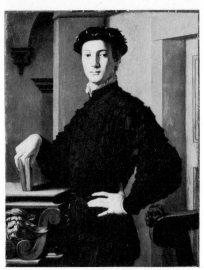

94. *Portrait of a Youth*. Bronzino .

the new court led to a new and therefore artificial aristocracy, and very artificial is the poise of the courtiers that Bronzino reveals to us [94]. This is certainly one instance in which style and subject coalesce in Mannerism with perfect decorum.

The trend-setting centres of Mannerist art coincide with the courts: Rome, Florence, Mantua, Fontainebleau, Munich and Prague. Venice does not belong with these, either socially or artistically. It is impossible to disentangle the extent to which courts influence style from the extent to which courts patronize a congenial style with an independent existence; but however the equation is composed there is no doubt of its reality. It is this link with the courts that accounts for the continuity in Mannerism of Gothic preciosities across the sometimes complete antipathy of style. It is significant, for example, that metalwork [87, 96[was as important an art-form in Mannerism as it had been in Gothic, whereas its role had been much diminished in the Renaissance. Mannerist 'wetting sports' have their origin in the late-Gothic Burgundian Court. The elegant stylizations of Mannerist literature are related not only to the classicizing tendencies of *Bembismo*, but also to the courtly forms of the fifteenth century: the Petrarchism established long before Bembo, the contorted word-play of the sonnets of Serafino dell'Aquila, or the self-conscious

artificiality of the *Rhétoriqueurs* in France. A detailed history of the development of Mannerist style would have to pay close attention to the period in Leonardo's career (1483–1500) when he was the court artist of Lodovico Sforza in Milan, busy with masques and automata. It is more than likely that the influential grace of his painting style after 1500 was connected with this courtly experience.

Mannerism was also directly inspired, across both Gothic and Renaissance, by antiquity itself. The ambiguity of this connexion has already been sufficiently stressed; now it is perhaps more interesting to wonder, not how antique was Mannerism, but how Mannerist was antiquity, or how much did it seem to be so? In the sixteenth century the science of archaeology was born, and artists (including Raphael, Pirro Ligorio, Palladio and Dupérac) did much of the groundwork. They were fascinated by the apparently infinite variety of antiquity, especially Roman antiquity and this, certainly, was a reflection of a predisposition of their own; but it was also a truer reflection of the real antiquity than we now normally allow. Roman art, above all, was full of irrationalities, eccentricities and irregularities. For example, in the decoration of the base of Cellini's *Perseus* [95] one meets strange forms that change their nature from architectural at one end to vegetable, or animal, at the other; and this 'irrational' freedom is, certainly, to be found in Roman ornament. There is no limit to the peculiarities of antique metalwork. The result of a predisposition to varieties of this kind is, in an extreme form, the architecture of the antiquarian Pirro Ligorio himself [79]; the licence in such free associations of antique forms is a feature of the sarcophagi from which many of them come. And then, to turn to other qualities of Mannerism – its refinement, elegance and grace – the sixteenth-century artist had every excuse for supposing that in his pursuit of them he was following a process begun in antiquity, and only interrupted by the dark ages; for as he read Vitruvius, for example, he would have found the development of the orders of architecture described in exactly these terms.

If we turn next to consider the relation of Mannerism to succeeding styles, the first to consider is that which grew up in Italy in response to the Counter-Reformation. There was, as we have seen, a natural antipathy between Mannerism and the Counter-Reformation, and the religious resistance to Mannerism was in fact well established before the decrees of

the Council of Trent (those on art came in the final session, 1564). The situation is far from simple. It is obvious, for example, that anti-Mannerist writers such as Gilio (1564) and Borghini (1584) took a view that was not only aesthetic, but humanistic and religious as well. But on the other hand it is probable that the Cardinals who formulated the decrees of Trent had as many different motives, if not in the same proportion, since so many of them were art-patrons and humanists. The artists who responded to their injunctions (' . . . all sensuality shall be forbidden . . . images shall not be painted nor adorned with excessive elegance . . . there shall be nothing dishonest or profane . . .') may well have thought that they made sense aesthetically, as well as in terms of function. Thus a new programme for religious art may have seemed, even from the purely artistic point of view, a welcome escape-route from what was becoming ever more clearly a dead end.

Bronzino changed direction accordingly in his last altar-piece, as we have seen; but artists of his generation, now set in their ways, changed much less readily than those who, in the decade 1560–70, were still young. Among these there were some who changed almost beyond recognition; for example, Santi di Tito, a pupil of Bronzino, painted about 1561 a set of frescoes in the Vatican that are extravagantly Mannerist (rather in the style of Salviati, but not as good), whereas his altarpiece of 1600, the *Vision of St Thomas Aquinas* (S. Maria Novella, Florence) is direct, intelligible and moving. There are a number of artists of this kind, in Rome, Florence, and elsewhere, the greatest of whom was unquestionably Federico Barocci of Urbino, a painter greatly admired by St Philip Neri. Barocci also began his long career, about 1555, firmly under the spell of Mannerism and ended it, in the first years of the seventeenth century, with a style disconcertingly like those of Rubens and Van Dyck. His *Deposition* [51] in Perugia of 1569, one of the finest altarpieces of the century, is full of passion and tenderness, animated by light and gesture, rich in colour and atmosphere, and in almost every respect it differs from Salviati's treatment of the same theme [50]; above all it communicates an emotion specific to its subject, as do all Barocci's mature paintings, and that is the origin of their variety.

Nevertheless the artists did not create in 'Counter-Mannerism' a wholly new style in the way that Caravaggio and Annibale Carracci were to do in the last decade of the century; it seems that, once trained in Mannerism, they could never

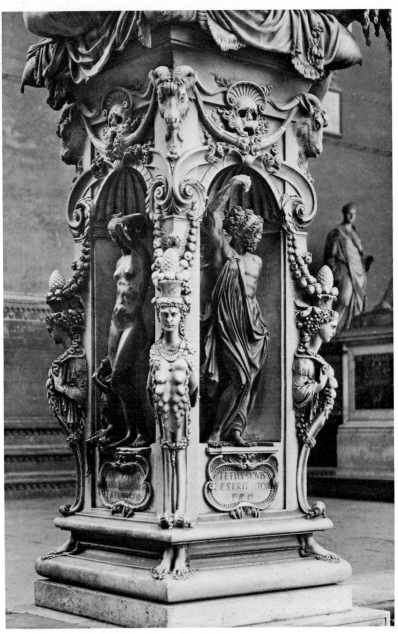

95. Base of the *Perseus* Statue. Benvenuto Cellini

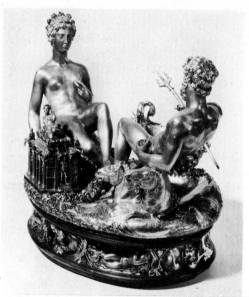

96. Salt-cellar. Benvenuto Cellini

entirely lose that touch of elegance and that beguiling preciosity which are still very evident in Barocci's *Deposition*. And in general this group of artists looked, for their new directness and naturalness, less to nature itself than to Venice or back to the High Renaissance – or rather to that part of the High Renaissance to which Mannerism had been blind.

There was certainly no clean break between Mannerism and Baroque, in spite of the obviously contrasting ideals of the two periods. There was, on the contrary, a strong element of continuity for the rather obvious reason that Baroque freedom was largely derived from Mannerist licence; and in fact there appears to have been growing tolerance of Mannerism as Baroque matured as a style. Some element of reaction may be real in, say, Annibale Carracci (but even in his case, not consistently), whereas it is non-existent in Pietro da Cortona and Borromini. In rather the same way we find in musical theory that the purist, anti-hedonist views of the Florentine Camerata group (Vincenzo Galilei, Bardi, Peri, Caccini and others, all following the theories of the humanist Girolamo Mei) were in conscious opposition to polyphony of all kinds, and especially to madrigals; but this situation, right at the end of the

sixteenth century, was then followed by the greater tolerance of the early-seventeenth-century theorist Giovanni Battista Doni, and by Monteverdi's new and stimulating synthesis of the expressive with the decorative.

Monteverdi exemplifies the qualities of the early Baroque style almost as well as Rubens (whom he must have known when they were both in service at the Mantuan court). In each case the expressive element in their style is based upon a rediscovery of the dynamism and sensuousness excluded by the aesthetic code characterized by *maniera*. The electrifying changes of pace and the vivid exploitation of *piano* and *forte* in the Vespers of 1610 are similar in effect to the dramatic movement and light in Rubens's work in Italy (1600–8). Musician and painter draw more directly upon sense experience than any Mannerist. There are similar changes in the development of landscape-painting. In the latter half of the sixteenth century we find a type of landscape that may with some justification be called Mannerist. This was the painting of Paul Bril [97], Coninxloo and the Frankenthal school: an abstracted, idealized, reconstructed view of the world in which natural forms – trees or ground-planes – are wilfully shaped with a sinuous grace like that of a *Madonna* by Parmigianino, and coloured just as artificially. Not a leaf stirs. In the early seventeenth century it was the wind, the passage of light, the qualities of change and growth and contrast in nature that

97. *Ideal Landscape*. Paul Bril

came to be described, often (as at first with Rubens) within conventions that survived from the Mannerist period. In poetry, too, it was a new sensuousness that distinguished a new period, even when – as in the case of Marino – there remained from the sixteenth century a high degree of artificiality.

The element of continuity in the relationship of Mannerism and Baroque can be illustrated ad nauseam. In brief: there are very late studies by Buontalenti, around 1605, for the architecture and tombs of the Chapel of the Medici Princes that convert his earlier scenographic interests into a true dramatization and his earlier fantasy of detail into a kind of formal freedom that combines wilfulness with energy. Like Tasso (his friend), Buontalenti is an artist who participates in the transition. And on the other side there is Rubens's evident enthusiasm for Polidoro da Caravaggio, or the predominantly Mannerist forms of the house he built for himself in Antwerp; and there is Borromini's extravagantly Baroque but at the same time Neo-Mannerist decorative licence, which is illuminated by the drawings he made after, for example, the capricious Hell's Mouth door of Palazzo Zuccari in Rome. One of the most typical of all Baroque inventions was in fact made by a Mannerist artist; the famous 'opera-boxes' from which members of the Cornaro family seem perpetually to watch the altar in the chapel that Bernini built and decorated for them in Rome were directly derived from those painted almost a hundred years earlier by Pellegrino Tibaldi in the Poggi Chapel in San Giacomo Maggiore, Bologna.

It was, however, in the eighteenth century that there occurred a resurrection of the spirit of Mannerism, not just of its bodily forms. In Rococo decoration, or furniture, there was

98. Table. Vignola

100. Page from the *Farnese Hours*. Giulio Clovio

a direct revival of the most extravagant grotesque-work of the sixteenth century; and decoration lost once more the qualities of energy and structure as its function returned to giving pure delight, to simply being beautiful. There is a very striking similarity between Rococo chinoiserie and the lightest of the fantasies of Wendel Dietterlin, or some later sixteenth-century title-pages (such as that of John Florio's *World of Wordes*, 1598). A renewed interest in the strange, distorted and monstrous side of Mannerism was shown by early Romantic artists such as Fuseli and Romney, and surely something of its elegance and attenuated grace returned with Giovanni Battista Tiepolo and the Sicilian sculptor Giacomo Serpotta. Above all it is hard not to suspect a direct link between Parmigianino's brand of Mannerism and Bavarian late Baroque sculpture, such as Ignaz Günther's – a link that seems to be present in emotional as well as formal aspects of style. Parmigianino's gestures and physiognomic expression [1] may come near to describing ecstasy but they seem equally redolent of affectation, and surely it was the formal rather than the emotional grace in which he was primarily interested. Yet such is the ambivalence of all means of expression that Bernini needed to make only the slightest adjustment of essentially the same means as Parmigianino's to turn them towards ecstasy and rapture, particularly in the Angels with the Symbols of the Passion now in Sant'Andrea delle Fratte, Rome. But with Günther it seems that by another slight shift of emphasis a situation was reached nearer Parmigianino's once more, exactly mid-way between spiritually and aesthetically expressive grace. In this proportion, as every visitor to a Bavarian pilgrimage church knows, beauty – blatant to the point of preciosity – is a powerful stumulus to piety, whatever doubts may have been entertained at the Council of Trent.

In a much wider view also, many of the features of the Mannerist period came to stay. The notion of the 'absolute work of art', with no other function to perform than that of being a work of art, has become so generally accepted that we now take it for granted. Paintings and sculpture continued to be made to take their place in galleries, and to compete in *virtù* with Old Masters and antiques. The probable reason why this kind of patronage ceased to provoke such demonstrative virtuosity was that the artists learnt, in time, to live on easier terms with it. When the 'divine right of artists' became normal it also became, as a notion, less heady.

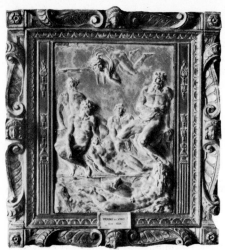

101. *The Story of Count Ugolino.* Pierino da Vinci

In this way Mannerism left a permanent mark on the history of art. Some of its most typical art-forms – the staircase, for instance, or the *pastorale* – remained just as conspicuous through the seventeenth and eighteenth centuries. And the premium that in Mannerism was placed upon fecundity of invention, in contrast to a relative inhibition in Renaissance art, has scarcely, if at all, been diminished since; fantasy has in general been respectable, but it has normally been less indiscriminately released than in Mannerism, and controlled by a sense of its fitness to certain purposes and not others.

Mannerism is a vulnerable style. Every conviction upon which it was based is easily reversible – the idea that complexity, prolixity, and unreasonable caprice are beautiful, or that virtuosity is something to be cultivated and exhibited, or that art should be demonstratively artificial. To a succeeding period with different views Mannerism seemed simply decadent. Just as a stylish person is asking for trouble if he moves out of his environment, so a Mannerist work of art invites ridicule when set among alien standards. It is difficult to think of a period more alien to Mannerism than the first half of the twentieth century (which is, perhaps, why Mannerism has not been approached straightforwardly, on its own terms, but deviously). We have survived an age of functionalism which, even if we may not care to admit it, was based upon premisses

just as irrational as the sixteenth-century conviction that non-functional decoration had a perfect right to exist, provided only that it was beautiful.

In Speroni's *Sopra Virgilio*, let us recall, there was an enthusiastic comparison, redolent of the whole Mannerist point of view, between the ample adornment of Homer's poetry, Hellenistic sculpture and the Corinthian style in architecture. In this sense Mannerism was a Corinthian period: its forms were slender, graceful, unashamedly and beautifully decorated. The point of view of our century has been well put by Le Corbusier (*Towards a New Architecture*): 'The Doric state of mind and the Corinthian are two different things. A moral fact creates a gulf between them'. Corbusier was right, as an artist, to believe in the superiority of Doric, for great works of art are always based upon ultimately indefensible convictions. But it is a confusion proper *only* to an artist to think of differences between styles as moral ones. For the rest of us the moral issue arises only when intolerance inhibits our enjoyment of all works of art.

Mannerist works of art were made, more assertively perhaps than any others, to be enjoyed. They are the products of an Epicurean society; one, certainly, that was given more to scepticism than to enthusiasm, but with one enthusiasm above all, for artistic beauty. Beauty they desired and cultivated in every imaginable context: in deportment, in hunting or in the theatre, in their tables [98] and in the objects they placed upon them [88, 96], in the music they performed, the books they read and all the works of art around them. Even in their suits of armour [99] they wore something as elegant and intricate

102. Cassone (Venetian?)

as the *Farnese Casket* [78]. In placing the emphasis upon the aesthetic experience they were no less high-minded than men of other periods who have exalted the function or the message of their works of art. Mannerism was, among other things, an extreme manifestation of civilized living.

Only a short while ago seventeenth-century art was under a cloud because it was seriously believed that art should avoid the overt expression of emotion. We have recovered from that inhibition, and now allow ourselves to enjoy Bernini. In the meantime it had not been Bernini that suffered, but ourselves. Every work of art has the right to be judged on its own terms, and the tolerance we now extend to Baroque art should also be extended to Mannerism. It is time that we stopped saying, for instance, 'the trouble with Tasso (or John Lyly) is his artificiality . . . ', trying to read them as if it were not there. History proves adequately that artificiality, and all the other qualities of Mannerism, could, and therefore can, be seen to be legitimate and – once accepted – satisfying sources of beauty. This much being granted, Mannerism requires no special pleading. Certainly it transgresses moderation, unclassically, towards excess, but we need only to emulate the tolerance of the criticism of classical antiquity which was ready to appreciate excess, if and when it was done well and with conviction.

Catalogue of Illustrations

ABBREVIATIONS

Acts of XXth Congress: Acts of the Twentieth International Congress of the History of Art (1961), II: The Renaissance and Mannerism, 1963.

Blunt, 1953: Blunt, A. F., *Art and Architecture in France, 1500–1700*, 1953.

Dhanens, 1956: Dhanens, E., *Jean Boulogne*, 1956.

J.W.C.I.: *Journal of the Warburg and Courtauld Institutes*.

Mitteilungen: *Mitteilungen des Kunsthistorischen Institutes in Florenz*.

Pope-Hennessy, 1963: Pope-Hennessy, J., *Italian High Renaissance and Baroque Sculpture*, 1963.

Vasari, 1968: Vasari, G., *Le Vite de'più eccellenti pittori, scultori, e architettori* (1568), ed. G. Milanesi, 1878–85.

Voss, 1920: Voss, H., *Die Malerei der Spätrenaissance in Rom und Florenz*, 1920.

1. MADONNA DEL COLLO LUNGO. By Parmigianino, 1534–6. Oil on panel, 2·14× 1·33 m. *Florence, Uffizi* (photo: Soprintendenza alle Gallerie).
 From S. Maria d'Servi, Parma. Unfinished, particularly in the background.
 Literature: Freedberg, S. J., *Parmigianino*, 1950, 85, 186; Davitt-Asmus, U., in *Zeitschrift für Kunstgeschichte*, xxxi, 1968, 305.
2. GALERIE FRANÇOIS 1er. By Rosso and assistants. 1534–40. Stucco, partly gilt, fresco, and wood panelling. *Fontainebleau.*
 Lit: Barocchi, P., *Il Rosso Fiorentino*, 1950, 99; Blunt, 1953, 35; Panofsky, E., in *Gazette des Beaux-Arts*, VI/52, 1958, 113.
3. THE DEATH OF ADONIS. After Rosso, 1541–50. Tapestry, 3·30× 6·40 m. *Vienna, Kunsthistorisches Museum* (photo: Bildarchiv d. Öst. National-bibliothek).
 From a set reproducing six sections of the Galerie François 1er. The principal productions of the tapestry-works set up by Francis 1 at Fontainebleau; cartoons by Claude Baudoin, manufacture by Jean and Pierre Le Bries.
 Lit: Göbel, H., *Die Wandteppiche . . . in Frankreich [etc.]*, 1928, 37.
4. WATER-NYMPHS. By Jean Goujon. 1547–9. Stone. *Paris, Louvre* (photo: Giraudon).
 From a set of low-reliefs forming part of the decoration of the Fontaine des Innocents, Paris; further fragments are in the Louvre.
 Lit: Blunt, 1953, 75.
5. MONUMENT TO THE HEART OF HENRI II. By Germain Pilon, 1559–63. Marble, the figures 1·5 m. *Paris, Louvre* (photo: Giraudon).
 From the Church of the Célestins, Paris. The base is by Domenico del Barbiere, the urn above is not the original. The design is derived from one by Raphael for an engraved salt-cellar or incense-burner for Francis 1.
 Lit: Babelon, J., *Germain Pilon*, 1927, 58; Blunt, 1953, 98; Goldberg, V. L., in *J.W.C.I.*, xxix, 1966, 206.

6. CHÂTEAU DE VERNEUL. By Jacques Androuet du Cerceau the Elder. 1565–76. Engraving.

From du Cerceau's *Les plus excellents Bastiments de France*, Vol. 1 (1576); the elevation of a range of buildings, with concave centre-section, to the rear of the château. It is by no means certain that this project, remarkable for the fantasy of its decoration, was in fact executed in this form. Du Cerceau's original drawing is in the British Museum.

7. APOLLO AND MIDAS. By Hendrick Goltzius. Signed. 1590. Engraving, 41·9 × 66·9 cms. *London, British Museum*.

The *modello* is in the Pierpont Morgan Library, New York. The composition is derived from earlier Netherlandish paintings of *St John preaching in the Wilderness*. The satirical treatment of the story (*Metamorphoses* XI) is typical of Goltzius.

Lit: Reznicek, E. K. J., *Die Zeichnungen von Hendrick Goltzius*, 1961, i. 74, 273.

8. PORTRAIT OF A LADY. By Isaac Oliver. Signed. *c*.1595. Miniature, 12·7 cms. *Collection of the Earl of Derby, M.C.*

From the collection of Horace Walpole who identified the sitter (romantically) as Frances Howard, Countess of Essex; she, however, was born too late for the apparent date of this miniature, deduced from the costume. The frame appears to be the original.

9. VENUS, MARS AND CUPID. By Hubert Gerhard. *c*.1590. Bronze, 41·4 cms. *Vienna, Kunsthistorisches Museum*.

Very similar in design to a marble group made by Gerhard for the fountain at Schloss Kirchheim, now in Munich.

10. LAOCOÖN. By El Greco. *c*.1610. Oil on canvas, 1·42 × 1·93 m. *Washington, National Gallery of Art (S. H. Kress Collection)*.

From the Alcázar, Madrid.

Lit: Cook, W. S., in *Gazette des Beaux-Arts*, VI/26, 1944, 260.

11. PIETÀ. By Jacques Bellange. Signed. *c*.1600. Etching, 30·6 × 19·1 cms. *London, British Museum*.

The composition is derived from a lost *Pietà* relief by Michelangelo.

12. APOLLO. By Giovanni Bologna. 1573–5. Bronze, 88 cms. *Florence, Palazzo Vecchio*.

From the *Studiolo* of Francesco de'Medici [85], where it is one of two figures symbolizing Fire.

Lit: Dhanens, 1956, 182; Pope-Hennessy, 1963, i.101, ii.79.

13. THE MARRIAGE OF PELEUS AND THETIS. By Joachim Wtewael. *c*.1610. Pen and brown ink, brown wash, white heightening, 15·6 × 20·6 cms. *London, Courtauld Institute (Witt Collection)*.

A finished study for the painting at Munich; the compositional type was invented by Spranger (*Marriage of Cupid and Psyche*, engraved by Goltzius, 1587).

14. VULCAN AND MAIA. By Bartholomäus Spranger. *c*.1590. Copper, 23 × 18 cms. *Vienna, Kunsthistorisches Museum*.

A pair to Hercules and Omphale, also at Vienna; painted at Prague for Rudolf II. The design was influenced by the pornographic *Poses* of Giulio Romano, engraved as illustrations to the notorious *Sonetti lussuriosi* of Aretino. The figure of Maia is perhaps derived from Giovanni Bologna's *Astronomy* [45], which Spranger would have known at Prague.

Lit: Diez, E., in *Jahrbuch der Kunsthistorischen Sammlungen des Allerhöchsten Kaiserhauses, xxviii*, 1909–10, 117.

15. JOSEPH'S COAT BROUGHT TO JACOB. After Jacopo Pontormo. 1546–53. Tapestry, 5·5 × 2·7 m. *Rome, Palazzo del Quirinale*.

From a series of twenty (of which two more are by Pontormo, the remainder largely by Bronzino), woven for the Sala dei Dugento in the Palazzo Vecchio; they were the first products of Duke Cosimo's tapestry-works, set up in 1546 under the direction of two Flemings, Giovanni Rost and Nicholas Karcher. According to Vasari, Pontormo's cartoons were ill received on all sides; like all his later work, they show a compromise, perhaps awkward, between his innate expressiveness and the current of Mannerism. The borders were designed by Bronzino.

Lit: Viale, M. V., *Arazzi italiani del Cinquecento*, 1961, 22.

16. MEDAL-PORTRAIT OF A LADY. By Alfonso Ruspagiari. *c*.1570. Lead, 7 cms. *London, Victoria and Albert Museum* (photo: Crown Copyright).

Ruspagiari, of Reggio Emilia, was not a prolific medallist, but one of the subtlest; his style is marked by the most delicate low-relief.

Lit: Balletti, A., in *Rassegna d'Arte*, xiv, 1914, 46.

17. ARMOIRE. French. *c*.1553. Walnut, partly painted and gilt, 2·46 m. *New York, Metropolitan Museum* (*Rogers Fund, 1925*).

Made on the occasion of the wedding of Diane de France with Orazio Farnese, Duke of Castro, 1553. The style is related to that of the Burgundian *maître menuisier*, Hugues Sambin.

Lit: Breck, J., in *Metropolitan Bulletin*, 1926, 45.

18. BOWL AND COVER. By Pierre Reymond. Signed. 1544. Limoges enamel, *c*.20 cms. diameter. *London, Victoria and Albert Museum* (photo: Crown Copyright).

The arms are those of Cardinal Sanguin; on the inside of the bowl is the *Rape of Helen*, after an engraving by Enea Vico.

19. STUDIES FOR A FIGURE OF MOSES. By Parmigianino. *c*.1532. Pen, brown ink, brown wash, 21 × 15·3 cms. *New York, Metropolitan Museum* (photo: Fitzwilliam Museum, Cambridge).

Studies for a detail of the vault decorations in S. Maria della Steccata, Parma. On the *verso* are similar studies for a figure of Eve in the same work, Parmigianino's principal project during his second period in Parma. A superb illustration of inventive facility.

Lit: Popham, A. E., *The Drawings of Parmigianino*, 1953, 40, 66.

20. THE BATTLE OF CASCINA. After Michelangelo. 1504-5. Oil on panel, 76·4 × 130·2 cms. *Holkham Hall, The Earl of Leicester*.

This copy, the principal document for the appearance of Michelangelo's lost cartoon, was made in 1542 by Aristotile da Sangallo from an earlier drawing after the cartoon itself, and was dispatched to Francis I; it does not show the whole composition intended by Michelangelo, but only the central, main figure-group.

Lit: Vasari, 1568, vi.433; Wilde, J., in *J.W.C.I.*, vii, 1944, 78.

21. IGNUDO, FROM THE SISTINE CEILING. By Michelangelo. 1511–12. Fresco; the figure slightly over life-size. *Vatican, Sistine Chapel* (photo: Anderson).

The figure is to the left of Jeremiah, in the last section of the ceiling to be painted; the whole work was begun in 1508. The swags of acorns refer to the arms of the patron, Pope Julius II.

Lit: De Tolnay, C., *The Sistine Ceiling*, 1945.

22. THE FLAGELLATION (detail). By Michelangelo. 1516. Red chalk, 23·5 × 23·6 cms. *London, British Museum*.

One of the drawings made by Michelangelo to help Sebastiano del Piombo with his wall-painting in San Pietro in Montorio, Rome (*c*.1521); Michelangelo's final design is lost, but there is a copy of it at Windsor; the composition was there reduced to the central group shown in the London drawing.

Lit: Vasari, 1568, v.568; Wilde, J., *Italian Drawings in the British Museum*: *Michelangelo and his Studio*, 1953, No. 15.

23. THE RISEN CHRIST. By Michelangelo. 1519–20. Marble, 2·05 m. *Rome, S. Maria sopra Minerva* (photo: Anderson).

Originally commissioned in 1514, this is in fact the second version, the first being left incomplete in 1516 because of a fault in the marble. Finally set up in 1521, in a niche to the left of the high altar, with its own altar in front; while it is not certain that such a setting was foreseen by Michelangelo, the statue is certainly meant to be seen only from the front.

24. TESTA DIVINA (detail). By Michelangelo. *c*.1523. Black chalk, 35·7 × 25·1 cms. *Florence, Uffizi* (photo: Soprintendenza alle Gallerie).

Almost certainly one of the set of 'presentation drawings' given by Michelangelo to a young nobleman, Gherardo Perini; Vasari mentions the acquisition of these drawings by Francesco de'Medici. Michelangelo's authorship is unjustifiably doubted by some modern scholars. The subject is obscure: it may be *Mars, Venus and Cupid*.

Lit: Vasari, 1568, vii.276.

25. SANTA CECILIA (detail). By Raphael. *c*.1515. Oil on panel, transferred to canvas, 2·38 × 1·50 m. *Bologna, Pinacoteca* (photo: Anderson).

From San Giovanni in Monte, Bologna. A first design for the altarpiece, which was engraved, has several differences – for example the Magdalene was at first less slender, less statuesque, but emotionally more active than the one finally painted (shown in the detail here reproduced).

26. SAINT MICHAEL. By Raphael. Signed. 1518. Oil on panel, transferred to canvas, 2·68 × 1·60 m. *Paris, Louvre* (photo: Agraci).

Painted as a present from Pope Leo x to Francis 1; one of the very few wholly autograph late works by Raphael. Severely damaged by repeated restorations.

27. PERSEUS WITH THE HEAD OF MEDUSA. After Polidoro da Caravaggio. *c*.1525. Pen and brown ink, brown wash, 22 × 42 cms. *Paris, Louvre*.

An accurate, early copy of a section of the façade-paintings of Palazzo del Bufalo, Rome, executed by Polidoro and his colleague Maturino in grisaille; the remains of the original frescoes, including this section, have been transferred to the Museo di Roma.

Lit: Kultzen, R., in *Mitteilungen*, ix/2, 1960, 99.

28. MARTYRDOM OF THE TEN THOUSAND. By Perino del Vaga. 1522–3. Pen and brown ink, brown wash, white heightening, 36·3 × 34 cms. *Vienna, Albertina*.

The *modello* for a fresco in the church of the Camaldoli, Florence; the cartoon (described by Vasari) was made during Perino's brief stay in Florence; the arrival of the plague in Florence prevented its realization in fresco. A drawing by Pontormo in Hamburg was either made in competition with Perino for the same site, or for a companion fresco.

Lit: Vasari, 1568, v.607; Popham, A. E., in *Burlington Magazine*, lxxxvi, 1945, 59; Davidson, B., in *Master Drawings*, i/4, 1963, 19.

29. VERTUMNUS AND POMONA. After Perino del Vaga. 1527. Engraving. *London, British Museum*.

Perino's drawing is in the British Museum; it was made for a set of fifteen *Loves of the Gods* to be engraved (in reverse) by Caraglio. The print here reproduced is a later version of Caraglio's, in the same direction as Perino's drawing. It may be noted that, according to Vasari, Perino's genial, hedonistic and lightly erotic designs were made in the humiliating months after the Sack of Rome; those theories of Mannerism that seek to explain the style by such catastrophes should be referred to this ideal test-case. See the note on [32] below.

Lit: Vasari, 1568, v.611; Davidson, B., in *Master Drawings*, i/4, 1963, 23.

30. THE MARRIAGE OF ST CATHERINE. By Parmigianino. *c.*1526. Oil on panel, 64 × 56 cms. *Private collection* (photo: Royal Academy).
From the Borghese Collection, Rome.
Lit: Freedberg, S. J., *Parmigianino*, 1950, 69, 172.

31. DEAD CHRIST WITH ANGELS. By Rosso. Signed. *c.*1526. Oil on panel, 133 × 104 cms. *Boston, Museum of Fine Arts* (photo: by courtesy of Museum of Fine Arts, Boston).
Painted in Rome for Bishop Tornabuoni; later in the collection of Giovanni della Casa (author of *Il Galatheo*). Then lost to view until its recent discovery in Spain. The torches are symbols of everlasting life, and at the same time give the sarcophagus the appearance of an altar; the nails, and vinegar-sponge, are on the step below. The figure-design is much influenced by Michelangelo's *Ignudi* and *Prophets* on the Sistine Ceiling, and by the antique.
Lit: Vasari, 1568, v.162; Shearman, J., in *Boston Museum Bulletin*, lxiv, 1966, 148.

32. SATURN AND PHILYRA. After Rosso. *c.*1526–7. Engraving. *London, British Museum*.
From the set of the *Loves of the Gods* (see note to [29]) engraved by Caraglio, to which Rosso also contributed a *Pluto and Proserpine*; Rosso's designs must have been made just before the Sack of 1527, and it was presumably he who began the set, which was completed after the Sack and Rosso's flight by Perino.

33. JUNO. After Rosso. *c.*1526. Engraving. *London, British Museum*.
From the set of twenty *Gods and Goddesses* engraved by Caraglio after designs by Rosso (of which one, for *Bacchus*, survives at Besançon); *Saturn* is signed and dated 1526. The print reproduced is the second, retouched state.

34. MARS AND VENUS. By Rosso. 1530. Pen and black ink, grey wash, white heightening, on purple-brown paper, 42·6 × 33·6 cms. *Paris, Louvre* (photo: Giraudon).
Made in Venice, according to Vasari, for Pietro Aretino; later engraved in France. Its authenticity is frequently, but unjustifiably, doubted; critics are not prepared for its very peculiar, very original, graphic style, which is to be explained by Rosso's study of Etruscan engravings on bronze, which he must have seen during the years 1527–30 spent in and around Arezzo, and which he presumably thought represented Roman draughtsmanship.
Lit: Vasari, 1568, v.167; Adhémar, J., in *J.W.C.I.*, xvii, 1954, 311.

35. THE MEDICI CHAPEL. By Michelangelo. 1520–34. Pietra serena, marble and stucco. *Florence, San Lorenzo*.
The chapel, sometimes called the New Sacristy, was originally projected in 1519 as a pair to Brunelleschi's Old Sacristy on the opposite side of the

church, a hundred years earlier; Michelangelo's final design for the main architectural parts, taller than Brunelleschi's but in some respects related, was made in 1520, and building began in 1521. The tomb shown is that of Giuliano de'Medici, Duke of Nemours (d. 1516); the figures on the sarcophagus are *Night* and *Day*. Two further reclining figures, River-Gods, were intended for the plinths below (a model for one is in the Accademia, Florence); standing figures, perhaps the Elements, were intended for the niches either side of the Duke. A matching tomb of Lorenzo de'Medici, Duke of Urbino (d. 1519), is on the opposite wall. A double tomb, for Lorenzo the Magnificent and his brother Giuliano, was intended for the entrance wall, opposite the altar; of this, the *Madonna* was made, but left unfinished by Michelangelo, and two *Saints* were carved by assistants, but the remaining figures and the architecture of the tomb were not executed. Except for a few details, work on the project ceased with Michelangelo's final departure from Florence in 1534.

Lit: Wilde, J., in *J.W.C.I.*, xviii, 1955, 54; Ackerman, J. S., *The Architecture of Michelangelo*, 1961, i. 21, ii.22; Pope-Hennessy, 1963, i.14, ii.28.

36. THE MEDICI CHAPEL (detail). By Michelangelo. 1520–34. Marble and pietra serena. *Florence, San Lorenzo* (photo: Alinari).
See the previous note.

37. THE LAURENTIAN LIBRARY VESTIBULE. By Michelangelo. 1523–34. Pietra serena and stucco. *Florence, San Lorenzo* (photo: Anderson).
The commission, December 1523, was one of the first acts of the second Medici Pope, Clement VII, after his election; erection of the main reading-room began in the next year, that of the vestibule in 1525. When Michelangelo left for Rome in 1534 he left behind pieces for the staircase; some of these were used in its eventual erection, supervised by Ammanati in consultation with Michelangelo, in 1559. In principle, if not in detail, this staircase must be similar to the one projected in the first phase of the work. Through the door at the head of the stairs the reading-room may be seen.
Lit: Wittkower, R., in *Art Bulletin*, xvi, 1934, 123; Ackerman, J. S., *The Architecture of Michelangelo*, 1961, i.33, ii.33.

38. PALAZZO BRANCONIO DELL'AQUILA. By Raphael. 1519–20. Drawing by G. A. Dosio, *c.*1570. Pen and brown ink, brown wash, 23·5 × 32·6 cms. *Florence, Uffizi* (photo: Soprintendenza alle Gallerie).
Erected for Giovanni Battista dell'Aquila on a site now occupied by Bernini's colonnade of St Peter's. The façade was dated 1520. The drawing has been attributed to Parmigianino, which is clearly wrong; it appears to be a characteristic work of Dosio.
Lit: Lotz, W., in *Acts of XXth Congress*, 241.

39. PALAZZO NEGRONE (detail). Attributed to G. B. Castello. *c.*1560. Stone, stucco and fresco. *Genoa, Via Carlo Felice* (photo:Alinari).

40. SANTA MARIA DI LORETO. By Antonio da Sangallo the Younger, *c.*1514, and Giacomo del Duca, 1573–77. Travertine and brick. *Rome, Piazza Foro Traiano* (photo: Gabinetto Fotografico Nazionale).
A striking contrast in styles – between Sangallo's simpler, High Renaissance classicism, and the late Mannerism of del Duca, chiefly derived from Michelangelo's contributions to St Peter's. The double-shell dome is, from the outside, like a reduced version of Michelangelo's, with the forms pressed more tightly together.
Lit: Benedetti, S., *Santa Maria di Loreto*, 1968.

41. VICTORY. By Michelangelo. *c.*1527–8. Marble, 2·61 m. *Florence, Palazzo Vecchio, Gran Salone* (photo: Brogi).

From Casa Buonarroti, presented to Grand Duke Cosimo I by Michelangelo's nephew in 1565, and set up by Vasari in the Gran Salone (the present niche dates from 1920). Made for the lower zone of the tomb of Julius II, where it was to be flanked by two of the unfinished *Slaves* now in the Accademia, Florence. The youth is crowned with a wreath of oak-leaves, referring to the Pope's family arms; the group therefore symbolizes a triumph personal to the Pope, probably political. Unfinished parts include the lower figure and the head of the youth.

Lit: Wilde, J., *Michelangelo's Victory*, 1954; Pope-Hennessy, 1963, i.34.

42. DISCOBOLOS. Roman copy of Greek bronze original by Myron, *c.*450 B.C. Marble, 1·3 m. *Rome, Museo Nazionale delle Terme* (photo: Anderson).

Although versions of this sculpture were known to sixteenth-century artists, including apparently Michelangelo at the time of the Sistine Ceiling, it should be pointed out that they were fragmentary and not then identified with the figure described by Lucian and Quintilian. This version came from Castelporziano, 1906.

Lit: Rizzo, G. E., in *Bollettino d'Arte*, 1907, 3.

43. SAINT ANDREW. By Francesco Salviati. 1551. Fresco. *Rome, Oratorio di San Giovanni Decollato* (photo: Gabinetto Fotografico Nazionale).

The decoration of the Oratorio constitutes one of the major Mannerist fresco-cycles in Rome; there are eight narrative scenes (of which Salviati painted the *Visitation*, 1538, and the *Birth of the Baptist*, 1551); the *Saint Andrew* is to the left of the altar-wall, with a *Saint Bartholomew* also by Salviati to the right, flanking the *Deposition* by Jacopino del Conte – to which the Saints turn, like double-bass players sharing a music-stand.

Lit: Hirst, M., in *Studies in Renaissance and Baroque Art presented to Anthony Blunt*, 1967, 34.

44. THE RAPE OF THE SABINE. By Giovanni Bologna. Signed. 1582. Marble, 4·1 m. *Florence, Loggia de'Lanzi* (photo:Alinari).

The statue supplanted Donatello's *Judith* in 1583; a site in the Loggia, the most desirable in Florence, was however foreseen in a letter of 1581. It is uncertain whether it was commissioned; Borghini's account (see text, p.162) suggests that it was not. A collection of laudatory poems was published in 1583.

Lit: Borghini, R., *Il Riposo*, 1584, 72; Dhanens, 1956, 232; Pope-Hennessy, 1963, i.52, ii.82.

45, 46. ASTRONOMY. By Giovanni Bologna. Signed, *c.*1573. Gilt bronze, 39 cms. *Vienna, Kunsthistorisches Museum.*

Lit: Dhanens, 1956, 184.

47, 48. MERCURY. By Giovanni Bologna. Signed. *c.*1576. Bronze, 62·7 cms. *Vienna, Kunsthistorisches Museum.*

One of a number of versions of this famous composition produced 1564–80; of these, the Vienna figure is the most fluent but at the same time the least in motion (the others are somewhat more angular, and seem to represent more positively a running figure).

Lit: Dhanens, 1956, 125.

49. PSYCHE. By Adriaen de Vries. *c.*1593. Bronze, 1·87 m. *Stockholm, Nationalmuseum.*

Made in Rome, with a companion piece (*Mercury and Psyche*) now in the Louvre, for the Kunstkammer of Rudolf II. The subject is Psyche's

successful completion of the third test set by Venus, to collect water from the Styx; de Vries must have studied Raphael's fresco of the same subject in the Farnesina in Rome.

Lit: Strohmer, E. V., in *Nationalmusei Arsbok*, 1947–8, 95.

50. THE DEPOSITION. By Francesco Salviati. *c*.1547. Oil on panel, 4·3 × 2·6 m. *Florence, Museo di S. Croce* (photo: Alinari).

Formerly in the church of S. Croce. The figure top right is an example of Salviati's rather frequent use of the *Discobolos* motif [42]. The frame is original.

Lit: Voss, 1920, i.252.

51. THE DEPOSITION. By Federico Barocci. 1567–9. Oil on canvas, 4·1 × 2·3 m. *Perugia, Cathedral* (photo: Alinari).

Barocci's first great altarpiece.

Lit: Olsen, H., *Federico Barocci*, 1962, 59, 152.

52. ALLEGORY. By Bronzino. *c*.1546. Oil on panel, 146 × 116 cms. *London, National Gallery.*

Almost certainly the picture which, according to Vasari, was painted as a gift from Duke Cosimo I to Francis I (d. 1547). The allegory is (typically) obscure. The two principal figures are identified by doves, golden apple and quiver as Venus and Cupid; the former disarms the latter while seducing him, signifying the triumph of Beauty over Love. On the left Jealousy and Deceit are discomforted, while on the right Folly and Pleasure (with a sting) represent, perhaps, Cupid's experiences. All this is revealed by Time, top right.

Lit: Levey, M., in *Studies in Renaissance and Baroque Art presented to Anthony Blunt*, 1967, 32.

53. CHRIST IN LIMBO. By Bronzino. Signed. 1552. Oil on panel, 4·43 × 2·91 m. *Florence, Museo di S. Croce* (photo: Brogi).

Painted for the Zanchini chapel in S. Croce. This painting gave rise to a revealing difference of opinion between Vasari (1568) and Borghini (1584), illustrating the influence on the latter of the Counter-Reformation. Vasari: Bronzino 'completed the work with the most extreme diligence possible for one who wishes to acquire glory in such a task; whence there are the most beautiful nudes, male and female, children, old men and youths, with varied expressions and postures . . .', including portraits. Borghini was sceptical of Platonic apologists for these beauties, and suspected a sensuality inappropriate to sacred paintings.

Lit: Vasari, 1568, vii.599; Borghini, R., *Il Riposo*, 1584, 187.

54. MAIA: COSTUME DRAWING. After Vasari, 1566. Black chalk, sepia wash, 44 × 29·3 cms. *Florence, Uffizi* (photo: Soprintendenza alle Gallerie).

From a volume of 279 designs for costumes and floats, records of the *Mascherata* of the Genealogy of the Gods (February 1566), invented by Vincenzo Borghini and Vasari as part of the celebrations for the wedding of Francesco de'Medici and Joanna of Austria in Florence, December 1565.

Lit: Baldini, B., *Discorso sopra la Mascherata . . .*, 1566; Seznec, J., *La mascarade des Dieux*, 1935; Petrioli, A. M., Catalogue of *Mostra di disegni Vasariani . . .*, Florence, 1966.

55. INTERMEZZO: APOLLO AND THE DRAGON. By Agostino Carracci after Bernardo Buontalenti. After 1589. Engraving. *London, British Museum.*

One of four engravings of the Intermezzi of 1589, performed in the Teatro Mediceo (also designed by Buontalenti) in the Uffizi, now destroyed; the engravings show multiple stages in the action – as, in this case,

the third intermezzo, the chorus expressing fear of the dragon and the
subsequent appearance of Apollo. Buontalenti's original drawing (with-
out Apollo) is in the Victoria and Albert Museum.

Lit: De'Rossi, B., *Descrizione dell'Apparato e degl'Intermedi* . . . , 1589;
Warburg, A., in *Gesammelte Schriften*, 1932, 259; Nagler, A., *Theatre
Festivals of the Medici*, 1964.

56. INTERMEZZO: HADES. By Epifanio d'Alfiano after Bernardo Buontalenti.
After 1589. Engraving. *London, British Museum*.

The fourth intermezzo; Buontalenti's drawing (without Lucifer) is in the
Louvre.

57. SEA-BATTLE (NAUMACHIA) IN PALAZZO PITTI. By Orazio Scarabelli.
Signed. 1589. Engraving. *London, British Museum*.

The courtyard is seen looking towards the Boboli Gardens; the fountain
and grotto are covered by Buontalenti's temporary structures, including
the Turkish castle. Above is the red canvas awning, or *velarium*, in imita-
tion of antique theatres; it had already been used in the festivities of 1579,
and the courtyard was probably built by Ammanati to be used as an
occasional theatre in this way.

Lit: Silvani, G., 'Vita di Buontalenti', in *Rivista d'Arte*, xiv, 1932, 518;
Baldinucci, F., *Notizie* . . . , 1688, 105.

58. NEPTUNE FOUNTAIN (detail). By Bartolomeo Ammanati and assistants.
1560-75. Bronze and marble. *Florence, Piazza Signoria*.

The reproduction shows one of the four peripheral groups round the
central figure of Neptune, by Ammanati himself; the female figure
('Doris') is attributed to Andrea Calamech, the fauns to Ammanati (*left*)
and Vincenzo de'Rossi (*right*); the 'Doris' is a particularly good example of
a *figura serpentinata*.

Lit: Lensi, A., *Il Palazzo Vecchio*, 1929, 200; Pope-Hennessy, 1963, i.74, ii.73.

59. CERES. By Bartolomeo Ammanati, 1556-63. Marble, 230 cms. *Florence,
Bargello* (photo: Soprintendenza alle Gallerie).

The central, caryatid figure of the fountain intended for the south wall of
the Gran Salone of the Palazzo Vecchio; the whole fountain was an
allegory of the generation of water, in which *Ceres* symbolized Earth.

Lit: Kriegbaum, F., in *Mitteilungen*, iii, 1919-32, 71.

60. PLAN FOR A VILLA SUBURBANA. By Giovanni Antonio Dosio. *c*.1580-90.
Pen and brown ink, sepia, pink, red and olive washes, 30·1 × 43·3 cms.
Florence, Uffizi (photo: Soprintendenza alle Gallerie).

From a group of plans, all for a specific though unidentified site. The
project is partly derived from Raphael's Palazzo Pandolfini in Florence,
and the garden is related to a part of the one designed by Raphael for the
Villa Madama in Rome; at its centre a removable dining table was inten-
ded. The large framed spaces on the façade were to be frescoed, and other
designs show far more elaborate stucco ornaments. A fountain was to go
in the large niche across the oval courtyard. The staircase in this design
begins at the letter F and ends at G.

Lit: Wachler, L., in *Römisches Jahrbuch für Kunstgeschichte*, 1940, 209.

61. VILLA FARNESE DI CAPRAROLA. By Vignola. 1559-73. *Caprarola
(Viterbo)* (photo: Anderson).

Begun *c*.1515 as a fortress by Antonio da Sangallo the Younger, completed
by Vignola as a villa for Cardinal Alessandro Farnese. A fish-pond, placed
by Vignola between the oval ramps, has been removed; the loggia above
the main door was originally open.

Lit: Walcher-Casotti, M., *Il Vignola*, 1960, 71, 156.

62. ALTAR-STEPS. By Bernardo Buontalenti. 1574–6. Stone and marble. *Florence, S. Stefano* (photo: Alinari).

Removed from S. Trinita *c.*1888.

Lit: Bocchi, F., *Bellezze di Firenze*, 1677, 192; Silvani, G., 'Vita di Buontalenti', in *Rivista d'Arte*, xiv, 1932, 510.

63. ARCHITECTURAL STUDIES. By Bernardo Buontalenti. 1574–6. Pen and brown ink, 32·5 × 21·5 cms. *Florence, Uffizi* (photo: Soprintendenza).

The study lower left is for the altar and screen to go above the steps [62] in S. Trinita, closing off the choir. Part, at least, was built – the doors survive in the Opificio delle pietre dure, Florence. The remaining studies are for the decoration of the Baptistery for the baptism of Prince Filippo de'Medici, 1576. The large figures between columns were made in stucco by Ammanati.

Lit: Giovannozzi, V., in *Rivista d'Arte*, xv, 1933, 316; Borsook, E., in *Mitteilungen*, xiii, 1967, 95.

64. OVERMANTEL. By Primaticcio. 1534–7. Stucco and fresco. *Fontainebleau, Chambre de la Reine* (photo: Giraudon).

The centrepiece represents Mars and Venus; the salamander in the framing is the personal device of Francis 1, whose initial is above. The lower part of the fireplace has been heavily restored.

65. FIREPLACE. By Alessandro Vittoria or Bartolomeo Ridolfi, 1552–3. Stucco. *Vicenza, Palazzo Thiene* (photo by courtesy of Banca Popolare di Vicenza).

Palazzo Thiene was built by Palladio *c.*1548–58. The fireplace shown is in one of the ground-floor rooms.

Lit: Cevese, R., *I Palazzi dei Thiene*, 1952, 100; Magagnato, L., *Palazzo Thiene*, 1966, 54, 99.

66. DOORWAY. By Vignola. *c.*1561. Engraving. From *Regola delli cinque ordini d'architettura*, Pl.44.

The entrance gate to the villa of the Cardinal of Sermoneta on the Quirinal in Rome; now destroyed; one of a number of gateways made to open on to the new Via Pia, mentioned in a letter of 1561. Not included in the first edition of the *Regola* (1562), but in later editions from 1602; in these it is one of a group of eight designs attributed to Michelangelo; this one is certainly not by him, but seems to be entirely typical of Vignola.

67. DOORWAY. By Wendel Dietterlin, 1598. Engraving. From *Architectura, von Austheilung, Symmetria und Proportion der fünff Säulen*, Pl.76.

From Book II, devoted to the Doric order(!).

68. DRAGON AND LIONS. *c.*1550–80. Stone. Over life-size. *Bomarzo (Viterbo), Villa Orsini, Sacred Grove.*

A herm-pilaster bears the date 1552, which is probably near the beginning of the work; additions were still being made in 1578, but the owner, Vicino Orsini, confessed himself bored with it in a letter of 1580. The artists are unknown; the names of Ammanati, Vignola and the Zuccari have been suggested. The 'monsters' are carved out of natural rock, and were once painted. The 'inventions' may have come from Vicino Orsini himself, a man of wide and exotic interests, and a minor literary figure.

Lit: Lang, S., in *Architectural Review*, cxxi, 1957, 423; Battisti, E., *L'Antirinascimento*, 1962, 126; Bruschi, A., in *Quaderni dell'Istituto di storia dell'Architettura*, x/55, 1963, 13.

69. THE FOUNTAIN OF THE LABYRINTH. By Tribolo and Giovanni Bologna.

c.1545 to *c*.1560. Marble and bronze. *Petraia (near Florence), Villa Medici* (photo: Alinari).

Originally in the near-by Villa Medici at Castello; complete at Tribolo's death (1550) except for the crowning figure which was made later, probably following his model, by Giovanni Bologna (one of his earliest works for the Medici); it represents Florence wringing water from her hair.

Lit: Pope-Hennessy, 1963, i.72, ii.59; Aschoff, W., *Studien zu Niccolò Tribolo*, 1967, 97.

70. GROTTO. *c*.1560–70. Stone, pumice, tufo, mother-of-pearl, shells, stucco. *Castello (near Florence), Villa Medici* (photo: Alinari).

Often attributed to Tribolo, who laid out the gardens at Castello; while very probably following his idea, it was made at least a decade after his death (1550). In one of the groups of animals appears a copy of the antique *Calidonian Boar* (now Uffizi) which did not enter the Medici Collection before 1556. The grotto may be among the 'new works being made for the Duke' (Cosimo) by Tribolo's pupil Antonio Lorenzi 'with animals and birds on fountains' mentioned by Vasari (1568, vii.636). Bronze birds made for it by Giovanni Bologna *c*.1567 are in the Bargello; the design of the animal-groups has also been attributed to him, but incorrectly.

Lit: Kris, E., in *Jahrbuch der Kunsthistorischen Sammlungen in Wien*, 1926, 200; Dhanens, 1956, 159; Aschoff, W., *Studien zu Niccolò Tribolo*, 1967, 115.

71. THE GROTTE DES PINS. By Francesco Primaticcio, *c*.1543. Stone. *Fontainebleau* (photo: Giraudon).

The attribution is far from certain, and is based on similarities of the forms to those of Giulio Romano, Primaticcio's master at Mantua.

72. DISH. By Bernard Palissy. *c*.1560–70. Faience, *c*.46 cms. *London, Victoria and Albert Museum* (photo: Crown Copyright).

73. VILLA MEDICI, PRATOLINO. By Justus van Utens. 1599. Canvas. *Florence, Museo topografico* (photo: Italfoto).

One of a set of 14 illustrating the Medici villas. Utens's view shows only the slope down from the villa towards Florence; beyond it should be a lake and Giovanni Bologna's gigantic *Appenine* fountain, now almost the only surviving part of the gardens; the villa (1569–75) has also disappeared.

Lit: Lassels, R., *The Voyage of Italy*, 1670, i.206; Hülsen, C., in *Mitteilungen*, ii, 1912–17, 152; Smith, W., in *Journal of the Society of Architectural Historians*, xx, 1961, 155.

74. THE FOUNTAIN OF VENUS. By Giovanni Bologna, *c*.1565. Marble, the figure 130 cms. *Florence, Boboli Gardens* (photo: Alinari).

The setting, in the innermost Boboli grotto, was devised by Buontalenti and Poccetti 1583–8; the support was probably made by Giovanni Bologna at this date for the statue he had made two decades earlier; Venus's *contrapposto* is given a new meaning as she seems to look round at the satyrs peeping lecherously over the basin. The statue is remarkably *serpentinata* when seen a little further from the left.

Lit: Dhanens, 1956, 177; Pope-Hennessy, 1963, ii.79.

75. BERNARDO TASSO, L'AMADIGI. First edition, Venice, 1560.

Frontispiece and first page of text; a typical example of first-rate book decoration in the sixteenth century. The style – with intermixed figures, scroll-work and architectural elements – is characteristic of Venetian decoration of the period (especially in stucco), in which Mannerism was certainly more evident than in Venetian painting.

76. NYMPHEUM. By Vasari and Ammanati. 1551–5. Stone, marble and stucco. *Rome, Villa Giulia* (photo: Anderson).

The Villa Giulia is an example of the application to architecture of the principle of variety; the view shown is roughly that of a visitor who has passed through the Villa proper, across an enclosed court and into a loggia on the same level as the upper one visible here (which leads, finally, to the garden). The sequence of shapes and forms is remarkably diverse in character. Descent to the level of the balustrade is by curved ramps at either side; communication between levels in the nympheum is by hidden spiral staircases. Antique statues originally filled the niches, and landscape frescoes decorated the walls of the approach-ramps; fountains and fish-ponds are in the nympheum itself, and further small fountains in the grottoes on the middle level. The stucco River-God (also a fountain) on the left is perhaps by Ammanati himself. Vasari supervised the whole project, Ammanati was especially responsible for this part.

Lit: Coolidge, J., in *Art Bulletin*, xxv, 1943, 177.

77. DESIGNS FOR WINDOWS. By Bernardo Buontalenti. *c*.1580–90. Pen and brown ink, 26·5 × 35 cms. *Florence, Uffizi* (photo: Soprintendenza alle Gallerie).

Purpose unknown, but certainly for a Medici project. The motifs are handled with almost abstract freedom; Buontalenti's licence is especially indebted to Michelangelo's work on Palazzo Farnese and the Porta Pia in Rome [84]. In the centre study the two halves of the pediment are reversed; Buontalenti had already taken this step in the Porta delle suppliche (Uffizi, *c*.1580).

78. THE FARNESE CASKET. By Manno Fiorentino and Giovanni Bernardi. *c*.1543–60. Silver gilt, crystal, lapus lazuli, 49 cms. high. *Naples, Museo di Capodimonte* (photo: Alinari).

Made for Cardinal Alessandro Farnese, nephew of Paul III and builder of Caprarola [61]. The crystals, by Bernardi, were made 1543–6; the metal-work, by Manno, was begun about 1548 and still unfinished in 1558. Some of the crystals are after designs by Perino del Vaga. The over-all design for the body of the casket may be by Manno's friend Francesco Salviati (by whom similar designs exist); the later parts, including the lid and the corner-figures, may be after models by Guglielmo della Porta. The purpose of the casket is unclear; the suggestion that it was a receptacle for books is not well-founded. It is elaborately carved inside, and could carry few objects without risk of abrasion; it is possible that it had no specific function beyond that of being an ornament.

Lit: De Rinaldis, A., in *Bollettino d'Arte*, 1923–4, 145; Kris, E., *Meister und Meisterwerke der Steinschneidekunst*, 1929, i.65.

79. CASINO OF PIUS IV. By Pirro Ligorio. 1558–62. Stone and stucco. *Vatican, gardens* (photo: Alinari).

The view is across the oval courtyard from the casino proper to the loggia which overlooks, on the far side, a fish-pond. The walls of the courtyard were originally crowned by antique statues, removed by Pius IV from the Villa Giulia [76].

Lit: Friedlaender, W., *Das Kasino Pius des vierten*, 1912.

80. EWER. By Wenzel Jamnitzer. *c*.1570. Mother-of-pearl, silver-gilt, enamel, 32·5 cms. *Munich, Residenz, Schatzkammer*.

81. PALAZZO DEL TÈ. By Giulio Romano. 1526–34. Stone, brick and stucco. *Mantua* (photo: James Austin).

A view across the courtyard; the arcade seen through the doorway is not original.

Lit: Gombrich, E. H., in *Jahrbuch der Kunsthistorischen Sammlungen in Wien*, viii, 1934, 79; Hartt, F., *Giulio Romano*, 1958, 91; Verheyen, E., in *Art Bulletin*, xlix, 1967, 62; Shearman, J., in *Bollettino del Centro Internazionale di Studi di Architettura*, ix, 1967, 364, 434.

82. THE DEL MONTE CHAPEL. By Ammanati and Vasari. 1550–5. Marble, stucco, paint. *Rome, San Pietro in Montorio* (photo: Vasari).

Commissioned from Vasari by Pope Julius III; on the advice of Michelangelo the sculpture was entrusted to Ammanati. The tombs are those of the Pope's uncle, Antonio del Monte, left (with *Religion* above) and Fabiano del Monte, right (with *Justice*). The altarpiece, by Vasari, represents the *Baptism of St Paul*. Drawings by Vasari for the whole chapel exists; his plans were simplified as a result of Michelangelo's criticism. The stucchi in the semidome are chiefly white against gold and blue-grey, with inset frescoes; the architecture below is white marble, grey-veined; there is a coloured-marble floor and a yellow marble balustrade in front.

Lit: Vasari, 1568, vii.226, 521, 693; Pope-Hennessy, 1963, ii.75; Barocchi, P., *Vasari pittore*, 1964, 36, 133.

83. CANDLESTICK. By Manno Fiorentino and Antonio Gentili. *c.*1561–81. Gilt bronze, lapis lazuli, crystal. *Rome, St Peter's, Treasury* (photo: Anderson).

From a set of two candlesticks and crucifix presented by Cardinal Alessandro Farnese in 1581. A drawing dated 1561, corresponding in every detail but the top section, probably represents Manno's original design; it is likely that Guglielmo della Porta provided models for some of the figures. The crystals with scenes from the Passion (one signed 'Muzius') are, in part, copies of a series (1539–47) by Giovanni Bernardi, designed by Perino del Vaga, for an earlier altar-set also made for Cardinal Alessandro. Four candlesticks were added by Cardinal Francesco Barberini in 1668–73.

Lit: Kris, E., in *Dedalo*, ix, 1928–9, 96; Lotz, W., in *Art Bulletin*, xxxiii, 1951, 260.

84. PORTA PIA. By Michelangelo. 1561–5. Brick and travertine. *Rome, Via XX Settembre* (photo: Anderson).

Part of a scheme of urban reorganization initiated by Pope Pius IV. The attic extension is a restoration of 1853, and only follows Michelangelo's project in general terms. The gateway has also been built on to at the back.

Lit: Ackerman, J. S., *The Architecture of Michelangelo*, 1961, i.114, ii.125.

85. THE STUDIOLO. By Vasari and his school. 1570–5. Wood, stucco, coloured marble, and oil on panel and slate. *Florence, Palazzo Vecchio* (photo: Alinari).

Made for Grand Duke Francesco de'Medici, who had a strong amateur interest in natural sciences and alchemy; the paintings conceal cupboards in which he kept his mineral specimens, jewels, gold, silver and crystal objects, and so on. The iconographic scheme (devised by Vincenzo Borghini) allocated one wall to each of the four Elements, to which bronzes and paintings refer. When the doors are closed the *studiolo* is completely sealed off, with no natural source of light; secret staircases communicate with the treasury and private rooms of the palace. The present entrance is modern.

Lit: Lensi, A., *Il Palazzo Vecchio*, 1929, 231; Rinehart, M., in *Burlington Magazine*, cvi, 1964, 74; Berti, L., *Il Principe dello Studiolo*, 1967.

86. MASK DESIGNS. By Rosso. *c.*1535. Engravings by René Boyvin. *London, British Museum.*

From a set of sixteen; the masks were almost certainly made for one of the italianate pageants of Francis 1 at Fontainebleau. Such designs inspired the more famous masks composed of fruit, vegetables, etc., painted by Giuseppe Arcimboldo at the Imperial court at Prague (1561–87); the present designs have been attributed, erroneously, to Arcimboldo.

87. THE ROSPIGLIOSI CUP. Attributed to Benvenuto Cellini. *c.*1550–1600. Gold, enamel, pearl, 20 cms. high. *New York, Metropolitan Museum (Altman Bequest).*

The gold is engraved and enamelled as follows; tortoise black; dragon's body emerald, head sky-blue, wings and back emerald, red and dark blue; the underside of the cup, emerald and crimson; the harpy's torso inlaid white, headdress emerald and red, wings emerald, red and dark blue, tail dark blue and emerald, legs black. There is no certainty that the attribution to Cellini is correct, and the only reason seems to be the cup's outstanding beauty and refinement of craftsmanship. There are striking similarities in form and technique with the Radziwil Cup in the Schatzkammer at Munich, attributed to Hanns Karl of Nurenberg (cf. also the material published by Holzhausen, W., in *Pantheon*, ii, 1928, 483).
Lit: Plon, E., *Benvenuto Cellini*, 1883, 262.

88. TABLE-SET. Probably by Antonio Gentili. *c.*1580–90. Silver, the knife 21·5 cm. *New York, Metropolitan Museum (Rogers Fund, 1947).*

A drawing corresponding very closely to the spoon is also in the Metropolitan Museum, and is inscribed with Gentili's name.
Lit: Avery, C. L., in *Metropolitan Bulletin*, v, 1946–7, 252.

89. PEACE. By Francesco Salviati. *c.*1545–8. Fresco. *Florence, Palazzo Vecchio, Sala dell'udienza* (photo: Brogi).

Over the door in the centre of the long wall, flanked by history scenes [90]; executed in grisaille. Salviati's major work in Florence; a campaign of restoration, completed in 1965, has revealed that far more of the work is autograph than had previously been supposed; the parts reproduced here are certainly Salviati's. See Lodovico Domenichi's comment, in the text, p. 171. Vasari, who defends Salviati enthusiastically, reports the jealousies caused by this work, and by Salviati's excessive pride, among his fellow-artists, some of whom said that he was 'lavorando per practica, non istudiava cosa che facesse' – working by knack, not properly studying what he was doing; this foreshadows later criticism of Mannerism (p.174).
Lit: Vasari, 1568, vii.22; Voss, 1920, i.237.

90. THE STORY OF FURIUS CAMILLUS. By Francesco Salviati. *c.*1545–8. Fresco. *Florence, Palazzo Vecchio, Sala dell'udienza* (photo: Brogi).

See the previous note; the main scene is brightly coloured; the simulated sculpture group on the right is bronze-coloured.

91. THE ADORATION OF THE SHEPHERDS. By Pellegrino Tibaldi. Signed. 1549. Canvas, 1·57 × 1·05 m. *Rome, Villa Borghese* (photo: Gabinetto Fotografico Nazionale).

An early work, perhaps his first in Rome, very much influenced by Michelangelo.
Lit: Briganti, G., *Pellegrino Tibaldi*, 1945, 62.

92. COSIMO I. By Benvenuto Cellini. 1546–8. Bronze, 112 cms. *Florence, Bargello* (photo: Alinari).

Made without a commission, but subsequently bought by the Duke. The

armour was originally gilt, the eyes silvered or enamelled.

Lit: Cellini, B., *Autobiography*, (ed.) 1949, 344; Heikamp, D., in *Paragone*, 191, 1966, 57.

93. PERSEUS AND ANDROMEDA. By Giorgio Vasari. 1570. Oil on slate, 117 × 100 cms. *Florence, Palazzo Vecchio, studiolo*.
See the note to [85].

94. PORTRAIT OF A YOUTH. By Bronzino. *c.*1538. Oil on panel, 95·5 × 74·9 cms. *New York, Metropolitan Museum (Havermeyer Collection)*.

95. BASE OF THE PERSEUS STATUE. By Benvenuto Cellini. 1545–54. Marble and bronze, 2·06 m. *Florence, Loggia de'Lanzi* (photo: Alinari).
Lit: Cellini, B., *Autobiography*, (ed.) 1949, 329, 360; Pope-Hennessy, 1963, i.99, ii.70.

96. SALT-CELLAR. By Benvenuto Cellini. 1540–43. Gold, enamel, ebony, 33·5 cms. long. *Vienna, Kunsthistorisches Museum*.
Begun in Rome for the Cardinal Ippolito d'Este, completed in Paris for Francis 1; given by Charles ix to Archduke Ferdinand of Tyrol. Salt was to be placed in Neptune's ship, pepper in the temple of Tellus (or Ceres). The subject is an allegory of the interaction of sea and land, producing salt.
Lit: Cellini, B., *Autobiography*, (ed.) 1949, 249, 273, 305; Kris, E., *Goldschmiedarbeiten*, 1932, i.24.

97. IDEAL LANDSCAPE. By Paul Bril. *c.*1600. Oil on copper, 19 × 28 cms. *Collection of the Earl of Crawford and Balcarres* (photo: National Galleries of Scotland).

98. TABLE. By Vignola. 1565–8. White marble, alabaster, and coloured-marble inlay, 3·9 × 1·8 m. *Net York, Metropolitan Museum (Dick Fund, 1958)*.
Made for Cardinal Alessandro Farnese; from Palazzo Farnese, Rome. The general design is closely based on fragments of ancient Roman tables.
Lit: Raggio, O., in *Metropolitan Bulletin*, 1960, 213.

99. ARMOUR OF ARCHDUKE FERDINAND OF TYROL. By G. B. Serabaglio. 1559–60. Steel, partly gilt. *Vienna, Kunsthistorisches Museum*.
One of the masterpieces of Milanese armour; the set includes an elaborate shield. Characteristically, well covered with scenes from mythology, and possible reference to Ariosto's *Orlando furioso*.
Lit: Boeheim, W., *Waffensammlung des Allerböchsten Kaiserhauses*, 1894, 13.

100. PAGE FROM THE FARNESE HOURS. By Giulio Clovio. Signed. 1546. Miniature, 17·1 × 10·8 cms. *New York, Pierpont Morgan Library*.
Painted, over a period of nine years, for Cardinal Alessandro Farnese; an elaborate silver-gilt binding was made by Antonio Gentili (cf.[83]). The narrative scenes are in full colour, the framing partly bronze, with simulated marble figures against coloured backgrounds. The ovals imitate cameos. The model for the *Temptation* shown here was an engraving after Raphael. In Naples is a portrait of Clovio, holding the *Farnese Hours*, painted by his close friend El Greco.

101. THE STORY OF COUNT UGOLINO. By Pierino da Vinci, *c.*1550. Terracotta, 62 × 44 cms. *Florence, Collection of Conte Giuseppe della Gherardesca*.
One of several versions of a celebrated composition (another is at Oxford, a bronze cast mentioned by Vasari is lost). This version has a fine contemporary frame, characteristic of those in which Mannerist works should be seen.
Lit: Vasari, 1568, vi.127; E. Kris, in *Pantheon*, 1929, 94.

102. CASSONE. Italian (Venetian?). *c.*1560–70. Wood. *Florence, Bargello* (photo: Alinari).

Books for Further Reading

The best survey of the literature and historiography of Mannerism is by Battisti, E., in *Rinascimento e Barocco*, 1960, 216. There is a sound résumé of modern usages of the term in Weise, G., 'Le Maniérisme: histoire d'une terme', *L'information d'histoire de l'Art*, vii, 1962, 113. For a more detailed treatment of the definition used here, see Shearman, J., 'Maniera as an Aesthetic Ideal', *Acts of the Twentieth International Congress of the History of Art (1961), II*, 1963, 200.

The following studies on the general theme are particularly recommended: Curtius, E. R., *European Literature and the Latin Middle Ages*, 1953, 273; Gombrich, E. H., 'The Renaissance Concept of Artistic Progress', *Actes du XVII^{éme} Congrès International d'Histoire de l'Art (1952)*, 1955, 290; Smyth, C. H., *Mannerism and Maniera*, 1962; Freedberg, S. J., 'Observations on the painting of the Maniera', *Art Bulletin*, xlvii, 1965, 187; Friedlaender, W., *Mannerism and Antimannerism in Italian Painting*, 1957; Blunt, A. F., *Artistic Theory in Italy 1450–1600*, 1956.

There is much fascinating material discussed in Battisti, E., *L'Antirinascimento*, 1962, although the main thesis is highly questionable. Among the most stimulating specialized studies are: Gombrich, E. H., 'Zum Werke Giulio Romanos', *Jahrbuch der Kunsthistorischen Sammlungen in Wien*, viii, 1934, 79, ix, 1935, 121; Béguin, S., *L'Ecole de Fontainebleau, Le Maniérisme à la cour de France*, 1960; Berti, L., *Il Principe dello Studiolo*, 1967. The catalogue of the Council of Europe exhibition: *De Triomf van het Maniérisme*, Amsterdam, 1955, is full of information and well illustrated over the whole field.

The problem of literary Mannerism has not been widely discussed, but the following are helpful: Weise, G., 'Manierismo e letteratura', *Rivista di letterature moderne e comparate*, xiii/1–2, 1960, 5 (most informative, even if some disagreement is possible); Kunisch, H., 'Zum Problem des Manierismus', *Literaturwissenschaftliches Jahrbuch*, N.F.ii, 1961, 174; two excellent surveys of literary theory, the first more detailed, the second more readable, are Weinberg, B., *A History of Literary Criticism in the Italian Renaissance*, 1961 and Hathaway, B., *The Age of Criticism: The Late Renaissance in Italy*, 1962; the reader may also find these studies revealing: Crocetti, C. G., *Il pensiero critico del Giraldi*, 1932; Williamson, E., *Bernardo Tasso*, 1951; Brand, C. P., *Torquato Tasso*, 1965; Rossi, V., *Battista Guarini e il Pastor Fido*, 1886; Jeffrey, V. M., *John Lyly and the Italian Renaissance*, 1928; Ogden, H. V. S., 'The principles of Variety and Contrast in Seventeenth Century Aesthetics and Milton's Poetry', *Journal of the History of Ideas*, x, 1949, 168.

Similarly for music: Hucke, H., 'Das Problem des Manierismus in der Musik', *Literaturwissenschaftliches Jahrbuch*, N.F.ii, 1961, 219; Lowinsky, E., *Secret Chromatic Art in the Netherlands Motet*, 1946 (controversial but interesting); Palisca, C. V., 'Girolamo Mei . . .', *American Institute of Musicology: Musicological Studies and Documents*, iii, 1960; Einstein, A., *The Italian Madrigal*, 1949.

Since Mannerism is given, at the present time, many interpretations different from mine, it seems only fair to the reader to suggest some of the more serious and rewarding studies which will give him completely different approaches: Dvorak, M., 'Über Greco und der Manierismus', *Wiener Jahrbuch für Kungstgeschichte*, 1921, 22 – a classic which has been translated as 'El Greco and Mannerism', *Magazine of Art*, 1953, 14; Becherucci L., *Manieristi toscani*, 1944; Pevsner, N., 'The Architecture of Mannerism', *The Mint*, 1946; Pevsner's longer essay originally published in 1925 has now been translated and republished as 'The Counter Reformation and Mannerism,' in his *Studies in Art, Architecture and Design*, 1968, i.ii; Antal, F., 'The social background of Italian Mannerism,' *Art Bulletin*, xxx, 1948, 102; Hocke, G. R., *Die Welt als Labyrinth, Manier und Manie in der europäische Kunst*, 1957; Briganti, G., *Italian Mannerism*, 1962; Wurtenberger, F., *Mannerism*, 1962 (good bibliography and illustrations). Similarly for literature: Scrivano, R., *Il Manierismo nella letteratura del Cinquecento*, 1959; Hocke, G. R., *Manierismus in der Literatur*, 1959; Ulivi, F., in *Bollettino del Centro Internazionale di Studi di Architettura*, ix, 1967, 399 (with further references). And for music: Schrade, L., 'Von der "Maniera" der Komposition in der Musik des 16. Jahrhunderts', *Zeitschrift für Musikwissenschaft*, xvi, 1934, 3; Wolf, R. E., 'Renaissance, Mannerism, Baroque', *Les Colloques de Wégimont IV (1957)*, 1963, 35.

The most interesting sociological work is Crane, T. F., *Italian Social Customs of the Sixteenth Century*, 1920.

Index

Page references are given first, in normal type, followed by the numbers, in bold type, of the illustrations (also referring to the Catalogue of Illustrations).

More about Penguins and Pelicans

Penguinews, which appears every month, contains details of all the new books issued by Penguins as they are published. From time to time it is supplemented by *Penguins in Print*, which includes almost 5,000 titles.

A specimen copy of *Penguinews* will be sent to you free on request. Please write to Dept EP, Penguin Books Ltd, Harmondsworth, Middlesex, for your copy.

In the U.S.A.: For a complete list of books available from Penguins in the United States write to Dept CS, Penguin Books, 625 Madison Avenue, New York, New York 10022.

In Canada: For a complete list of books available from Penguins in Canada write to Penguin Books Canada Ltd, 2801 John Street, Markham, Ontario L3R 1B4.

Style and Civilization

Early Medieval

by George Henderson

Early Medieval art is without parallel in its vigour and variety. Fantastically wrought sword-hilts of warrior kings rival in splendour the gold shrines of apostles and martyrs; heroic tales of war and adventure displayed in embroideries or carved in ivory or stone vie with solemn Bible narratives painted on church walls or illuminated in precious manuscripts. This book traces developments in European art from the age of the barbarian migrations to the age of the pilgrimage roads and the great monasteries. The beliefs and loyalties of early medieval men, their popular lore and their hard-won learning, are sifted in an attempt to explain the meaning of the term 'Early Medieval' in art.

Byzantine Style and Civilization

by Steven Runciman

For more than eleven centuries Christian civilization was dominated in the East by the imperial city of Constantinople, and a deeply religious conception of the universe is reflected in Byzantine art. Whether he was designing some great architectural monument like the cathedral of Saint Sophia, or the smallest enamel reliquary cross, or an article for secular use, the Byzantine artist wrestled with colour and harmony to interpret divine beauty to humanity.

In this liberally illustrated study Sir Steven Runciman draws on his profound knowledge of the period to show how early Christians acquired this belief in the purpose of art and how it survived changes in technique, fashion and resources for as long as the Empire stood.

Style and Civilization

High Renaissance
by Michael Levey

Supreme accomplishment and total artistic confidence characterize the work produced, not just in Italy but all over Europe, during this marvellous period – in the palaces at Fontainebleau and Granada, in Holbein's portraits as much as Raphael's, in the princely monuments at Innsbruck and Antwerp. Considered as the interpreters of a divinely inspired energy and lauded for their ability to transmit pleasure and refinement, the High Renaissance artists, ranging wide in time and place, produced a luxuriant profusion of paintings, buildings and jewellery.

Michael Levey, author of the widely praised *Early Renaissance* (which earned him the prestigious Hawthornden prize), views the age as one triumphantly sure that art can rise above nature. Here, writing absorbingly and aided by a great understanding of the period and a selection of over 150 illustrations, Levey demonstrates how Michelangelo's 'David', Titian's 'Assunta', a piece of Spanish jewellery or a Palissy dish – to name only a few – illustrate the defiant virtuosity of the High Renaissance.

Neo-Classicism

by Hugh Honour

David's martyr icons of the French Revolution, Ledoux's symbolic architecture of pure geometry, Canova's idealized erotic marbles – in such Neo-classical masterpieces the culminating phase of the Enlightenment found artistic expression. Neo-classicism was no mere antique revival. If it began with the elegant sophistication of Adam and Gabriel, it ended in the ruthless simplifications of Flaxman's rudimentary linear technique. This primitivism consciously evoked a Spartan world of simple, uncomplicated passions and blunt, uncompromising truths. And these virile and ennobling ideals inspired *avant-garde* painters, sculptors and architects as far apart as Jefferson in Virginia and Zakharov in Leningrad.